THIS IS GONNA HURT

Music, Photography, and Life Through the Distorted Lens of
Nikki Sixx

WILLIAM MORROW

An Imprint of HarperCollins*Publishers*

HarperCollins books may be purchased for educational, business, or sales promotional use.
For information Please e-mail:Special Markets Department at SPsales@harpercollins.com.
195 Broadway, New York, NY 10007.

FIRST EDITION

Designed by P. R. Brown
Cover painting by Kevin Llewellyn. "Nikki Sixx". 2009. 40" x 30".
Oil on panel. Collection of Nikki Sixx, Los Angeles.

Library of Congress Cataloging-in-Publication Data has been applied for.

ISBN 978-0-06-206188-1

21 SCP 10 9 8 7 6

This Book Contains . . .

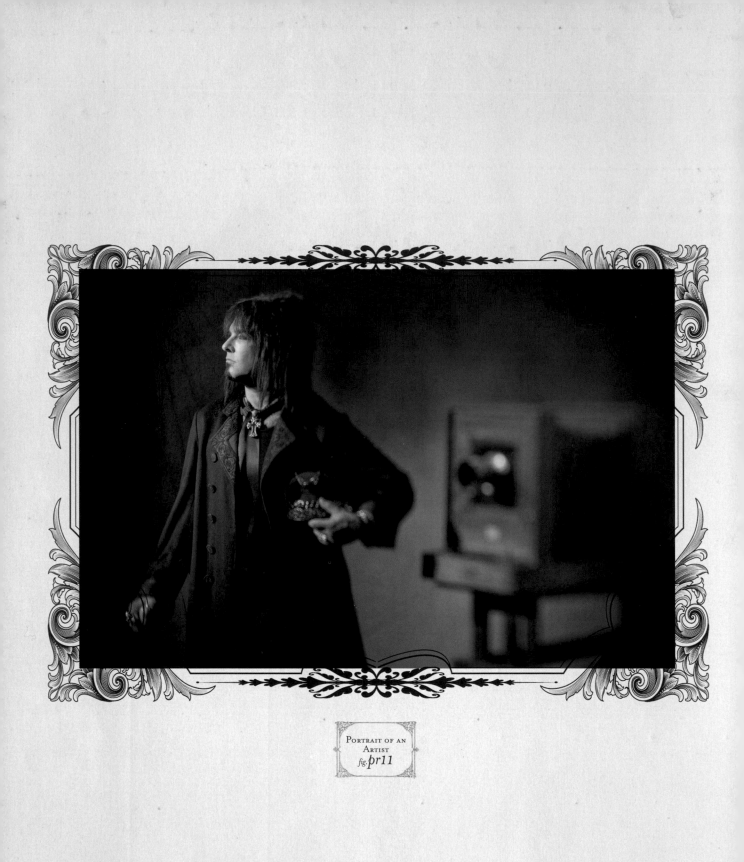

PORTRAIT OF AN
ARTIST
fig. *pr11*

YOU'RE PROBABLY WONDERING
WHY I INVITED YOU HERE

So here we sit again, pen to paper, heart in hand, me whispering softly in your ear as I prepare to take you on another journey. Last time we were together in *The Heroin Diaries*. Now we've moved on. I, cozy in my truths, and you, sometimes agitated in your opinions of me . . . but we're still going to sit here together, nose to nose, pondering each other.

This is gonna hurt.

My dream has always been the same since I was a kid, to somehow show people life through different-colored lenses. Now more than ever I feel it's important to see that way. We need to be aware that the warped perspectives of television, Internet, and magazines are sometimes poisonous. I cannot walk down the street without feeling I am being subjected to some constant sales pitch on what we should look like, smell like, dress like, or even worse, what we should *be* like.

I hope to take your breath away from time to time as you read about my experiences, my life, my rants and celebrations. I am going to lay it all out there for the world to see, not worried about ridicule. In my short life I have been wrong in my attitudes from time to time, have made bad decisions that have affected other lives, and still to this day I work hard at spiritual growth. The fact that when death knocked at my door I was lucky enough to tell him to come back later is reason enough to tell my story.

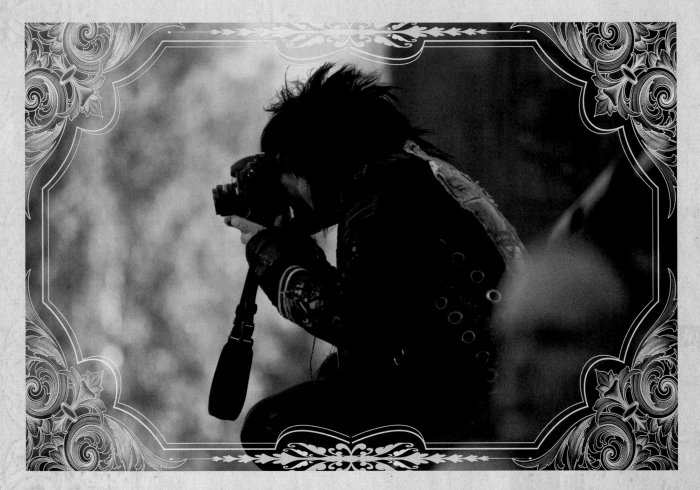

On Stage
Helsinki, Finland
fig. 52hs

But my story isn't so much about me as it is about life. I am just a man with a megaphone. Maybe I'll even be telling your story. I am sure you will let me know if it moves and motivates you. After *The Heroin Diaries* I got hundreds of thousands of e-mails and letters telling me how readers' lives had been changed for the better. I shared my story and maybe someone else's life was spared too. (I am speaking of the families as well.) If the photographs of human beauty and the words in this book show you the beauty in the downtrodden side of our souls, then I am happy. I have done my job. It's never too late to wake up. It's never too late for change. I, too, am changing.

I am writing this book partly in hopes that I will move somebody to pick up a camera, write a poem, pen a song, or take a shot at any other dream. I have always said, "If you can dream it, you can have it." In my heart, I'm wishing that these musings might motivate someone somewhere to go do great things.

Back when I wrote "Shout at the Devil" I was motivated by anger as I shouted into a million teenage ears. As the years go by, I become more aware that I am in a position to be heard. As I mature and become more conscious, I take this responsibility seriously.

My personal struggle is this: How do I continue to do things of importance—to grow as a man—yet remain this crazy artistic father, photographer–rock n roller, and businessman? And still not lose my edge? I think the only answer is to keep digging in my past and poking at all the wounds until I have discovered and healed every last one. The pain gives me the edge. I am grateful for it.

I think I have answered a few of my own questions here in this book. I try to be honest and walk my talk. I am happy to roll up my sleeves (tattoos and all) and let you see that I wear my heart for the whole world to see (scars and all).

So the question is, are you ready? I am, so let's go.

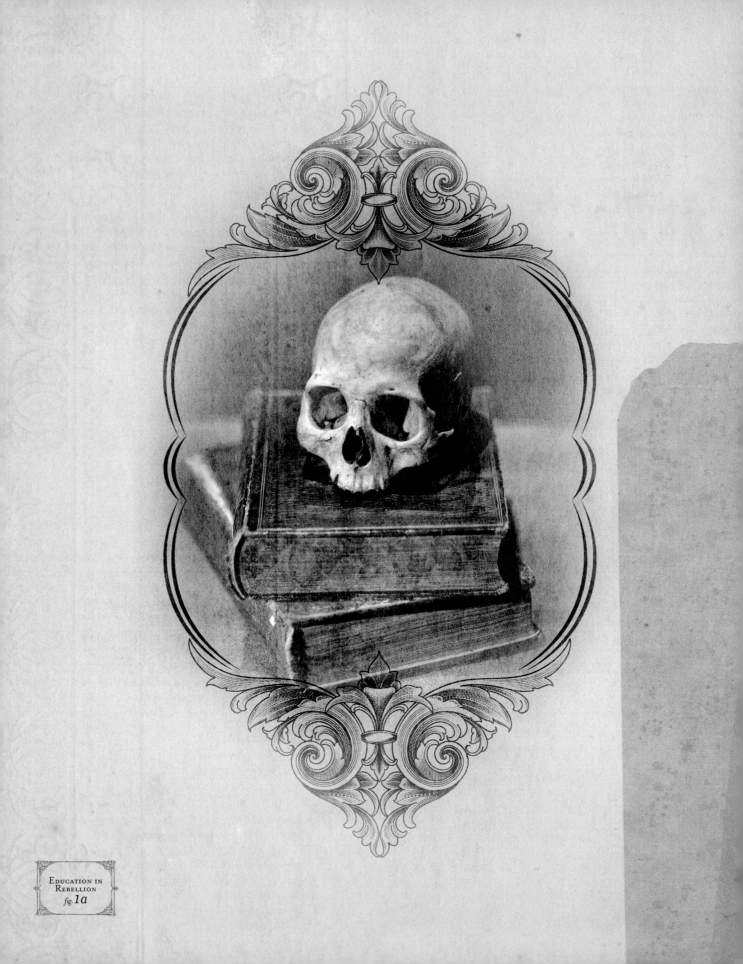

Why I Invited You Here | Look Thru My Cracked Viewfinder | Life's Not Always Beautiful | Ghosts Inside Me | This Is War | One Man, Two Bands | Killer's Instinct

Help Is On The Way | Tale Of The Siamese Twins And The Black Rose Tattoo | Rock N Roll Will Be The Death Of Me | The End, Unless It's The Beginning

I

LOOK THRU MY CRACKED VIEWFINDER

This all started innocently enough . . .

It was a crisp spring morning in 1989. I was newly sober and looking for something to replace the drugs that had been running through my bloodstream for years, and for some odd reason decided to go into a camera store. It was a simple little Canon 35 mm SLR and a couple of lenses that started an adventure that will probably plague me forever, like music.

(Well, okay, to be honest, it wasn't really the beginning of me shooting pictures: I had been snapping Polaroids of the band and our life on the road for years. But that's a different book.)

I believe my photography addiction somehow ties into the fact that I've always had an eye for the oddities in life. Even as a kid I saw the world in my own way and thought most things that were different were beautiful and magical. Even things that other people thought were horrifying and disgusting and weird.

I'm six or seven years old, walking down a street in L.A. with my mother. We pass by an amputee. I gaze at her, transfixed.

"Don't stare," my mother says.

"Why not?" I say. "She's beautiful."

A couple months ago I'm sitting on a plane next to Tommy Lee. I'm on my laptop, going through some of the photographs I've created. He asks to see. He clicks through a bunch, then stops and stares at one showing an obese woman standing on a pedestal, mouth open wide in a scream, spewing some kind of clear liquid.

"You know, Sixx," he finally says, "you are one of the most seriously fucked-up people I've ever met," and he laughs, and I laugh, too, but I'm thinking, *Man, thirty years together and he still doesn't get me.*

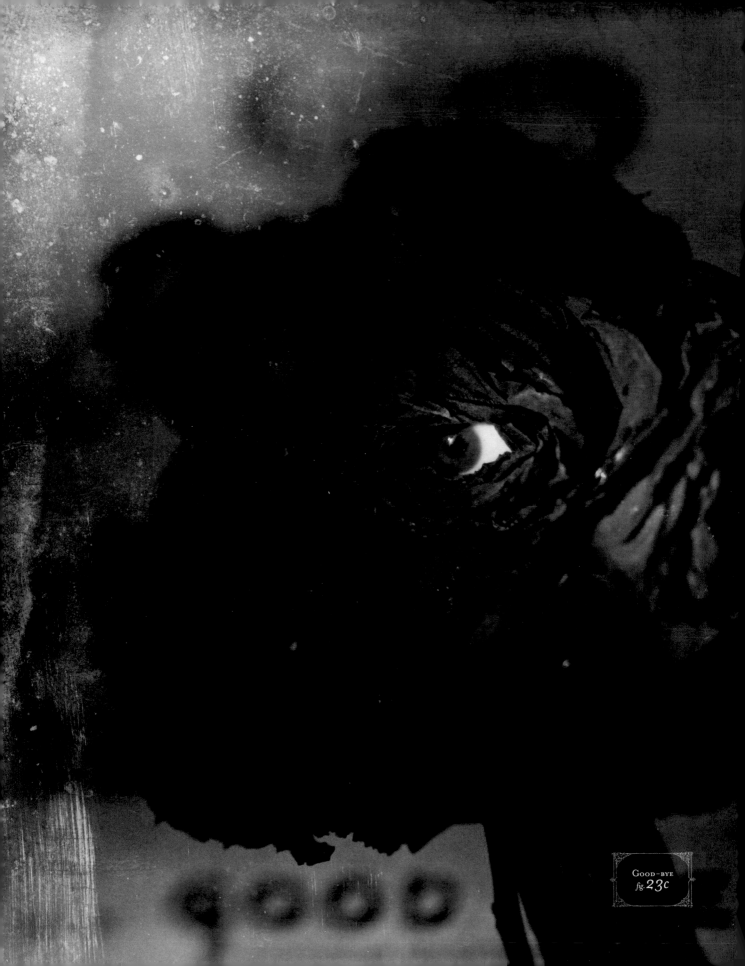

GOOD-BYE
fig. 23c

I see a lie. Some people look at a rose and see romance and love. I see thorns and droplets of blood and heartbreak. I see the struggle to survive and connect and find a happy ending.

I remember as a kid looking through old photography books about sideshows and circus performers and wondering why people thought them so odd. Just people think they don't have feelings because they're missing teeth? They can't have emotions because their features are misshapen? They can't be beautiful because they don't conform to our stereotype of beauty?

Maybe we're the ones who are ugly.

Whilst walking in downtown Los Angeles one day, a homeless man asked me for a helping hand. I think the fact that he had no hands played to the sense of me that finds such irony poetic. I told him I had a few dollars to spare if he had a few moments for me in exchange. We sat together, not more different in our stories, but worlds apart in our realities. At one point he asked me why I was sitting there talking to him. After all, most people just look away at the sight of someone in his place, or lack thereof. I told him, as I tell you now, I didn't know why. I just let my heart tell me to go and often I don't understand, but I do know that that day was one of the last times I was without my camera. This man's image haunts me still. Not in terror, but because he, too, is a survivor, and he felt blessed to be alive, even on the hard, cold street of downtown L.A. Not capturing that moment was a great lesson in being a photographer.

Life is full of too many false starts and abrupt finishes and unexpected detours. Just when you think you have it all figured out, something new comes along and rips the rug out from under you. I cherish this about my existence. People come up to me and ask, "Nikki, how can you be in one of the world's biggest rock bands, have a side band with a hit album, have a clothing line, be a successful author, have your own radio show, be a father of four, and on top of that still have such cool-ass hair?" I say, "Wait, what about my photography?"

By now, I can't imagine not taking pictures whenever the moment moves me—from the first rays of morning light bouncing off the windowsill to the loveliest strung-out of a wild rose standing on the

corner of the freeway, begging for change. Beauty is in the eye of the beholder, they say, and I say they're right. I also say you see what you want to see, so I keep my eyes wide open at all times.

I sometimes feel like a robot, scanning the planet for information. The conversation I have with a fan in an airport, **DOWNLOADED** into my brain. The kid who runs in front of my car chasing a ball, making me stop on a dime, **DOWNLOADED**. The woman at the gas station driving a Rolls-Royce and yelling at the attendant that he didn't properly clean her windshield, **DOWNLOADED**. As an artist, I take it all in knowing it will somehow be regurgitated later, maybe as a lyric, or a chapter in a book, or a photograph.

When I see something, I grab whatever's handy and start clicking— my iPhone, my Holga or Diana toy cameras, my little Canon point-and-shoot, my homemade pinhole wooden camera, or the big Nikon D3, or my new friend, a Gilles-Faller wet-plate camera from 1890. All just different ways to collect what falls beneath my gaze.

I think the photographer who turns up his nose at a low-res cell-phone camera has lost what he fell in love with in the first place: capturing that magical moment. Taking a picture is just telling a story. You know, like the blink of an eye, a flash, then it's gone. I know that for me, the magic is in the moment. I live for the mystery of that. I learned this somewhere along the way. I hear it in AA meetings often: one day at a time. I even hear one minute at a time.

I forget this sometimes, and when I do I start to feel out of sync with life. I think photography realigns me with the moment.

I don't have a favorite style of photography. I love the same greats that every fan does, like Joel-Peter Witkin and Diane Arbus. But there are so many others. I recently found a wonderful book when I was in London, titled *Le Temple Aux Miroirs* by the French photographer Irina Ionesco. She turned the world on its head in the 1970s when she took photos featuring her underage daughter in tantalizing positions, a presexual kitten mixed with bordello queen. Raw and beautiful in the lighting and rich in texture thanks to the darkroom work, it is brilliant. But it is also her own young daughter, nude for all the world to see. It makes me think, as an artist and a parent. One side of my brain is inspired, one side repulsed.

Old cameras capturing odd people with ancient

souls, sitting on antique books and furniture, sometimes shot in abandoned places, or sets made to look suitably destroyed and decayed . . . everything and everybody here on this polluted blue marble is destined to leave a mark, and this is one of mine. I will leave it to the history books to decide whether it's good or bad. If it's up to the critics, well, put it like this: word on the street is there ain't no Grammy in my future. I ruffled way too many feathers in the old boys' network for that to happen. I hope to follow suit in photography.

Photo sessions for me are like injections of life. I pace back and forth impatiently, like a man with a machine gun, and trust me when I say I have an itchy trigger finger. Once I get the picture, I "get the talent out," as the expression goes, meaning I send the models away. This is the moment when the magic comes to life. It's like capturing a soul. Going through the photos frame by frame, cursing the focus of this one, amazed at the perfection of that one.

Then it's all about the processing of the images, the dodging and burning, and if there is any juice left in your engine (or time on the

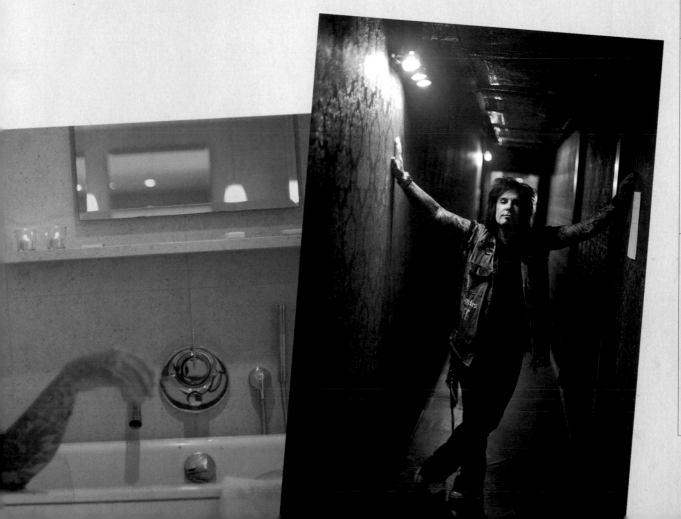

clock) maybe a print or two to hold in your hands. I almost always take an image home with me at the end of a shoot, like a cannibal takes a head. A trophy, I guess.

My favorite sessions are with the old, decrepit, deranged, and uniquely beautiful. The once living or now on the verge of dying. Maybe we're just stopping time until we graduate to the next level (some call it heaven). No matter how they look, I say they are pretty things. After all, if they can make you feel, they must be special. There is a sensation to something that has been around for a long time, a kind of energy that I get from it. The older we are, the better we become. Just look at Keith Richards. (I am not far behind.)

I search high and low to find people who move me emotionally to photograph. Some come to me through friends of friends, casting directors or other photographers, but it isn't easy. I have tried my hardest to get into places most people run from. Shooting galleries are almost impossible to penetrate, and mental institutions have so much red tape you'd think they were sacred. Whorehouses aren't easy to get into when you're lugging a camera, but I have gotten into a few.

For me, it's love of personal contact that pushes my creativity. That's why I love shooting on the street. Whether it was in Cambodia, Thailand, Australia, or someplace else, finding people who have fallen on the hardest of times, those who seem forgotten, has provided me with my happiest times as a photographer. They need to have their beauty acknowledged by capturing the image.

I always take my cameras with me on tour. Photography takes me away from the normal routine (and boredom) of airport-limo-hotel-venue. Sometimes it takes me far, far away.

In Vancouver, I was talking to the concierge at the hotel where Mötley Crüe was staying. You're supposed to ask the concierge when you're searching for the nearest great restaurant or local hot spot. Somehow I always feel like an alien because I never want to know about the nightlife (at least not that kind). But I knew that some questions are better whispered than announced to the whole lobby.

I looked down at her name tag and asked the question under my breath—way under my breath, so far under my breath I may have seemed like a crazy person miming. I said,

"Julie, I'm trying to find the most drug-infested part of town."

She said, "Of course, sir, I'll get my manager to help you."

The next name tag in front of me belonged to Karl. "May I help you, sir?" he asked. By the way he blurted it out, I could tell Julie hadn't

filled him in on my request. I repeated it, at which point Karl took me aside and asked a few questions, mostly to cover the hotel's ass, I think. When you look like I do and ask where the crack houses are, people might assume incorrectly about what you're after. Once I explained, he said he had a few friends who are photographers and so he knew the perfect place, but first I needed to understand how dangerous it was. Imagine my smile when I got what I asked for.

Jumping into a van with a bag of cameras and six hundred Canadian dollars in my pocket was my idea of a perfect day off from the crazy traveling circus. Running up behind me came my 350-pound (and equally bighearted) security guard, Kimo. I told him he had to stay at the hotel because he would scare people away. We had a heated argument, during which the tour manager and then actual managers were called. Finally, to save time, I just caved in. We all agreed that Kimo could come—as long as he stayed far enough away so nobody would notice him, but close enough to save me if necessary. Frustrating sometimes to be thought of as a commodity.

Sucking up my ego and picking up my cameras, I was off to the crack district. It took ten minutes to get there from our five-star hotel, and three hours to get Kimo to allow me to enter the most dangerous alley in Vancouver. It wasn't unlike a million other alleys I've seen except it looked bottomless. I couldn't even tell if it was a dead end or not. Brick buildings lined it, old banks and government offices, now abandoned. This isn't prime real estate unless you're a junkie.

I sat alone at the mouth of that alley for over an hour until one guy came up and asked what I wanted. I told him I wanted to take pictures. I wanted to be a fly on the wall, so to speak. I told him I was an ex-addict and maybe some of these pictures would help other people who were thinking about doing drugs.

His response was simple: "How much?"

Now, being one to bait the hook with the fattest worm, I gave him fifty dollars and he took off to tell the others that I had money and was one of them. Before long I was twenty feet into the alley and a hundred dollars lighter. I saw Kimo pacing back and forth as I handed out cash and disappeared deeper and deeper until finally I was out of his sight altogether. At last.

The alley smelled like dank piss and rotting garbage. Plastic tarps strung from one garbage bin to another created shelter from the rain and added to the stink. At first it looked like ten, maybe twelve people in clusters, but as I went deeper I saw more groups, maybe trying to keep

WHY I INVITED YOU HERE · LOOK THRU MY CRACKED VIEWFINDER · LIFE'S NOT ALWAYS BEAUTIFUL · GHOSTS INSIDE ME · THIS IS WAR · ONE MAN, TWO BANDS · KILLER'S INSTINCT

HELP IS ON THE WAY · TALE OF THE SIAMESE TWINS AND THE BLACK ROSE TATTOO · ROCK N ROLL WILL BE THE DEATH OF ME · THE END, UNLESS IT'S THE BEGINNING

OH MY GOD
By Slick A.M.

She was born at 6am on New Year's Day
In an alley right at the heart of where
homeless children play

*And the truth is we will never even
know her name
Cuz as long as we can fill our glasses up
we will look the other way*

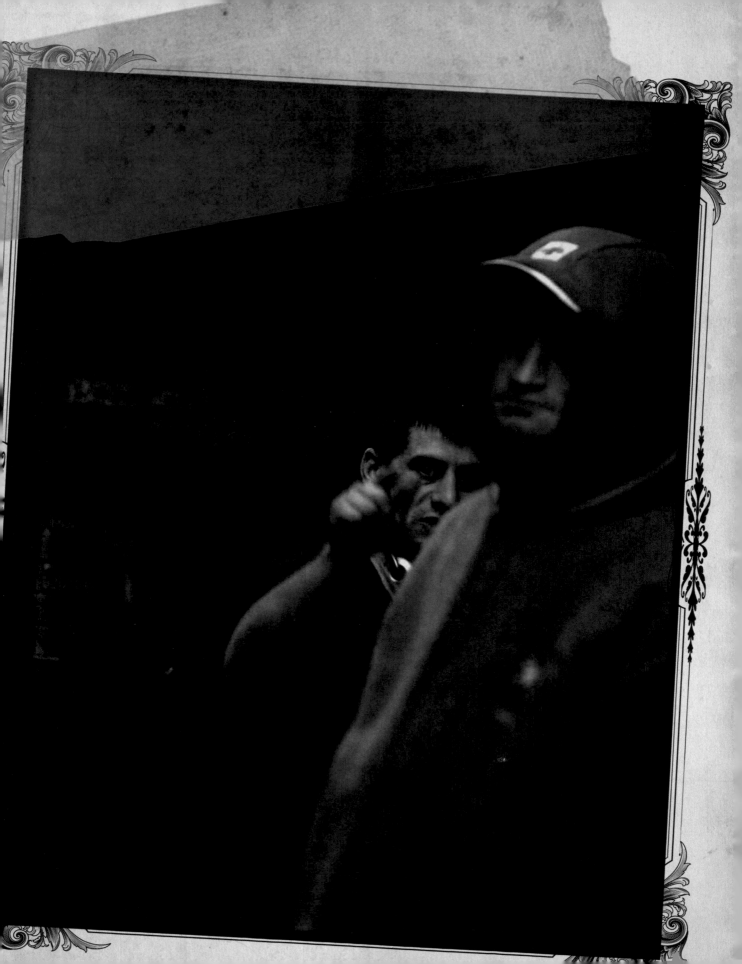

warm and definitely trying to get high together. It was like a community from hell. There were no young kids that I saw. I don't think I could have handled that. I saw enough of that on a trip to Cambodia and that is another level of heartache.

My interaction was minimal. Nobody knew who I was, and if they did, why would they care?

Still, I was treated with more respect and given more polite "thank yous" and "excuse me, Nikkis" than I get in some of the nicest neighborhoods in the world. They wanted to know about my addiction and recovery. They told me their dreams and downfalls. I took two hundred pictures that day, two hundred moments of hope. As I was leaving one guy asked me if I would come back and say hello someday.

I remember getting into the van and telling Kimo that people are amazing—all they want is to be accepted. Kimo looked at me and said, "Dog, you always find the good in everything. I always learn something on these photography missions with you." It was quiet in the van riding back to the hotel. A feeling of gratitude falls over you after a day like that. Next time I'm in Vancouver, I plan on going back there. I hope I don't recognize a single face.

Another model search started in St. Petersburg, Russia. I tried explaining to our translator, Andrei, what I wanted to shoot. First word I said was, "Prostitute." He looked at me sadly and said in very broken English, "You are want me find girl for you today?" I said "Nyet, not girl . . . *girls*." I explained how I had once rented a whole brothel in Thailand just to make some photographs. Andrei still looked confused but said, "I will see if I can find girls to take pictures of . . ."

Didn't happen.

Next stop, Stuttgart. I asked Ossy Hoppe, our German promoter, the same question I had for Andrei. This time there wasn't a pause, or an "I'll ask around," or a "nyet." There was just a simple, "What time do you wanna go?"

"Right after the show," I said, sealing the deal.

As soon as we left the stage I grabbed my camera bag and said to Rex, the tour manager, "I'm ready to go and you're coming with me."

Rex is British and has worked with every band you can name, most notably Led Zeppelin. I told him not to be slow and he rolled his eyes and smiled. He has seen this movie or some version of it a million times.

We arrive at the brothel. Rex runs in first, then a minute later runs back out shouting, "Let's go!"

Camera bag in hand, I walk in and the girl at the front desk asks, "So you want to shoot picture?"

"Yes, like this . . ." I say and break out some reference art I had brought along.

Soon, I was like honey for the bees and the girls started coming up, buzzing, chatting in German, and then it came. I explained what I wanted. All I heard was *nein*, again and again.

The girl up front saw the disappointment in my eyes and said, "Okay, okay, I will let you take pictures of me." Problem was, she was a blonde and somewhat pretty. I was looking for the seamy underbelly—the addiction, the pain, the hell that is their lives. Not some German version of a California party girl.

I was about to grab my stuff and leave when I saw something in her eyes. Just a glimpse, but it was there—what I was looking for. I just needed to see it again and capture it with my camera.

"Okay," I said, and she dragged me and Rex upstairs, the madame in tow.

I had a choice of four rooms, all pretty much the same, so I picked the red one and asked where the light was. The madame says, "Light? We don't need light." *Oh shit*, I thought, *maybe not for what you do . . .* I asked if they had any kind of lamp and after much discussion in German, a guy appeared with a work light not unlike one you would find on a construction site, harsh and way too bright.

I looked around and saw the paper towels the girls use to clean up after sex. I draped some over the lights, making a very ugly (and flammable) diffuser. I positioned the girl to get just her eyes and prepared to shoot.

I did a quick test, told her she looked beautiful, took the shot, and showed it to her. She smiled. But it still wasn't what I wanted, what I had seen before.

Okay, I thought, *now this is the part where I either get the shot or I get kicked out*.

I focused the camera on her face and asked, "Do you like what you do for a living?"

Suddenly I saw that hurt look in her eyes, *snap, snap . . .*

Question two, "Does your mom know you're a prostitute?"

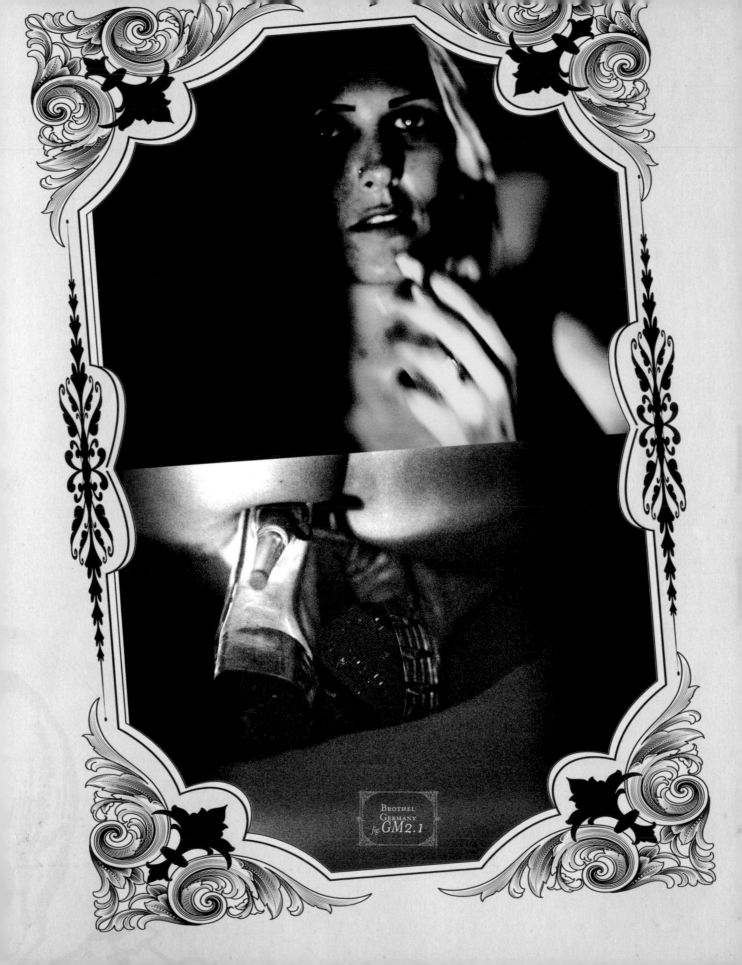

BROTHEL
GERMANY
fig. GM2.1

Fig. 1.

Fig. 1. Seitenansicht.

Fig. 2.

Lies of the Beautiful People

THIS AIN'T NO SIDE SHOW
THIS IS THE GREAT UNKNOWN
THIS IS THE POISON WE TAKE

OUTSIDE THE VELVET ROPE
STANDING THERE ALL ALONE
ARE THE GROTESQUE AND ASHAMED

IF YOU THINK REAL BEAUTY'S ON THE OUTSIDE
WELL THAT'S A FAR CRY FROM THE TRUTH
MAYBE ALL THE INFORMATION YOU RECEIVE
YOU SHOULD NOT BELIEVE... THERE'S NO PROOF

SAVE YOURSELF FROM ALL THE LIES OF THE BEAUTIFUL PEOPLE
JUST RUN AND HIDE FROM THE LIES OF THE BEAUTIFUL PEOPLE

LIFE LOOKS SO TRAUMATIZED
DOPED UP AND TELEVISED
IT CAN BE CRUEL AND INSANE

WE'VE GOT THESE UGLY SCARS
ON OUR INFECTED HEARTS
MAYBE IT'S TIME FOR A CHANGE

IF YOU THINK THAT REAL BEAUTY'S ON THE OUTSIDE
WELL THAT'S A FAR CRY FROM THE TRUTH
MAYBE ALL THE INFORMATION YOU RECEIVE
YOU SHOULD NOT BELIEVE... THERE'S NO PROOF

SAVE YOURSELF FROM ALL THE LIES OF THE BEAUTIFUL PEOPLE
JUST RUN AND HIDE FROM THE LIES OF THE BEAUTIFUL PEOPLE

SIXX:A.M.

Oh, that was tough to ask. The look again, *snap*, *snap* . . .

Next I asked if I could shoot her from the rear. She seemed perturbed but I snapped a quick picture and told her again how pretty she looked.

I had a feeling I was running out of time so I had her sit on her Plexiglas heels, six inches high at least. She told me she didn't like her ass. I told her I was shooting her shoulder, and to look out the window. I fired off maybe ten pictures, all of her ass, when she blurted out, "Do you want to drink?"

I told her I don't drink. Then she said, "Do you want drugs?" I said I don't do drugs. She mustered up the last question, the one I knew was coming and I dreaded: "Do you want sex?"

I said, *"I don't do sex."*

She turned toward me, crawling off her heels and off the bed. She stood erect, stunned. I took a quick picture of her then, too.

"If you don't drink, do drugs, or want sex, what do you do?" she asked, and I said, "Oh, I just take pictures." Then I turned on my leather Chuck Taylors and split, leaving Rex to pay the bill. I think I captured her pain and maybe even her essence. I know one thing for sure: I pissed her off. She's got a tough life, I realize, and even though I sound like a punk, I truly respect her for surviving such a hard road.

It's not always easy to get the person on the other side of the camera to see what I see. When I am doing a shoot with someone, I spend as much time talking to them as I do taking pictures. I want to know everything so I can make the moment honest. These people have been told over and over that they're bad and ugly. That they're not perfect like us. They've been pointed at and laughed at since childhood. Life can be cruel. It's been my struggle, my personal battle, my obsession to make people see that different isn't always bad.

But then I contradict myself. I instinctively believe that the face of an angel usually hides something iniquitous and wicked under that porcelain-white soft skin. (I really hate it when I am judgmental, but I am working on that.) Meanwhile, my experience has shown me that beneath the darkest of visages usually gleams the softest of hearts. The glow is easy to see if you are willing to open your eyes and admit that all life is beautiful.

Unfortunately for our society, we have been brainwashed into believing the lies of the "beautiful people."

For example, once a year *People* magazine puts out a list of the one hundred most beautiful people. I could hurl at this public display of deception. Makes me sick to think that millions of teenagers and young adults are being lured into believing that some made-up list is the standard for beauty and success.

Why I Invited You Here | Look Thru My Cracked Viewfinder | Life's Not Always Beautiful | Ghosts Inside Me | This Is War | One Man, Two Bands | Killer's Instinct

Help Is On The Way | Tale Of The Siamese Twins And The Black Rose Tattoo | Rock N Roll Will Be The Death Of Me | The End, Unless It's The Beginning

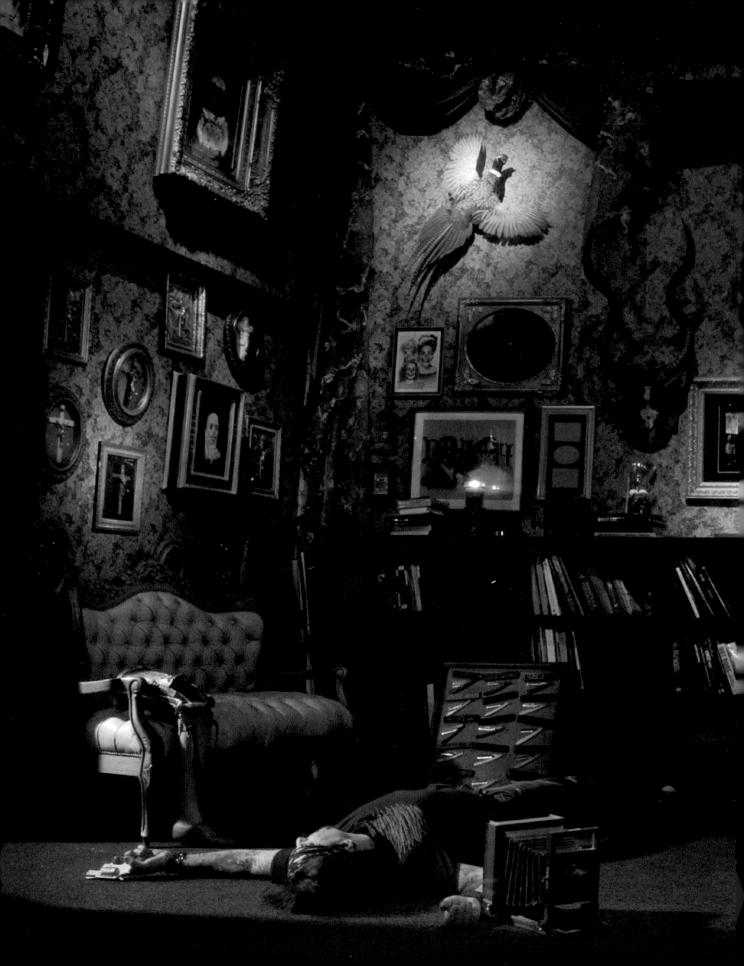

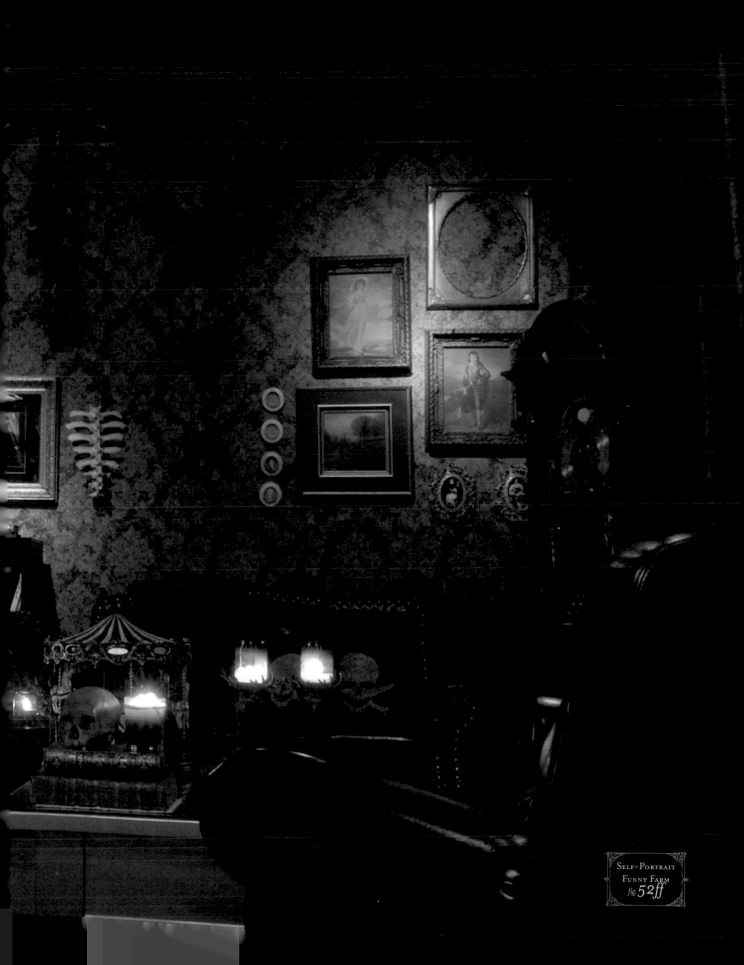

SELF-PORTRAIT
FUNNY FARM
fig. 52*ff*

I am not a psychiatrist, but I stand firm in believing that allowing this kind of trash into our homes via TV, Internet, and magazines is a kind of mental-health terrorism.

It's hard to imagine how someone's creative energies go into reality shows like *The Girls Next Door*, showing the mental retardation caused by overbleaching while millions of viewers sit on the edge of their couches watching Hef's Girls—watching them stare into a mirror so long that they believe the silicone is really them.

I am not saintly; I just have seen this movie before and I want my money back. I want more for myself and my loved ones.

"Entertainment" is today's deadly poison, and we're Tivoing it all straight into our brains. That's how our perception of life gets distorted. It's then that we start to believe that what's washing over our brains is "reality." Brainwashing, anybody?

I want us to return to the days of hard work and harder determination to better ourselves. Not being famous for being famous. I am not wrong for forbidding *People*, *Entertainment Weekly*, and garbage Dumpsters full of other, even worse magazines into my home for my kids to absorb like deadly diseases.

Driving to the studio today I heard a voice on the radio say, "From the same people who brought you the Kardashians, an even more messed-up family, *Meet the Lamas*," or something like that. I faded off into the rain that was hitting my windshield. The new generation of puppets don't even know what they're in for, sadly.

I turned off the radio and turned on some Neil Young. I felt embarrassed to be in this industry and felt sad for the viewers who think it's OK to idolize the newest of the beautiful people rotting from the inside out.

"Stand outside the velvet rope and yearn to be in our grace," the message is beamed into our brains. "Try to be like us, and maybe we will accept you."

But what if you don't like what you see, or maybe you even view the people in *People* magazine as the freaks, the oddities, the disfigured?

Humans have always needed some version of the bearded ladies, amputees, midgets, or looming giants and other freaks.

Is it as the photographer Diane Arbus said, that we need freaks because they scare us? Or is it just human nature: we want to fit in so badly that it feels good to point out people who will never make the grade, no matter how hard they try?

It all gets really interesting when the self-made freaks become the stars that the "in crowd" wants to imitate. Oh, what a confusing mindfuck we are converging upon. In the 1980s I tattooed my body pretty much top to bottom. My own mother asked me, "Are you gonna join the circus?" Today, it's almost mainstream to have your arms tattooed from shoulder to wrist. To have steel bolts catapulting from your lobes, nipples, and belly buttons. Now it's OK to tattoo yourself everywhere and *not* join the circus. You can be tattooed and pierced with crazy hair and still get a job at Kinko's or Starbucks or some other big, international chain. Thank God the lines are getting blurred by our acceptance of one another's differences.

I love seeing the straight-looking man in a suit and tie talking to the girl with pink hair and a pierced nose at the local coffee shop. I love sitting on a bench talking to a homeless man and us both walking away feeling good. Maybe we really are capable of progress. I think we are on the road to awareness that it takes *all* of us to make this wonderful world.

If that can happen, maybe someday we'll be capable of admitting that the one hundred "most beautiful people in the world" could possibly be the ugliest ones of all.

There was a time in my life, after living on the fringe for years, that acceptance was granted to me, like an unwanted award. I had fought hard to not conform to a society of anti-joysticks. It infuriated me that I was asked into their social clubs, VIP rooms, and roped-off celebrity enclaves. It felt like a mockery to me—to accept these "honors" would be a betrayal of my own self. I was confused by fame and success from the beginning, always more of an artist and less of a red carpet wannabe. It all just made me angry. I don't believe anybody set out to insult me. It just came out that way.

The other day I found a journal entry from 1984. It simply said:

People tell me I am a star, fuck them.

That sentiment was comforting to me then. It tells me I was willing to stand up as an artist and not be strung up as a puppet.

It looked to me like the beautiful people had stuck their noses under our circus tent and exclaimed, "Sorry we laughed at you. We didn't know you would be so popular and all the rage. Now we love you. Now we wanna look like you. We'd love to introduce you to all our friends . . ."

Hence my journal entry. *Fuck them.*

How could I forgive them when I didn't trust them?

Not so long before, they wouldn't let me in their little world, their restaurants and clubs and hotels. I remember being asked, "Are you some kind of faggot?" because I painted my nails. Suddenly I was a sex symbol?

That was a lot for anybody to handle. I'm still trying to this day. Trying to forgive people for judging me, and to forgive myself for judging people. For becoming what I hated.

I feel like my photography somehow ties into all this.

I'm just pulling up to my studio here in Los Angeles. It's aptly named Funny Farm, not only for the voices that speak to me from inside my

own head, but also for the lunatics who crawl through the door at all hours to create with me. Funny Farm is not the kind of studio you'd imagine from a guy in a rock band. There isn't a piece of musical equipment here except for a random, out-of-tune acoustic guitar in a corner.

Between the overstuffed leather couch on which I'm sprawled and the antique, hand-carved Chinese cherrywood chairs, you can see flickering on the wall a twelve-foot-tall cross that I bought right off the top of a church. Nailed here and there are 1920s French crucifixes, thirteen in all, under antique glass and mounted on old, fading velvets. There are also some mannequins with giant spread wings, a steampunk-meets-Mad-Max child-sized mannequin dripping in raven feathers, surrounded by Persian carpets and books . . . tons and tons of old books. The taxidermy on the walls makes me feel like I have a million friends with two million beady eyes staring down.

This is my home away from home, my office, my haunted haven. My photography studio.

This is where I pull ideas out of thin air and somehow "see" them before I start the process that will end with them captured, mounted, and nailed to my walls. There is no Welcome to Funny Farm Studios sign. There is just an iron gate that needs three keys to open. So maybe it's a bit like Fort Knox here, and that suits me and my taxidermic friends just fine. (If I told you they all had names, would you think me insane?)

If you wander out of the lounge, you have a few choices. Turn to your left and you end up in the medical room. I have always had a fascination with 1800s medicine. It's surreal to think of what humans had to endure not so long ago. A bone saw is more than even I can fathom. There are oversized syringes, bottles that once held everything from cyanide to formaldehyde, and illustrated medical cards from a time long past, once used by doctors to compare symptoms in order to come up with diagnoses. Encircling the dental molds and meat cleavers is my collection of jawbones.

The wall behind you is covered in prints of my latest work, strung up on raw wire and held there by antique clothespins. I've taken the ceiling out, leaving the industrial inner workings of the building exposed (the guts, so to speak). Fluorescent light fixtures hang down, and inside the clear plastic covers, I've placed my collection of old medical scissors. When the lights come on, you see thirteen-inch shears floating above your head.

In still life (and death) photography, I express my love of bones, and not only human ones, by the way. I do have a nice collection of human skulls. Maybe a femur or two as well. They're all unique and all beautiful like people, and unfortunately for those around me, they all have names. When workmen come to Funny Farm, I often get a call from my wonderful assistant Sara (imagine her job) saying the painters won't go into the studio alone or they heard noises in the other room . . . Good God, just think what the UPS man would say if he knew what he'd been delivering to me for years.

Point being, death seems to take on a life of its own in my photography.

So here's a good question: Why, if photography makes me feel so alive, do I so often end up shooting some form of death? "I live in death, I can smell it, it's in the air and the air smells sweet," I've been overheard saying.

The *Tibetan Book of Living and Dying* says that death is the graduation ceremony, while living is just a long course in learning and preparing for the next journey. If we acknowledge death as the beginning, then how can we fear it? In my twenties I wanted it so bad

Why I Invited You Here | Look Thru My Cracked Viewfinder | Life's Not Always Beautiful | Ghosts Inside Me | This Is War | One Man, Two Bands | Killer's Instinct

Help Is On The Way | Tale Of The Siamese Twins And The Black Rose Tattoo | Rock N Roll Will Be The Death Of Me | The End, Unless It's The Beginning

that I got it, but I wasn't ready. I hadn't finished what I started, so to speak, nor have I now. I don't fear death; I welcome it with open arms and a smirk. But until that wondrous day, I will continue to savor and celebrate all those who have graduated before me.

The makeup area is strung with silks and lace and painted gold, like a bordello. On the directors' chairs I spray painted "horror" and "pimp." (Nobody ever gets the horror/whore joke.) I had state-of-the-art makeup lights and tables put in for all the crazy shit we do here. Actually, it's been a godsend considering the massive amount of time working on makeup, hair, and prosthetics here. I had a huge hole cut in the wall and framed like a picture so I can keep an eye on the models and makeup artist as I prep the studio and the lights.

When I see old faded black-and-white Polaroids of me in the 1960s, I wish I could have shot them. I constantly scrounge for new techniques everywhere, from online to foreign secondhand stores to the back rooms of friends' darkrooms. I am always exploring, always pushing myself. When I see my kids laughing, it's a picture. My girlfriend painting, it's a picture. And so on and so on . . .

For one memorable session I did here, I needed a model who would be basically a blank canvas, but at the same time would seem like something just left of center. I needed her to do partial nudity, or else the clothes were going to date the image. Ralis, the makeup artist I hired, took the reins, knowing what was in my head and what was about to happen to the model's face. He sent me photos of a dozen candidates and only one jumped out at me. Her name was Ekaterina, and you could see her Russian ancestry even through her glossy modeling pictures. I had a vision that involved turning her pretty face to hell. I felt that if I took a beautiful girl and disfigured her, I might be able to capture something unique in the lens. These girls usually pose to look as gorgeous as possible, so how would she respond to the camera once we were through with her? Old habits die hard. So even though on the outside she would be falling apart, on the inside her instinct tells her she is still beautiful. I was excited to see if I could capture an emotional meltdown.

My vision was very carnival-sideshow but mixed in with a bit of androgyny. I shot her in a way that brought out her beauty and the scars equally. She could either be a transsexual, a Russian circus performer, or just a beautiful girl who had been doused in battery acid. Disclaimer: I only took the shots . . . the story is in your head (well, there was a story in mine, too). But I must leave you with these parting words from Ekaterina, who told me, "Thank you, Nikki. I have never felt so

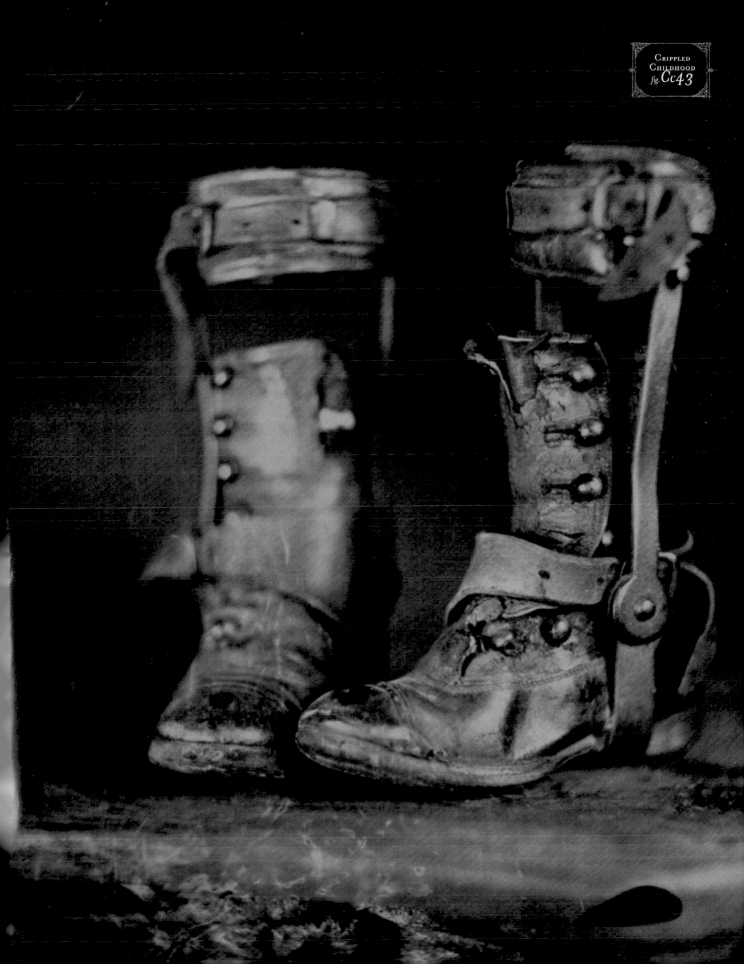

beautiful in my whole life." I smiled that smile I get when I want to say, "I told you so."

One of the first big shoots I did at Funny Farm was the "You Will Not Grow" session.

I like to say that all things start off innocently enough before taking on a life of their own, and this was no different. I called up graphic designer Paul Brown and explained the idea. I needed a set built to look like a dilapidated, decaying, postnuclear children's classroom. For models, I needed a female midget and a male at least seven feet tall. I also needed a master at lighting, a prosthetic makeup artist, and someone to help me get the set, clothes, and vision down on paper first.

Paul took it all in casually and said, "Benny Haber is the best assistant in the business and a master at lighting. Ralis is the best there is for makeup, prosthetics, set design, and all around demented visions." That's all I needed to know as I was basically foaming at the mouth at this point.

The idea of the photo was about being held back. The midget teacher was a small, angry dictator abusing her authoritarian role. The giant student was a meek, overgrown schoolboy. You could see, not only on his face, but in the hate drooling out his screaming mouth and down his chin, that he was frustrated to the verge of becoming something monstrous . . .

My part in all this, you ask?

Well, I have been held back for moments, sometimes brief, sometimes longer (my bad for giving my power away to abusive assholes). I wanted to convey the absurdity of someone so small telling a person, "You will not grow." The giant student could easily destroy his teacher but he has been brainwashed and mind-fucked, and he follows the rules even though the rules can't cage him. "You Will Not Grow" is his reality until he decides to change it.

My photography is one huge purge. Like everything else—all the music and lyrics, the videos, and now the photographic images—they all boil down to a single moment of creation: me sitting here alone at Funny Farm, writing to you from my heart, trying as I always have, since I was a kid, to say, "Look how beautiful that is." I remember hearing many times,

"Don't point at people less fortunate than yourself," to which I exclaimed, "But they're beautiful!"

I turned myself into the person everyone pointed at. All the scars and markings of a life seen through the eyes of a dreamer. Dreaming of better things, honest things.

Beautiful things . . . like the ones in this book.

I am not angry any longer, I am grateful. I am able to see my life through photography because of these experiences.

Life is weird living in a cage. It's sometimes weirder being let out.

That's where creativity has stepped in time after time and saved my life.

Creativity in its purest form is when you're willing to stand erect, eyes slammed shut, and let yourself fall. Whether it's backward toward a cement floor or forward off a thirteen-story building, you have to believe that somehow, someway, you're not going to crack your head on the floor or hit the street below. Unlike the overblown ad campaign for the newest cologne, or the equally horrible-smelling commercial featuring the diamond ring that signifies a love that lasts "forever," this journey is not one that has a safety net waiting to catch you softly in its arms but, I hope, one that is more like laying your head upon a bed of nails. And, if you're lucky, piercing your heart in the process and reminding you how to feel. I live and love and make music and make pictures in this place and, like I said, I don't know what I'm doing or why I do it, but I do know this: I love it, and *I hope it moves you like it moves me.*

###

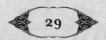

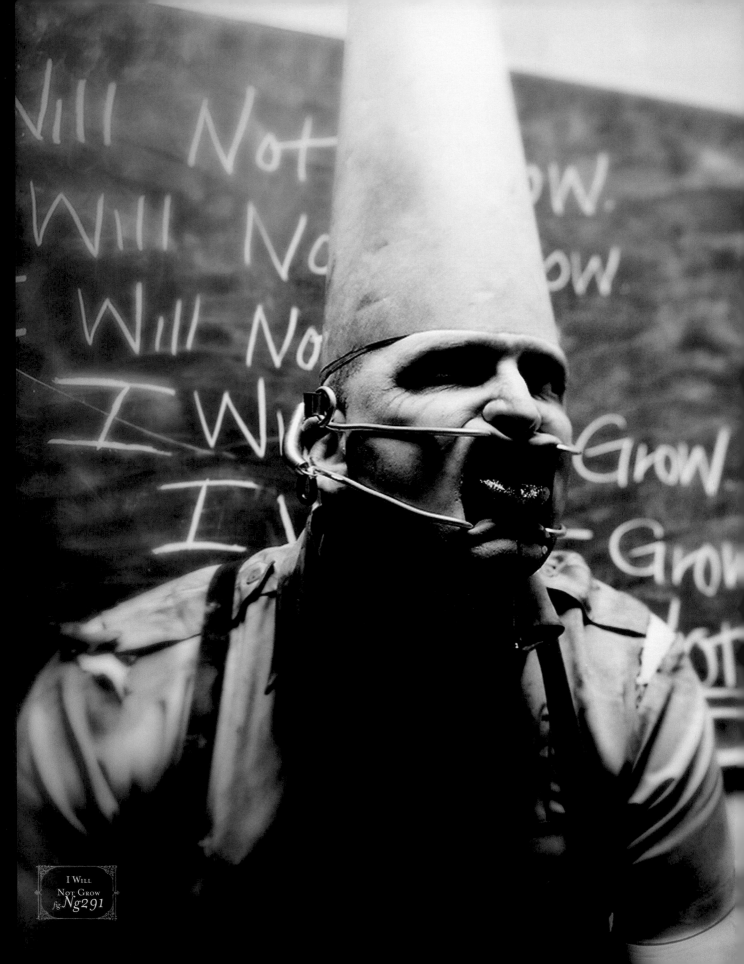

I Will
Not Grow
fig.Ng291

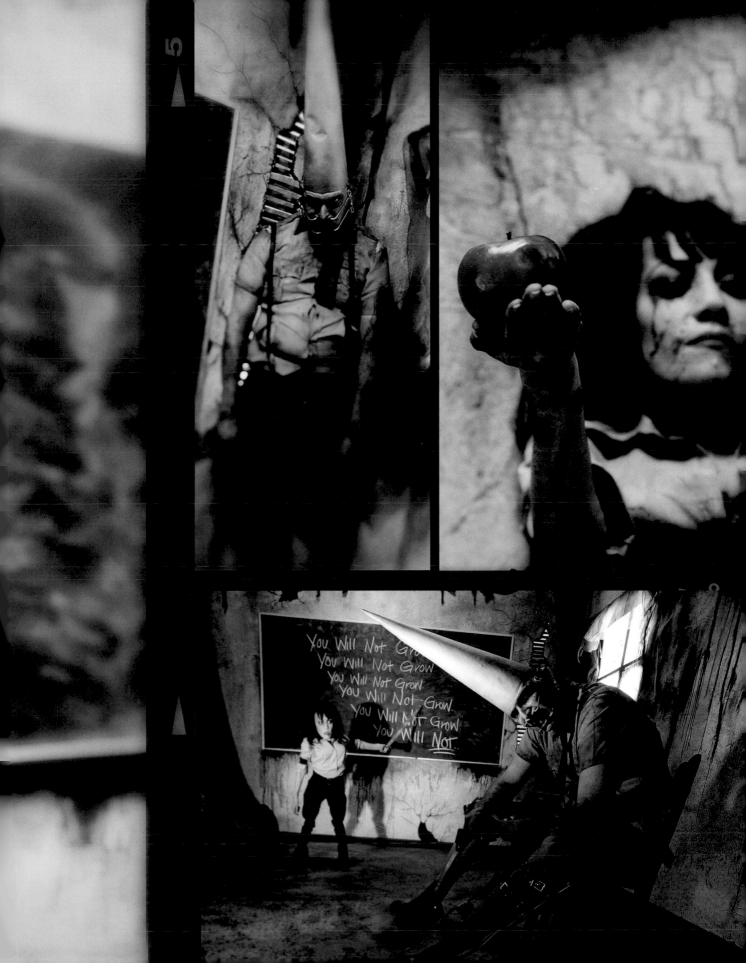

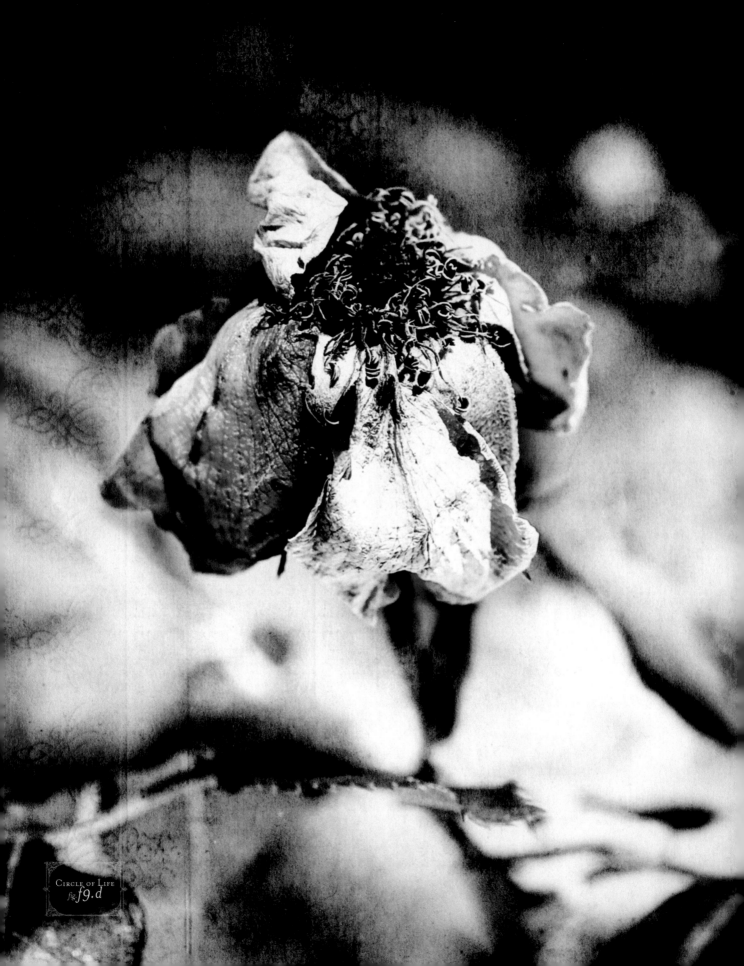

CIRCLE OF LIFE
fig. f9.d

Interlude

LIFE'S NOT ALWAYS BEAUTIFUL

I was young and remember everything was beautiful. I am told I used to pick flowers and give them to my mother. I would smell the air and sigh "I love you" to whomever was near by. I was told I loved all animals (even dead ones) and was sweet as apple pie. I was told I used to mutter the words "God is good." That's where the story gets muddled and murky and, to be honest, I only remember going to church and being told to kneel before and confess to God. I do believe in God, but not the god that's forced down the throats of innocent "god-fearing" pedestrians. I won't remember that part of my childhood as "blessed." Some say I am cursed, demons in my scrunched up fists, calling out to those who will listen (I got you right now).

I am confused about a few things but not this. The Bible, the book of lies, the spoliation of my industry, the lies of fame, the narcissism of neurotic behavior, victim saints and soul-sucking whores, say it now, I say, bloody rosary in hand; fuck you for the memories. *I am not my past but my past is me.* Pain is a beautiful reminder of what I try to forget.

I am the outcast come home to roost and the eggs of tomorrow are incubating in my fame. You hate me, you love me, you made me, and now I am in you. I am like that disease brewing in your loins and I think you like it . . .

I once wrote a song for Mötley Crüe called "Poison Apples":

Poison Apples
Mötley Crüe

TOOK A GREYHOUND BUS DOWN TO HEART ATTACK
AND VINE WITH A FISTFUL OF DREAMS AND DIMES.
SO FAR OUT I DIDN'T KNOW THAT I WAS IN.
HAD A TASTE FOR A LIFE OF SLIME.

WHEN PUSH CAME TO SHOVE, MUSIC WAS THE
DRUG AND THE BAND ALWAYS GOT TO PLAY.
SEX, SMACK, ROCK, ROLL, MAINLINE, OVERDOSE.
MAN, WE LIVED IT NIGHT AND DAY.

WE LOVED OUR MOTT THE HOOPLE,
IT KEPT US ALL SO ENRAGED.
AND YOU LOVED US, AND YOU LOVED US,
AND YOU LOVED US.
WE'RE SO FUCKING BEAUTIFUL!

PRETTY LITTLE POISON APPLES, SEE THE SCARS
TATTOOED ON OUR FACE.
IT'S YOUR DISGRACE.
PRETTY LITTLE POISON APPLES, MAMA SAID,
"NOW DON'T YOU WALK THIS WAY,
JUST FIND SOME FAITH."

TABLOID SLEEZE JUST MAGGOTS ON THEIR
KNEES DIGGIN' IN THE DIRT FOR SLAG.
MOONSHINE, STRYCHNINE,
SPEEDBALL, SHOOTIN' LINES.
ANYTHING TO PUSH THEIR RAGS.
STILL WE LOVE OUR MOTT THE HOOPLE,

mother

IT KEEPS US ALL SO ENRAGED.
AND YOU LOVE US AND YOU HATE US
AND YOU LOVE US.
WE'RE SO FUCKING BEAUTIFUL!

PRETTY LITTLE POISON APPLES,
SEE THE SCARS TATTOOED ON OUR FACE.
IT'S YOUR DISGRACE.
PRETTY PRETTY POISON APPLES, MAMA SAID,
"NOW DON'T YOU WALK THIS WAY, JUST FIND
SOME FAITH."

BLUEPRINTS FOR DISASTER.
YOU BETTER NOT PUSH ME
'CAUSE I'LL BRING YOU TO YOUR KNEES,
TO YOUR KNEES.
BLUEPRINTS FOR DISASTER.
YOU BETTER NOT LOVE ME
'CAUSE I'LL BRING YOU TO YOUR KNEES,
MAMA, TO YOUR KNEES.

PRETTY LITTLE POISON APPLES, MAMA SAID,
"NOW DON'T YOU WALK THIS WAY,
JUST FIND SOME FAITH, FAITH, FAITH, YEAH."

PRETTY LITTLE POISON APPLES.

FATHER & SON

father

NONA

This Is Gonna Hurt

Sixx:A.M.

Feels like your life is over
Feels like all hope is gone
You kiss it all away
Maybe maybe
This is a second coming
This is a call to arms
Your finest hour won't be wasted wasted
Hey hey hell is what you make make
Rise against your fate fate
Nothing's gonna keep you down
Even if it's killing you
Because you know the truth

Chorus:
Listen up listen up
There's a devil in the church
Got a bullet in the chamber
And this is gonna hurt
Let it out let it out
You can scream and you can shout
Keep your secrets in the shadows and you'll be sorry
Everybody's getting numb
Everybody's on the run
Listen up listen up
There's a devil in the church
Got a bullet in the chamber
And this is gonna hurt

You got your hell together
You know it could be worse
A self-inflicted murder
Maybe maybe
You say it's all a crisis
You say it's all a blur
There comes a time you've gotta face it face it
Hey hey hell is what you make make
Rise against your fate fate
Nothing's gonna keep you down
Even if it's killing you
Because you know the truth

MOTHER & SON

Why I Invited You Here | Look Thru My Cracked Viewfinder | Life's Not Always Beautiful | Ghosts Inside Me | This Is War | One Man, Two Bands | Killer's Instinct
Help Is On The Way | Tale Of The Siamese Twins And The Black Rose Tattoo | Rock N Roll Will Be The Death Of Me | The End, Unless It's The Beginning

I was speaking sarcastically of growing up and having the sword of judgment always waving above my head . . . I was laughing at you for laughing at me by saying, "We're so fucking beautiful."

I was making fun of you . . . again . . . It was revenge through pen and paper. I don't see how this could be any plainer than the poison on the end of my tongue. But at that time I couldn't see it. I could feel it for sure, but that's a whole different thing . . . I am not angry, or defiant, anymore. (Well, maybe a bit here and there.) I am more aware now that we're all on a journey, and mine is not only to be different but to "show" and help others to "see" the beauty in difference.

I rant and rave, I push and shove you with these words to make you feel. To make you see all that is before us is *maybe* not the truth. I push myself to ask questions and engage; why would I not do the same to you?

Right now, as we speak we're on the same page, but maybe not in agreement and that too is OK.

Some things sticky don't always stick.

I was driving my '32 Ford hot rod today, windows down, roar of the motor in my half-deaf ears, Starbucks in hand, and as I slowed to a stoplight I noticed the pedestrian ahead of me reading *Autobiography of a Yogi* as the Santa Ana winds were kicking up. I went into one of those stop-motion moments where it seems your life is flashing before your eyes.

Glendale, California . . .

. . . using, speed-taking teenager, I set of on the . . .

in my angry, twenty (speed's such a wonderful drug) hands. It stuck with me for weeks, sticky in its content. I couldn't put it down. Mesmerized and then forgotten. So there I was thirtysome years later and remembering how at ease it made me feel. I wasn't ready for the journey of peace; I wanted war and I got what I went after.

Isn't it wonderful how life tugs and tugs on your heartstrings, sometimes gently, sometime not? This was a gentle reminder that I am a different man now. The part of me I "see" clearly is the beauty in the honesty of just being yourself. When I photograph you, I hope to see it in you . . . Only the honest stand before me now.

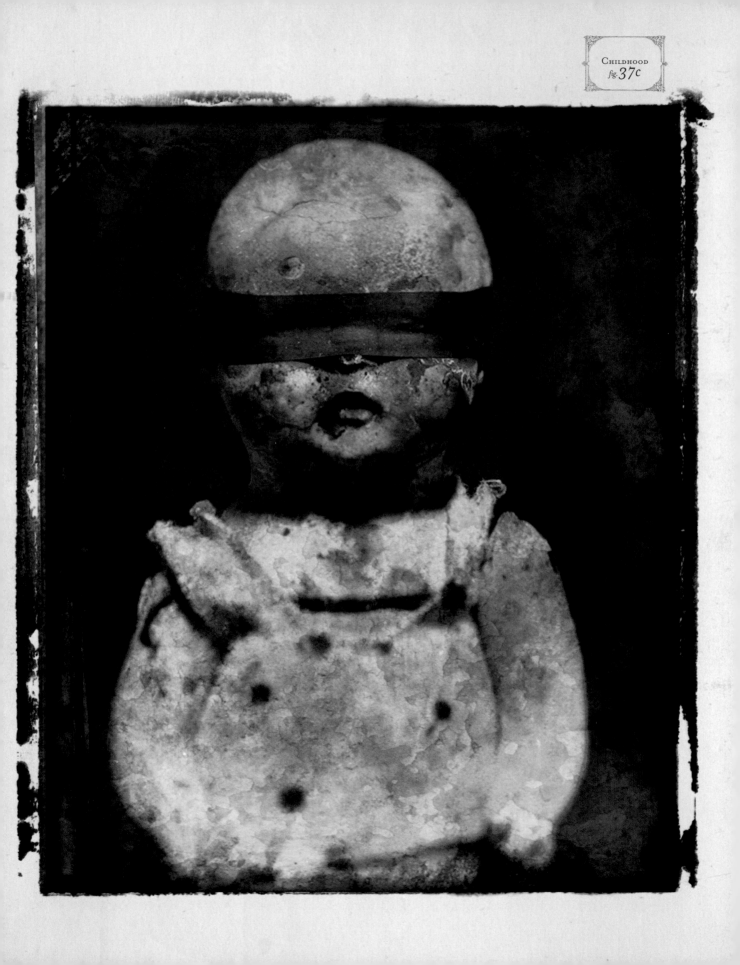

Why I Invited You Here | Look Thru My Cracked Viewfinder | Life's Not Always Beautiful | Ghosts Inside Me | This Is War | One Man, Two Bands | Killer's Instinct

Help Is On The Way | Tale Of The Siamese Twins And The Black Rose Tattoo | Rock N Roll Will Be The Death Of Me | The End, Unless It's The Beginning

H

GHOSTS INSIDE ME

New Anthony, New Mexico, doesn't seem so long ago or far away. I remember being nine years old, walking down a dirt road toward the gas station that sold my favorite penny candy. I remember how impermanent I felt even then.

Bouncing back and forth between my mother, who moved every few months, and my grandparents, who also roamed, I really never felt like I fit in anywhere. I realize now the damage that was done, but at the time I just felt like I could evaporate at any moment and wake up in a new city, with a new life and a new school, only to be unhinged again in the blink of an eye. It was the beginning of the disconnection that has always made me feel like a ghost . . .

I am constantly rummaging in my past, trying to find me, and sometimes I stumble upon memories that spawn even more digging. It's not always such a happy thing. But I am so lucky to have all these skeletons rattling around in my closet. Through them my awareness grows, and thanks to that I feel inspired to make music, do photography, and even write these words.

As I explore this paranormal fantasy of my life, it becomes obvious that it isn't a fantasy at all. My father abandoning me at such a young age left a ghost in his place, a huge hole that I tried filling with a million toxic concoctions. My mother, vacant and ghostly in her own way, was living the high life of the sixties and seventies and wouldn't realize the hurt she was causing me until it was too late. I have had to learn to forgive to move forward.

And there was at least one more spirit I had to face.

Flash forward. I was sitting in my mansion. Married with kids and all the trimmings. Proud to be sober, not only off alcohol but cocaine and heroin, too. Mötley Crüe had just finished the Dr. Feelgood tour and we were rolling in success. Ferraris lined the driveway, custom Harleys overflowed the eight-car garage. Years of hard touring and smart business decisions had paid off.

It wasn't enough.

Being off drugs isn't always a cure-all. Once the numbness lifts, the original pain is still there. I don't think that it was all my mother's fault. But at that moment I couldn't find a better target for my anger. I told myself that I was trying to be a good son by reaching out to her from time to time. And maybe I was. But now I see I also had something else in mind.

I picked up the phone and invited her to come down and stay with me awhile. Maybe if she saw the material success, the financial brilliance, the stable family man, she would have to recognize that I was right all along and she was wrong. Maybe then she would have to say, "I am sorry, son, I wasn't there for you. I wasn't a great mother." And then all this anger would melt away. I felt that my misery needed to be shifted and lifted off me onto her.

Looking back, I think my head was big but my heart was crumbling.

Mom arrived at the house and we did all the usual stuff families do. I showed her to the guest room and she settled in. It's weird sitting across the table from your mother when you two don't really know each other. I was trying, really trying to connect, but that damn pang in my gut, the one that always got me in trouble, just wouldn't leave things alone even for a minute, and suddenly there it was, bam, right between the fucking eyes . . .

"Mom, where is Lisa?"

Okay, there goes that happy moment.

Lisa Feranna was my sister, born about two years after me. I don't remember seeing her, ever. All I remember is my mom telling me Lisa was in an institution somewhere, and it upset Lisa too much for us to visit her. She was comfortable there, with people who cared for her, and seeing us would ruin everything. I didn't have a clear idea what any of it meant. I didn't even know if she was handicapped or retarded or mentally ill. Once, someone in a club in Hollywood called me retarded,

and I knocked the guy out—not because of the insult (I have heard worse), but because it somehow connected to my sister. To the unknowing, to the secret.

Whenever I would ask my half sister, Ceci, she told me the same things my mother had said. But how would Ceci know any more than I did? All we had was Mom's word.

I can smell a rat a mile away, and that day at my house my intuition was on high alert. So I asked my mother and then waited to hear what she would say.

Again she told me Lisa was with a nice family who loved her very much. "They have always taken care of her, Nikki, and she is better with them than if I had raised her." It was the '60s, my mom said, and things were different back then. She had no way of caring for a child with the problems Lisa had.

I have always felt guilty that I didn't think of Lisa very often when I was growing up. I went through life just accepting the situation: Lisa was not present in my childhood. I've never even seen a picture of her, much less one of us together. In my early years, moving around with my mother and grandparents, I felt like a tumbleweed blowing in the wind, only stopping when I got tangled up in something. Like barbed wire. No wonder I seemed to have forgotten Lisa. It feels like she was erased in all that moving back and forth. God, it's confusing when this stuff bubbles up, and it fucking hurts.

Listen up
Listen up
There's a devil in the church
Got a bullet in the chamber
This is gonna hurt

—*"This Is Gonna Hurt," Sixx:A.M.*

I started to hammer my mother with more questions. Do you talk to the family that cares for her? Is Lisa OK now? How old is she?

My mother just sat there, looking down at the table.

Then came my final bullet.

"Mom, I want their phone number."

Silence.

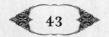

Why I Invited You Here · Look Thru My Cracked Viewfinder · Life's Not Always Beautiful · Ghosts Inside Me · This Is War · One Man, Two Bands · Killer's Instinct

Help Is On The Way · Tale Of The Siamese Twins And The Black Rose Tattoo · Rock N' Roll Will Be The Death Of Me · The End, Unless It's The Beginning

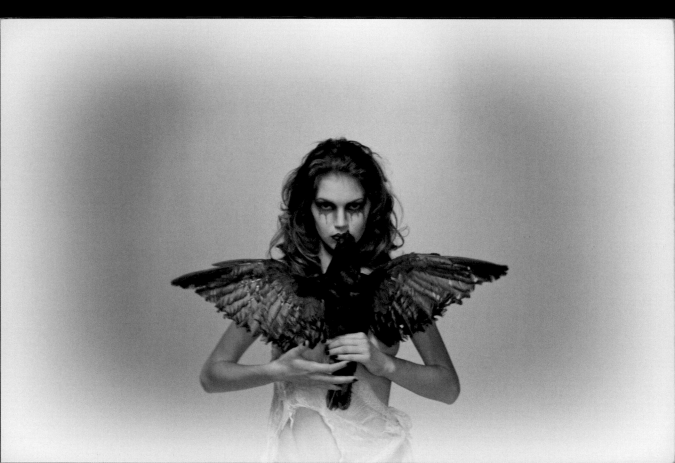

Lisa, I don't remember what you look like anymore,
the years have decayed my memory
But if I could imagine you as anything,

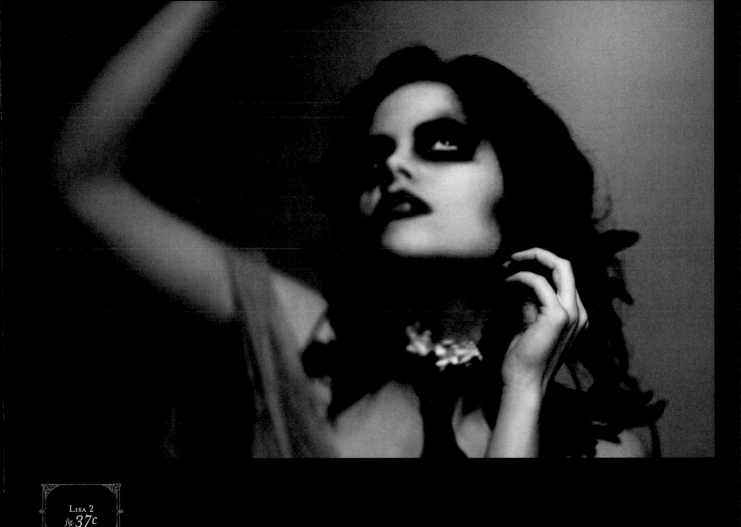

LISA 2
fig. 37c

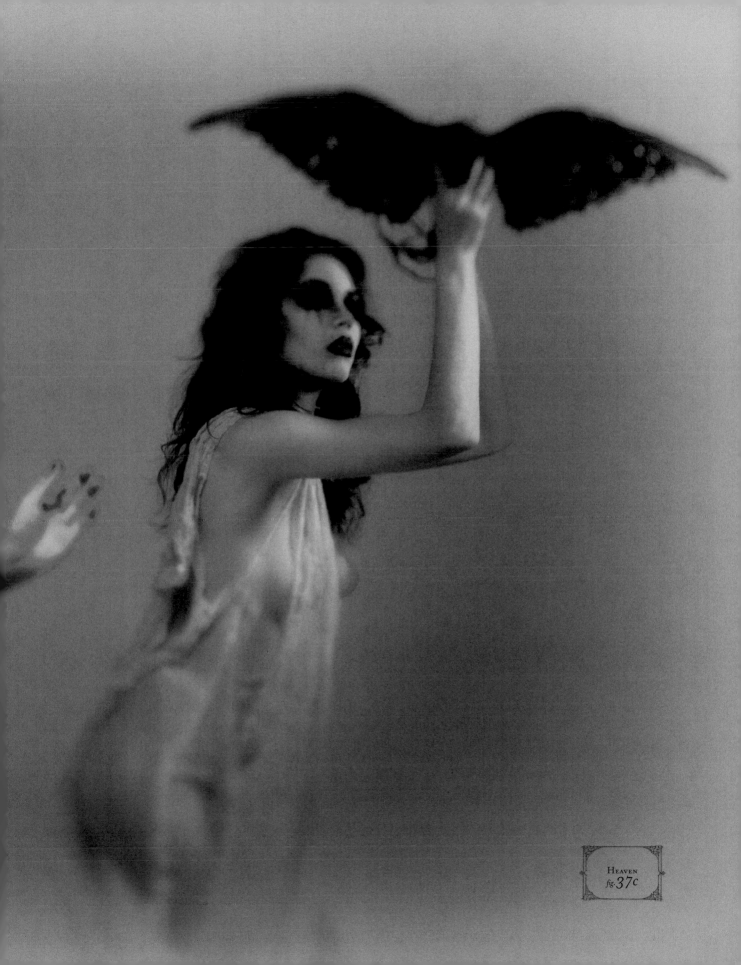

Heaven
fig. 37c

Fig. 1

"Tell me the number. I want to go see her. Please . . . I don't understand any of this and I need to . . ."

She had the phone number memorized. Amazing.

Trust me when I say that, as a father, I understood for the first time the pain my mother must have felt putting my sister in that home. I saw it on her face, and my heart softened.

I wrote down the number and took a deep breath. I had no idea what I was going to do next, but somehow I felt prepared.

You say it's all a crisis
You say it's all a blur
There comes a time you've gotta
face it face it
—*"This Is Gonna Hurt," Sixx:A.M.*

I left the room and headed for my library. I sat in the overstuffed leather chair behind the desk and reached for the phone. Finally ready for some answers, yet I still didn't know if I had the balls to spit out my questions. I punched in the seven digits.

A simple "Hello." There was no "San Jose Medical Hospital," or even an official-sounding answering machine saying, "We're out of the office and bla bla bla . . ." Just a simple "Hello."

I felt numb and cold. I am sure I sounded shaky, but I began my explanation, zombielike.

"My name is Frank Feranna . . ." I said to the phone. I had barely begun when the man's voice on the other end said, "We were wondering when you were gonna come back."

He told me that his father ran the facility and he grew up with my sister Lisa. They took care of about four people, but Lisa had been there the longest. He remembered when I used to visit Lisa, and he and I would play together since we were around the same age. They didn't understand why I stopped coming.

I was in shock. I had no idea what he was talking about, no memory of any of the things he was describing to me. Even today I can't remember him, or the visits, or even Lisa. Sometimes it feels like they're all ghosts. Other times I think *I'm* the ghost.

Hanging up, I looked out the window. I didn't know what I felt.

Why I Invited You Here | Look Thru My Cracked Viewfinder | Life's Not Always Beautiful | Ghosts Inside Me | This Is War | One Man, Two Bands | Killer's Instinct

Help Is On The Way | Tale Of The Siamese Twins And The Black Rose Tattoo | Rock N Roll Will Be The Death Of Me | The End, Unless It's The Beginning

```
Lisa Marie Feranna, born November 12, 1960,
          in San Jose, California
       Father, Serafino Feranna
        Mother, Deanna Feranna
Brother, Frank Carlton Feranna (now Nikki Sixx)
         Born with Down's syndrome
          90% deaf and 100% blind
         Crippled and paraplegic
       Confined to a wheelchair or bed
```

She never weighed more than sixty pounds, so she spent her entire life dressed in children's clothes, and her Sunday shoes never had a scuff because she never took a step.

Her greatest pleasure, he told me, was to sit in her wheelchair and listen to the local rock radio station. She loved music and since she was almost completely deaf, she really needed it loud. That made me smile.

With Mötley Crüe, I played shows right down the street from where Lisa lived. She may even have heard the rumble of my bass while thousands of people sang along to the music that was inspired by the tear in my heart. What the fuck has happened to me? The coffin had cracked open and the skeletons were about to come to life.

When I got off the phone, my mom was still sitting at the kitchen table, and as I sat down I knew nothing between us was ever going to be the same.

One night, years later, I got a call from Vince Neil, who was weeping into the phone. He said someone had called him to say that my sister was dead. My heart stopped as I thought of my half sister, Ceci, and wondered what the hell had happened. Vince said the call had come from San Jose and then it hit me. Not Ceci. Lisa.

The problem with procrastinating is that sometimes it bites you in the ass. At that moment, as Vince hung up the phone, it hit me.

After all the conversations with my mother, after the phone calls with the family that was taking care of my poor sister, after all the anguish . . . I got busy. I went on tour, I went through a divorce, and I fucking lost connection to that feeling that I had to make Lisa's life right. And now she was dead.

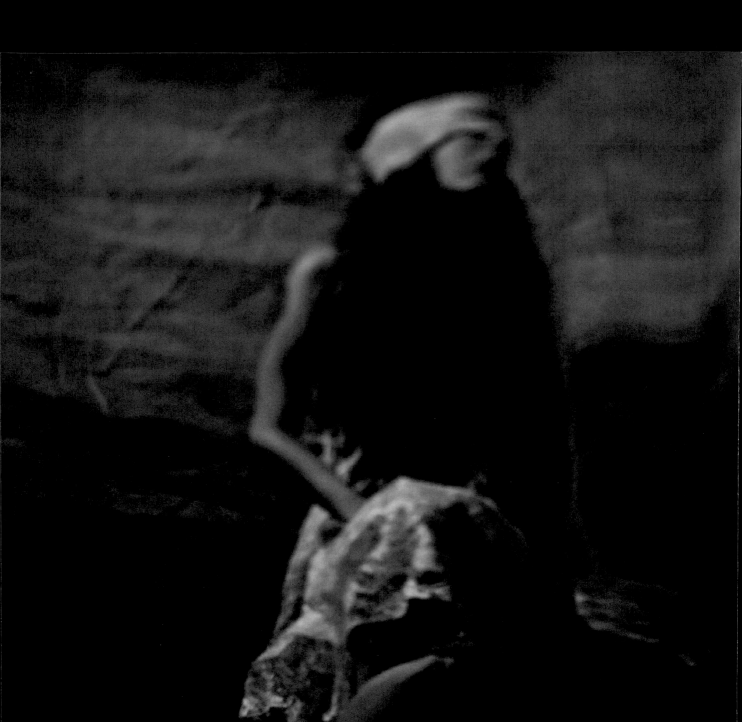

I have had to forgive myself for a lot of things in my life, but this was the hardest.

The next day I flew to San Jose. I met my mother and Ceci there. I got Lisa the most beautiful casket I could find, and I said hello and good-bye all in the same hour. I asked for a moment alone with her. I locked the door behind me and walked over to the gold-leaf child's casket where she lay so peacefully. I reached down and held her hand, our faces not so different. I told her I was sorry and I am, still, to this day. Now she haunts me. Maybe she always has.

Lisa was cremated and my mother has the ashes. I kept some of her clothes for a while and eventually sent them to my mom too. When my life felt hard, when I was stressed or overwhelmed, I would take out her little white church shoes, hold them in my hands, and remember that my life is blessed.

The Voices in My Head

I am not sure how old I was, but I was really young, maybe five or six. I was living with my mother at the time somewhere in Los Angeles, bouncing from house to house. These things don't really affect you so much as a kid. You think of them as little adventures. But today I look back and wonder what the hell we were doing. I do know that we were living with another family, I remember that much. I mostly have a blurry vision of my childhood, and some things I can't remember at all, but this, this I can tell you is clear.

I had one of those little record players that spun 45s. (They were also known as singles, for those of you too young to remember what I am rambling about. Go google it.) This was somewhere in the mid-1960s. (Maybe 1964, if I do the math, but that's beside the point.) The needle was in the lid of the player, so when you closed it, the music started, voilà, magic. I'd play the same three or four singles (A side and B side) over and over and, well, you get the picture.

One evening as I was playing one of my records (I believe it was Alvin and the Chipmunks), I overheard a voice in the distance. It sounded hollow yet distinct. Something about it pulled me from what I was doing. (A great relief to my mother, I am sure.) I wandered out of my room and up the hall to where the sound was coming from.

The other kid who lived in the house was maybe nine, maybe ten. He had this strange-looking box open before him, wires exposed, glass tubes of some kind glowing in the darkness. He was turning a knob

Why I Invited You Here | Look Thru My Cracked Viewfinder | Life's Not Always Beautiful | Ghosts Inside Me | This Is War | One Man, Two Bands | Killer's Instinct

Help Is On The Way | Tale Of The Siamese Twins And The Black Rose Tattoo | Rock N Roll Will Be The Death Of Me | The End, Unless It's The Beginning

back and forth. Somewhere in the static coming from the speaker were voices and songs shifting in and out of focus. I was mesmerized at first. I can still feel the excitement in the pit of my stomach. This box, this sound—it wasn't anything like my little record player. There was something instantaneous and living in its touch.

I asked what it was and the kid said, "It's a radio." I asked, "Why are there voices coming out of it?" And he said a man somewhere is talking into a microphone and we hear it.

I stood there, like I have other times when I have fallen in love, eyes wide open and heart pounding.

Some years later, when I was watching *The Wizard of Oz* on TV, I wondered if that's what radio was like: a man in a room, speaking from behind a curtain, microphone in hand. Important.

I sit here right now, in my Los Angeles home, listening to the radio. It seems both peculiar and familiar. I now know how radio works, I know it's not magic, not the Wizard of Oz, and yet it doesn't change a thing. I still love it.

I have just embarked on my own radio show, called *Sixx Sense*. We did a handful of shows for practice but to be honest, I didn't need much. This thing fits me like a glove. I hope that the Tin Man, the Cowardly Lion, and the Scarecrow are listening. And Dorothy, maybe someday you can be my cohost.

Running Wild in the Night (1)

Being a teenager in Seattle in the 1970s was an amazing time. I discovered music there. Sitting in my friend Rick Van Zandt's living room listening to T. Rex for the first time or going to Cellophane Records down by the University of Washington were life-altering experiences. Sifting through the bootleg vinyl section of the store not only inspired me, it made me feel part of something bigger.

Moving to Seattle was great, but it was just another attempted escape for me. I went there from Idaho, to live with my mom and give my poor grandparents a break. Seattle was my first experience of a real city, of other kids doing worldly things. It really was a mindfuck for me coming from Jerome, Idaho, a city of four thousand people. The combination of Seattle and me was like putting gasoline on a fire. The flames quickly burned out of control. LSD, pot, speed, drinking, selling mescaline and pills by the truckload. Nothing I can look back on proudly, but our lives are our lives, and we hope not just to learn

from them but maybe to pass along some wisdom, too. (For me, that means many thoughts of what *not* to do.)

But once damage is done, can it be undone? Once the phantoms exist, do they ever go away?

I don't know. I hope so, not only for me but for the millions of people who also are destined to feel like outsiders, loners, ghosts.

In Seattle, I was always one step away from living on the street. When I was fourteen, I ran away from my mother's home. I slept in a closet I rented in an apartment belonging to two prostitutes I knew. A friend who worked in a restaurant got me a job as a dishwasher. I figured it was better than no job at all, which is what I had at the time. I sold drugs to supplement my income. Life seemed fine to me. I was happy to have my music and a warm place to sleep. I had a few friends, mostly drug addicts.

After the prostitutes kicked me out, I moved into a two-bedroom apartment . . . with ten other teenagers, which was the only way we could make the rent. I have no idea where these kids came from or where they are today. Isn't life weird? Once we were as close as brothers and sisters, then they vanished into thin air. More ghosts.

I remember one night watching the *Don Kirshner's Rock Concert* program on an old black-and-white TV one of the kids had stolen. While we watched the New York Dolls perform, that kid leaned over and told me he had stolen a gun, too, and he had an idea. It involved me, the gun, and a liquor store. The idea was that I would stand outside the store and watch for police while he went in and robbed it.

Always one for adventure, I agreed, and we split a tab of four-way windowpane LSD and snorted a line of elephant tranquilizer. By the time he walked into the store, I was so high I almost followed him inside.

Soon he ran out screaming, "Let's go!" We headed into the damp Seattle night laughing until we finally ran out of road and breath. I remember at last feeling connected to something bigger than myself. I felt grounded, like I had found a purpose in life.

But then I remember climbing on top of a fire hydrant, balancing there as the rain came pouring down, and the bad acid trip kicked in. I was alone in the middle of an ocean, standing atop a buoy, swaying back and forth, scared I would fall in and drown. I called out to my friend, who had already wandered off into the night with the money. Here I was again, alone.

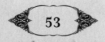

Running Wild in the Night (2)

More ghosts that haunt me . . .

I came to Hollywood in 1979 on a Greyhound bus.

I don't remember the month, but I do remember my aunt Sharon picking me up at the station. I don't think she or my uncle Don or their kids, my cousins, knew what they were getting into. I sure as hell didn't.

She was all housewife smiles and proper middle-class hellos as I stumbled off the bus with a T. Rex cassette in my back pocket and a guitar case in my hand. Driving through Hollywood on our way to my new home, all I thought about was Sunset Boulevard and Hollywood and Vine. My new stalking grounds. Where the wild things could roam and the unforgiven would birth the next generation's rock n roll extravaganza. For now, though, I would need to settle into suburbia and maybe take a shower. I remember my aunt saying something about me looking like I needed one.

Next we're driving down the street toward a cul-de-sac not unlike the homes in the neighborhood scene from *ET*. Basically the same house, street after street, mile after mile, only changing slightly in color. I was about to become the canker sore on the face of Perfect Little Family Boulevard.

Having left Seattle with a warrant for my arrest (for selling drugs at a Rolling Stones concert) and then exiled to Idaho to work on farms (to save money to buy guitars and bus tickets), I can safely say that I was fueled with toxic teenage waste, dripping in cheap sunglasses and jaws locked down on my dream . . . That dream, it seemed, was to destroy everything in my path. Including this family.

My poor uncle, Don Zimmerman, president of Capital Records at the time; his perfect wife, Sharon; and two wonderfully normal, balanced kids, Rick and Michelle. Beautiful home, nice cars, weekends at the beach, BBQs by the pool, friends, and family for holiday dinners, and then there was me, Frank Carlton Feranna. Even today I cannot say I am sorry enough to that family. I feel like I was a tornado that ran right through their serenity. Sigh . . .

But at the time I thought I had arrived in hell and to be honest, I may have. Looking back I remember thinking the darkest secrets are always born in these perfect little communities.

Today I sit in my house in Southern California in a neighborhood not unlike my uncle's almost thirty-five years ago. We

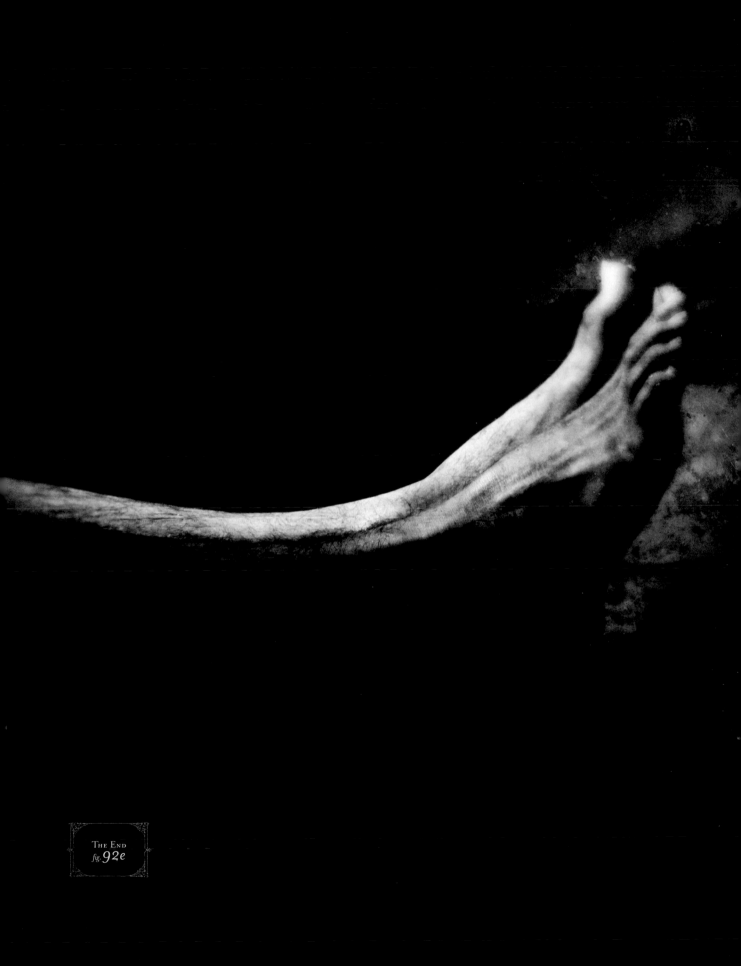

THE END
fig. 92e

have a beautiful home. Nice cars. Weekends at the beach. BBQs by the pool. Friends and family over for holiday dinners.

Unbelievably, I am alive to see all this come true.

While living with my uncle Don's family, I was offered great opportunities. I defiantly looked the gift horse in the mouth. In fact, I punched him square in the kisser. So, to make a long story short . . .

I was given the family pickup truck to drive. I wrecked it.

I was given my own room. I wrecked it.

I was given a job at a Music Plus record store. I punched the manager and got fired for stealing, so I guess you could say I wrecked it.

Before long I was asked to leave the family home. I did, but with a huge middle finger as my parting gift. I wrecked that, too.

I am even sorry for their neighbors, almost. I don't know if it was the Marshall stacks and Les Pauls or the way I crawled into the house in the middle of the night (middle of the day, sometimes), but I wasn't exactly a calling card that read, "Come on over and meet our nephew, he's a really nice kid who also plays a little guitar . . ."

They tried to help me, but I couldn't help myself.

Probably didn't hurt that I was drinking my dinner in that sweet suburban bedroom and popping pretty little white pills for breakfast.

I didn't know that I didn't know how to fit in.

So, as the story goes, I left. Abruptly.

Moved in with some kids I met at Music Plus, started playing in bands. Ended up in Hollywood living on Sunset Boulevard, exactly what I had wanted.

I got a job at Warehouse Records on Sunset and sometimes would stop at the blood bank and sell blood or at the pawnshop to pawn my 1976 Thunderbird bass for food, rent, or drugs.

One day coming home late from work I saw half a dozen fire trucks surrounding the house where I lived. Exiting the bus, I saw nothing but smoldering ruins. I had left a candle lit in my room and burned the house down to the ground. I remember saying, "Thank God my bass wasn't in there." I don't remember saying anything about my roommates.

One last ghost . . .

As I've said, my father split when I was really young, but my family doesn't have a timeline that they all agree on. I've always gone

with the "I was three when he left" story. Weird, when your own family can't tell you your history.

My father's legacy is somewhat vague. I've heard everything from he died of an overdose on Christmas morning to he was shot to death in a woman's arms by her jealous husband. I have no idea what's true. But two facts I know for sure: he's dead, and I am alive. As cold as that sounds, at least I know it's true.

I never knew my father, or more important, I like to say, he never knew me.

Looking down for the first time on his grave was one of the hardest things I've ever had to do. Not because he was dead. It was the fact that he should have loved me no matter what, but never did. He wasn't even alive to me. He was just a dream, something invisible I had railed against for so long that it had worn me out. There I stood, face-to-face with the reality that I had wasted a lot of time, energy, and alcohol on this guy. It didn't take long for me to forgive him. It was finally over. I left him, or the idea of him, there in the ground that day. As I walked away, my only thought was how small and unkempt his grave was. No flowers, no notes, probably few visitors ever. The worn-out nameplate was cracked across the top . . . like our relationship. But that story is his now, not mine.

I never looked back.

In life, when the baggage gets too heavy, you have to put it down.

Peace
Perfect
Peace

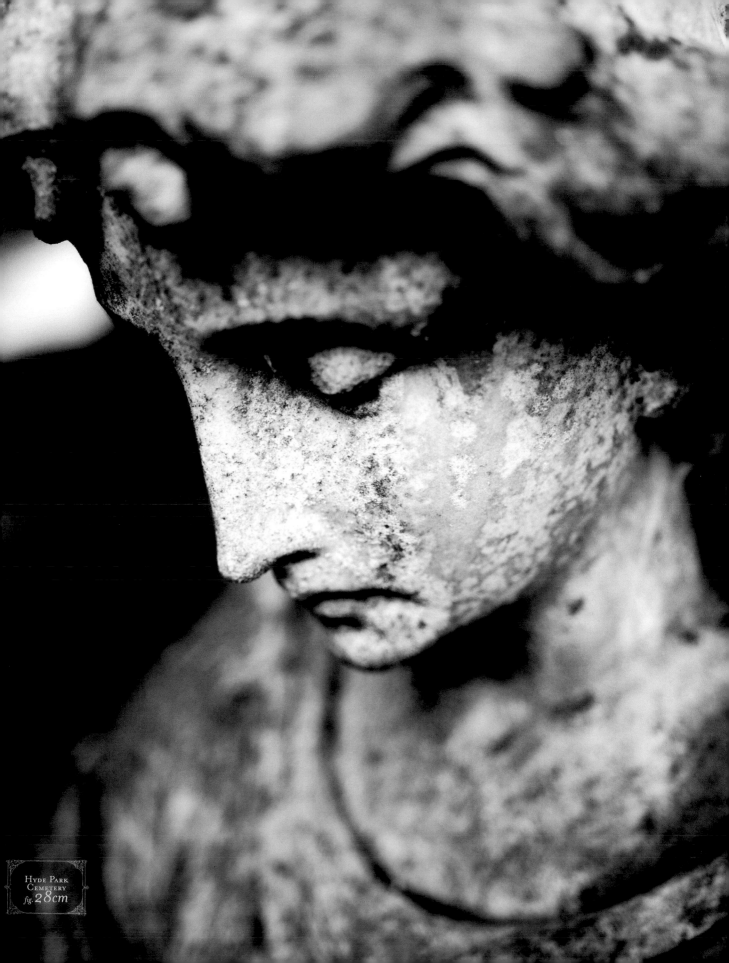

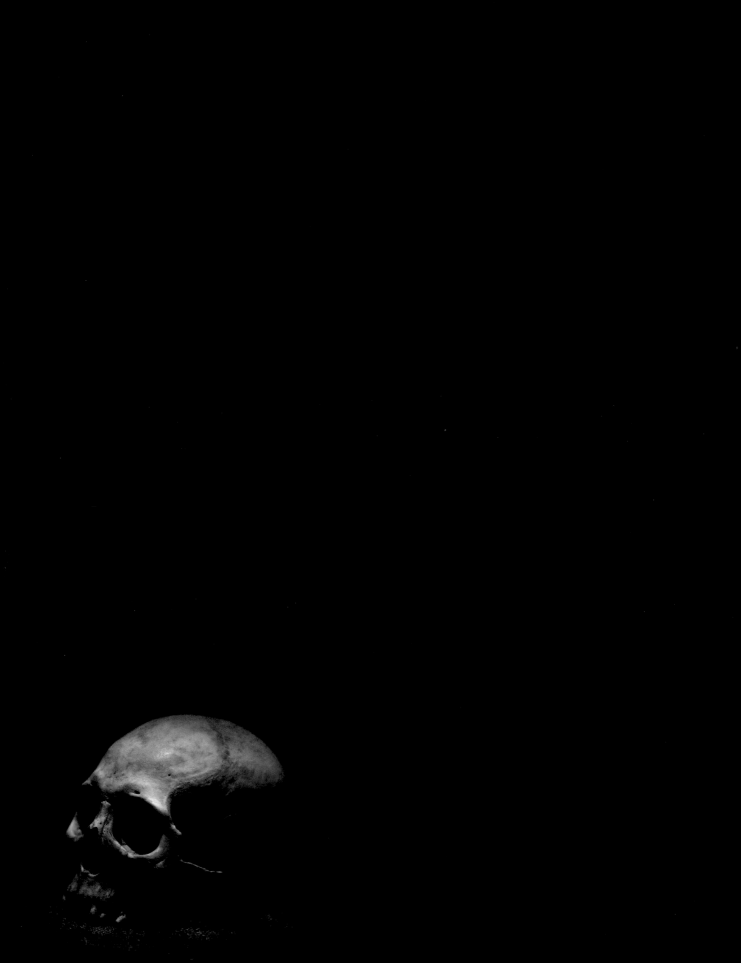

Why I Invited You Here | Look Thru My Cracked Viewfinder | Life's Not Always Beautiful | Ghosts Inside Me | This Is War | One Man, Two Bands | Killer's Instinct

Help Is On The Way | Tale Of The Siamese Twins And The Black Rose Tattoo | Rock N Roll Will Be The Death Of Me | The End, Unless It's The Beginning

How do we all move on now that Mötley Crüe knocked you out, bloodied your nose, and busted your balls?

What if we say we're sorry and keep our tactics to ourselves?

What if we go back to our corner, take the brass knuckles outta our sixteen-ounce boxing gloves, and come out and fight fair?

How about we just forget the whole thing ever happened?

How about if we just stop dancing around the land mine and just say it?

Go fuck yourself. Mötley Crüe beat your system.

Music belongs to the creator of the music, not to the labels.

Publishing belongs to the creator of the songs, not the labels.

"360" deals are criminal, in my opinion.

I won't ever tell an artist to do one.

The label sharing in the publishing, album sales, merchandising, and touring?

What the hell is next, your firstborn?

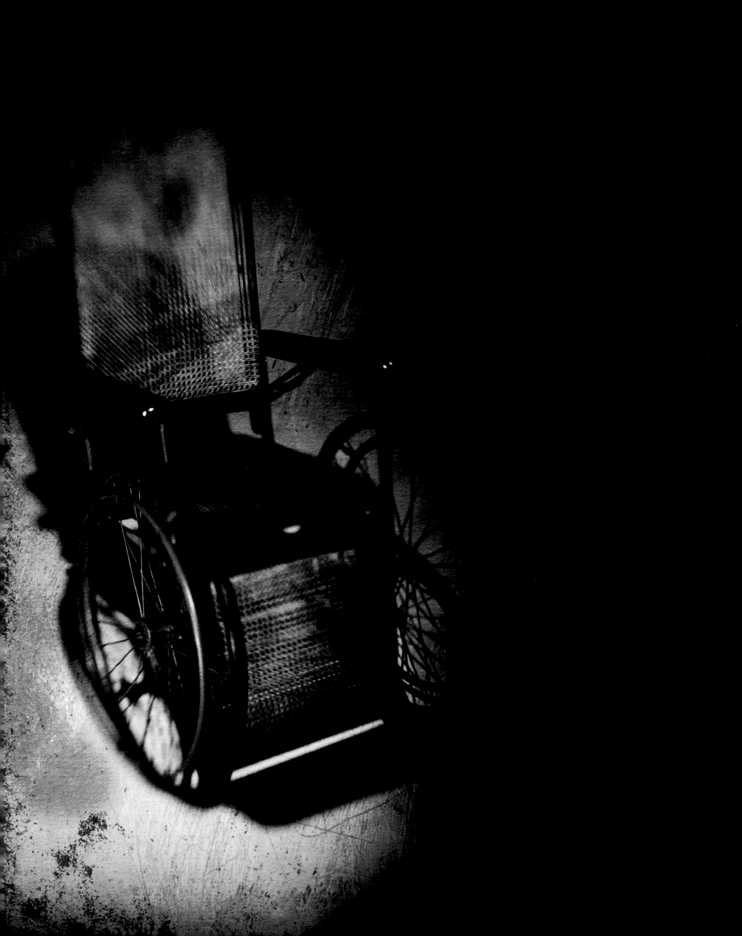

1. If you're an artist, stand up for your rights.

2. If you're a fan, support artists who don't follow the old brick-and-mortar model.

3. Remember there is no music business without

There seems to be a misunderstanding that we need them.

We don't need them, they need us.

4. Learn the system.

5. Know and understand marketing and branding.

6. Do it yourself. Keep it yourself. Keep your leverage.

7. Manifest your future.

It's yours for the making, not theirs for the taking.

8. Get out your baseball bats and straight razors. This is war.

I ain't bitter, I am fucking better . . .

SELF-PORTRAIT
fig. ff25

III

ONE MAN, TWO BANDS

Nobody ever sounded like or will ever sound like Mötley Crüe. I can take that to my grave. I am not saying we don't wear our influences on our tattered sleeves, because you can hear the Sex Pistols and AC/DC plain as day. You can smell the Ramones and Aerosmith stirred in together. We never denied any of that. But something about each guy in the band mixed with those influences makes us like nothing you've ever heard before.

To do that once is like a gift from the gods, but to have it happen twice, well, I am either one lucky motherfucker or just destined to have two bands take over the world during my lifetime. At this point I'm still counting my blessings, so I'll await what happens and try not to predict the future. I am a firm believer in believing in yourself, and I have no doubt that what I am doing now means as much to me as what I have done in the past with Mötley and whatever I will do in the future.

Sixx:A.M., like Mötley Crüe, is a passion. Like music, photography is emotional, and when you breed music with imagery, you get honesty. That's why people either hate it or love it. Please don't ever tell me you "like" Mötley or Sixx:A.M., and for God's sake either fucking hate my photography or love it but don't sit on the fence. I have come too far to not evoke some kind of emotion from you. You deserve rage as much as you do love. I will continue to push your buttons until I take my place six feet under, one tattered sleeve saying Mötley Crüe, the other saying Sixx:A.M.

You ready to stand for something? Are you with me now?

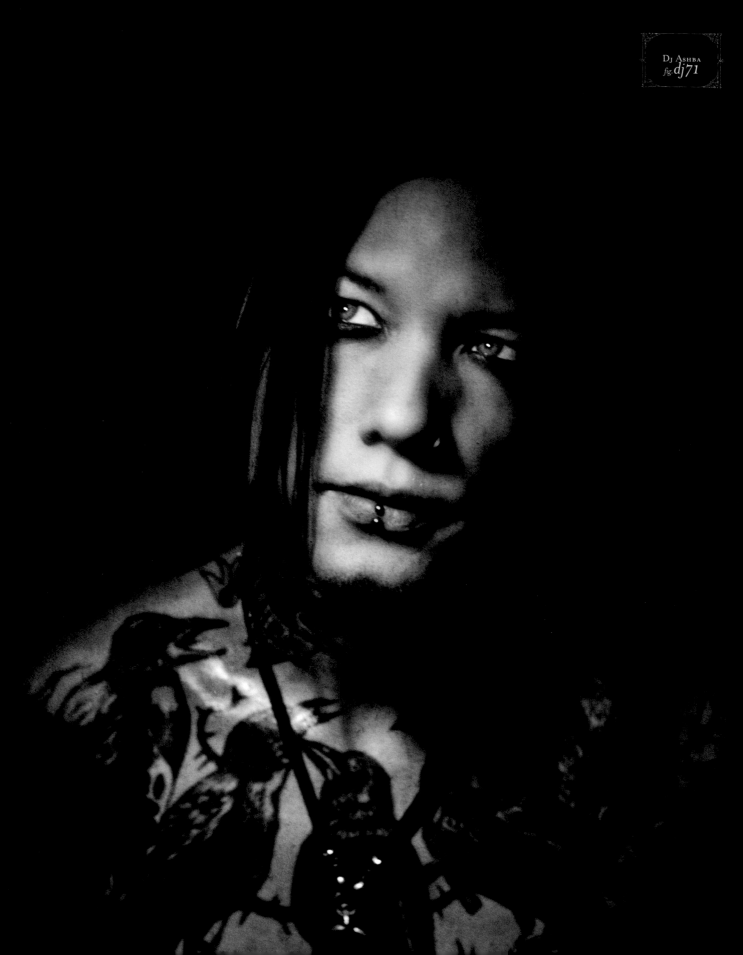

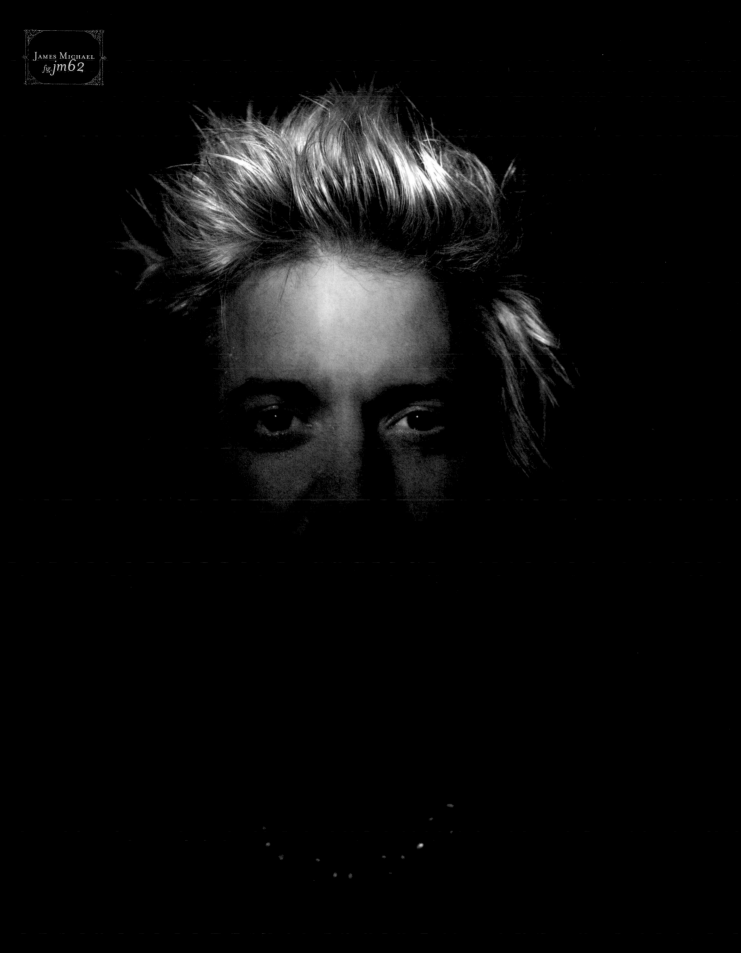

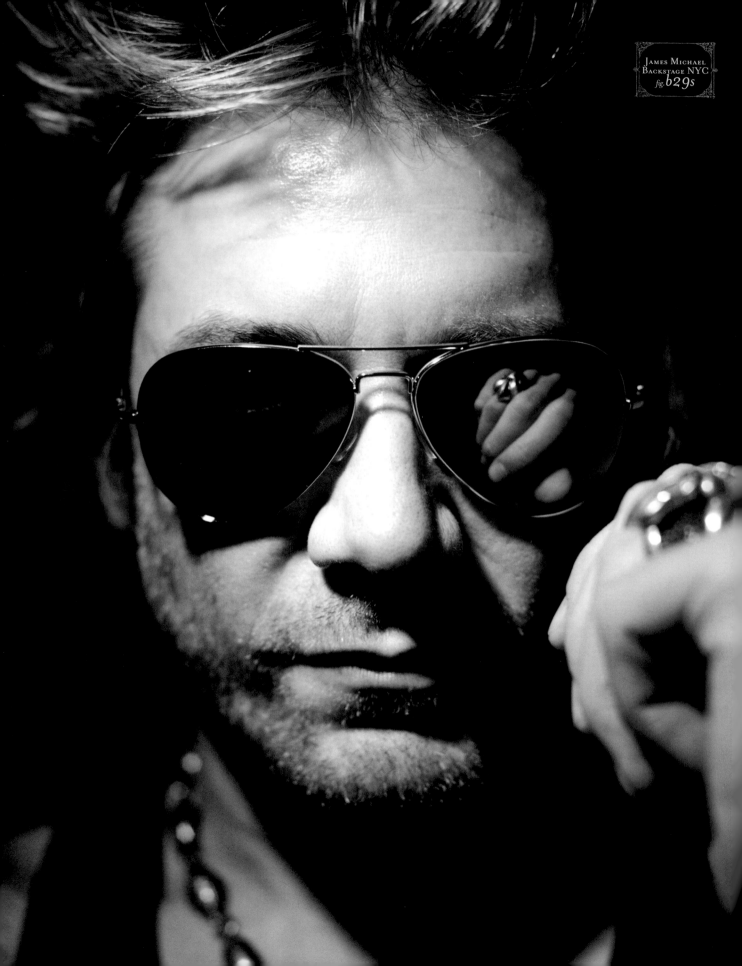

It's Sixx:A.M. Do You Know Where Your Soul Is?

Sixx:A.M. is the band that never wanted to be a band.

I met James Michael ten years ago in an office in Beverly Hills. He was a budding songwriter then, discovered by my manager Allen Kovac, with whom I had started a record company called Americoma.

James was walking down the hall one day, hair a mess, unshaven. I said hello not even knowing who this disheveled guy was. (Is that the pot calling the kettle black or what?)

One day when I was in the office, listening to some of the thousands of demo tapes from new bands looking for a label, Allen popped in. "There is someone I think you might like writing with," he said. Now, in those days Allen knew well that I was not interested in collaborating with other songwriters. So for him to even mention this was kind of like stepping onto a minefield. Except that Allen has the savvy to pick his battles, and he also has my respect. So when he mentioned it, I was receptive.

"Let me meet the guy," I said.

The next day, standing at my office door, was the same scruffy, unshaven Kurt-Cobain-meets-male-model dude I saw before. For some reason I was in a chipper mood and invited him to have a seat (ever seen a record company president with leopard print chairs?), and we hit it off like two bats outta hell.

There is something magical about James's voice, and I heard it day one in his little apartment in Hollywood. We two with acoustic guitars and ideas for days on end. We were like pigs in shit, and there hasn't been a bad creative day since with James Michael.

Years later, sitting at the piano in the front room of my Malibu ranch, overlooking the canyon at sunset, someone would think we were two childhood friends cracking up over an inside joke. We were writing songs for Meat Loaf's album, and James tried to sing like him while I

Why I Invited You Here · Look Thru My Cracked Viewfinder · Life's Not Always Beautiful · Ghosts Inside Me · This Is War · One Man, Two Bands · Killer's Instinct

Help Is On The Way · Tale Of The Siamese Twins And The Black Rose Tattoo · Rock N Roll Will Be The Death Of Me · The End, Unless It's The Beginning

had the duty of topping Jim Steinman lyrically as we were pouncing back and forth on the keyboard. In hysterics, we weren't laughing at Meat Loaf or the music but at ourselves and the amount of fun we were having.

On a totally different front, I saw an ad in a magazine somewhere with this really cool-looking guy in it. Oddly, it said he was Dj Ashba. I personally can't stand the whole concept of DJs, so I shrugged him off as another fly-by-night tattooed poser playing hip-hop or electronica, and turned the page.

At the time, Mötley Crüe was in a holding pattern and I had just met with Slash for lunch in Hollywood. I told him I knew the singer from Buckcherry and we should put a band together. Slash seemed to like the idea but didn't know if the singer was right. Time passed, Slash hung out with Duff McKagan, and they decided to form a band, which became Velvet Revolver. So I ended up writing music for a band that existed only in my head.

Then I got a call from the guitar player from L.A. Guns. Tracii Guns had heard I was thinking about doing a side project and he was calling to see if I was still interested. We had a history in the glammed-out '80s in L.A. (though for the life of me I couldn't remember exactly what we did together). I had known Slash for years as a friend and that was a big part of why I wanted to do a new band with him (besides, he is up there with Mick Mars among my favorite guitar players). Tracii pushed to get together and jam and so we did. He is a great player and quite the little networker. It was Tracii who found the singer London LeGrand for us. He discovered him working as a hairstylist on Melrose down in Hollywood. So we three started jamming in a funky little studio in Santa Monica. Before long we found a drummer, and I wanted to fill out the band with a second guitar player.

Allen Kovac says, "Why don't you try that Dj Ashba kid?"

"A DJ?" I said.

Allen laughed and said, "No, his *name* is Dj, but he's a really good guitar player."

That's when I remembered he had been in the band Beautiful Creatures. So I listened to the album and called him. He was a motherfucker on guitar and a real nice guy to match. I asked if he wanted to join my new band, which I had named Brides of Destruction. And he passed. He was committed to another project, he said, and that was the end of me and Dj Ashba, or so I thought.

Why I Invited You Here | Look Thru My Cracked Viewfinder | Life's Not Always Beautiful | Ghosts Inside Me | This Is War | One Man, Two Bands | Killer's Instinct

Help Is On The Way | Tale Of The Siamese Twins And The Black Rose Tattoo | Rock N Roll Will Be The Death Of Me | The End, Unless It's The Beginning

I continued to write with James for all kinds of bands, from Mötley and Meat Loaf to Saliva and Brides of Destruction. After the Brides' album came out, I did a short tour to support it and then it was time to fire up the Mötley machine again. It had been in hibernation long enough. Time to wake the sleeping giant.

The Brides went into hiatus, although I planned on doing another album with them after a Crüe tour. Long story short, Tracii wasn't happy about this and popped off in the press about Mötley, and if you know me, you know those are fighting words. So we fought, and that was the end of Brides.

At the end of a long, grueling Crüe tour, and newly divorced, it was time to get my creative juices flowing. One thing I did was start a clothing line with St. John CEO Kelly Gray. The other was to finish work on my book, *The Heroin Diaries*.

One day, while I was still writing, I handed James and Dj copies of the rough manuscript and said, "Read this, and then let's write a sound track to the movie you see in your head." It didn't even take three days and the songs were all falling into place. I have only felt that once before and it was in that li'l old band from Hollywood I've been in for thirty years. Using the lotto analogy, how many people win once, much less twice in a lifetime? And so it began . . .

The idea was just that we would create some music. Maybe there would be downloads you'd get with the book, maybe a CD with a few songs, maybe someday a play or a movie, and maybe, just maybe . . . well, we didn't have a master plan at all. We honestly were letting the book lead us lyrically and musically down an open highway. No speed limit and no destination in sight.

Then it started growing. Other exciting ideas came. Maybe it would be songs and videos, or a short, demented film tying the book and songs together. Basically, it was a playground for creativity, and that always leads to more creativity, just like good always breeds more good. And this was really feeling good.

Dj and I would spend hours writing songs together. The glue between us was that we were having the best time of our lives. We would call James, who was busy producing different projects, and play him our deranged musical interpretations of my life misspent, either over the phone or through e-mails. And he would just lose it. Some of the songs were pretty much arranged and others in a raw infancy. In turn, he would call us and play a piece or two of music, and we would go crazy.

It never really occurred to the three of us to form a band. We just loved making music.

Writing songs is nothing new for me. It's what I have done daily since I was a teenager. I pick up a bass or a guitar or even sit at the piano, as bad as I am on it. And a melody and a lyric will always come. Ninety percent of the time, it's forgotten in minutes. You do what you love and what you love does you in return. It's the relationship with the moment that I cherish, like meditation, like drugs before that and photography now. It's a very personal thing, and I think all artists have it. If you look back to a moment of creation, it was a pure, one-on-one experience. Whether we choose to share it with a friend, or a lover, or a million people is the decision you make after that personal moment.

To have a creative experience with another person has been rare for me. There's usually a kind of selfishness in it. When I crossed that bridge with James and Dj, my creativity blossomed to another level. I saw things differently. I had a wall to bounce my ideas off. They had me looking at things differently than I usually would. Ideas started to untangle, and we got into areas of writing that seemed fresh and exciting. Their talent inspired me like nothing else had in years. It didn't even matter to me if anybody ever heard what was being created—we had a singular vision. We found a safe harbor where critics didn't reside.

As I wrote that sentence, I thought, *Imagine being an artist with no critics, either internal or external.* I think that pretty much sums up the creative process with us.

But life is busy, and Los Angeles is a thousand miles of freeways littered with tourist buses and traffic jams. There have been times when I was gone touring or just so busy that we didn't write for long periods. Then James, Dj, and I would sit back down and reconnect and find that our creativity hadn't skipped a beat.

Down the 101 freeway from James's studio is my home away from home, Funny Farm. At the time my life there was 50 percent music, 50 percent creative insanity (wait, aren't those the same thing?). Dj and I locked at the hip like two madmen stewing up some crazy remedy. We had more music than we knew what to do with. "Xmas in Hell," "Life after Death" and "Intermission" are three that stand out as bookends and segues for the other songs we had been writing. I would come in with "The Elephant Man" on DVD and show Dj the passing chords from a scene that would inspire him to write a dark little piece based around cellos, timpani, and over-the-top guitars. He would call

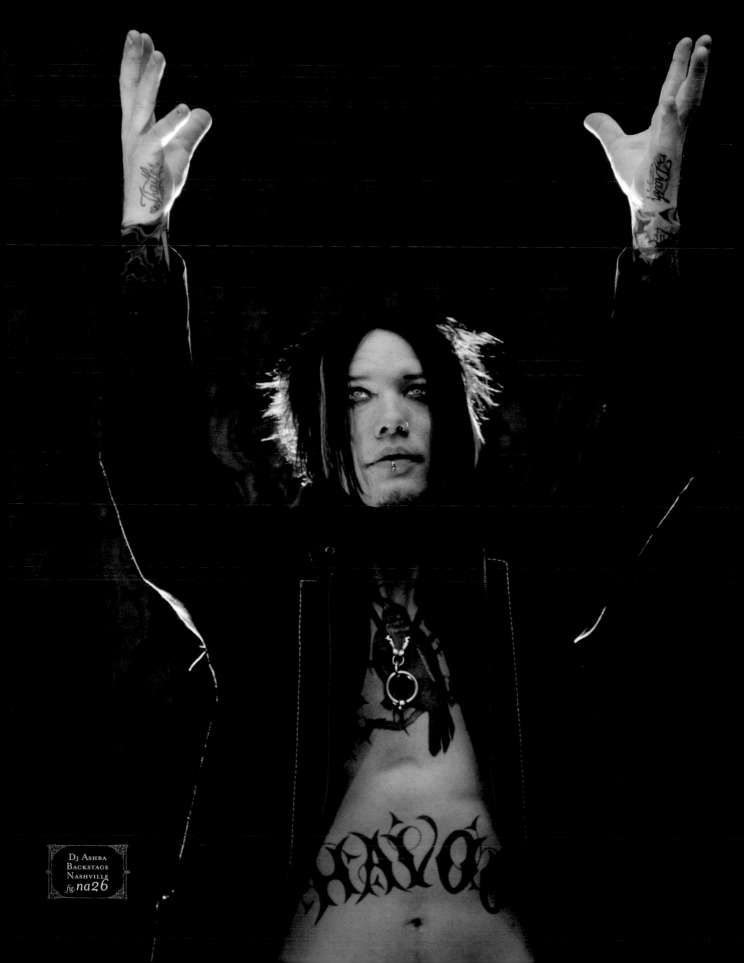

DJ ASHBA
BACKSTAGE
NASHVILLE
fig. na26

late at night with the crazy idea of children's voices mixed with chords from a song we had written but wanted to throw in a demented Danny Elfman blender. It felt like we were weightless in our freedom. Almost dreamlike. As perfect as imperfection can be.

The only thing holding us back was that neither Dj or I can really sing. I remember like it was yesterday the phone call that changed our lives.

We called James from Funny Farm and asked if he wanted to do a vocal on a song or two we had, and maybe in exchange we could do some bass and guitar on some of his. By then we had been playing music over the phone to each other for months and it was exciting to help each other out.

He came out to the farm, where we hammered out a few lyrics and a guide vocal. He grabbed the hard drives and took them back to his studio and the next day pretty much changed history for us. James e-mailed Dj and me a song called "Funeral," but like all things in Sixx:A.M., it was to evolve. The track inspired Dj to take the guitars to the next level, which inspired me to re-record the bass and push harder on the lyrics.

The song was basically written in stone when, instead of "funeral" James sang "life is beautiful." Lyrically, it had been a very dark song, but the new chorus opened up to what I believe we all need, and that is *hope*. There needs to be light at the end of the tunnel.

Life Is Beautiful

SIXX:A.M.

You can't quit until you try
You can't live until you die
You can't learn to tell the truth
Until you learn to lie

You can't breathe until you choke
You gotta laugh when you're the joke
There's nothing like a funeral
to make you feel alive

Just open your eyes
Just open your eyes
And see that life is beautiful.
Will you swear on your life,
That no one will cry at my funeral?

I know some things that you don't
I've done things that you won't
There's nothing like a trail of blood
to find your way back home

I was waiting for my hearse
What came next was so much worse
It took a funeral to make me feel alive

At that second, we all burst into laughter. The kind you might laugh if you had just won the lotto. Like you can't quite believe what just happened and you feel like maybe someone is playing a trick on you. I've had these moments before with Mötley Crüe. I can tell you that as an artist, nothing compares to that feeling. We had accidentally found ourselves in a moment. Suddenly we knew we had to finish all the songs the three of us had been working on, individually or collectively.

So it had started innocently enough: laughter, music, satire, words, friendship and, voilà, we had accidentally written a concept album to go with my book, *The Heroin Diaries*. Of course, we had a big problem on our hands. Some of the songs had such a stand-out reaction from everybody ("Life Is Beautiful," just to name one) that we were getting asked what's the name of the band going to be?

"Now what do we do?" I asked.

We were three friends, producers and songwriters, and forming a band was the last thing we had in mind. James said those days were gone for him. He was happy producing and writing. Dj had been burned so badly by the industry that he wanted just to write for other artists. His big ambition was to score horror movies. And for me, life was complicated enough being in Mötley Crüe, without adding another band to the mix.

Still, many a band name was thrown around, and the only thing that mattered to me was that it didn't mention me. First thing James said was, "How about SIXX?"

"Argh, we're a band!" I shouted.

"OK," Dj said, "how about 6?"

"No, we are a fucking band, not a number, and it's not about me."

A few other possibilities came from e-mails, text messages, and late-night calls. Excitement built as though we were three high school friends starting their first garage band and I thought, wait, if 6 is me and A is Ashba and M is Michael, then we could be 6am.

I also liked this because 6-AM is the scientific nickname for the chemical compound 6-acetylmorphine, which, when found in urine, is evidence of heroin use. So I gleefully called James and Dj and announced, "I got it!" We all agreed and that was it. We were a band.

But, unbelievably, there was already a band called 6am. So we settled on Sixx:A.M.

The Heroin Diaries came out and slammed into the *New York Times* bestseller list despite its name and the radical Paul Brown graphic

design. My publisher told me they wouldn't release the book with such a horrid cover, to which I responded by asking for their address so I could send back the advance money. They caved and later admitted it was their second-best-selling book that year, right behind *The Secret*, which was a blockbuster. The funny thing about doing unique things is watching the fear on people's faces. I laugh because I know it doesn't hurt, but you would think I was proposing to saw someone's arm off with a dull bone saw, the way they go on and on worrying about demographics this and hitting the marketing hotbeds that.

(I have seen similar looks in people's eyes when they see my photography for the first time. The funny thing is, they ain't seen nothin' yet! This road is long and littered with things the imagination can't grasp. I can't wait to turn people on to what's next.)

Then came the Sixx:A.M. album, the sound track to *Diaries*, which nailed a number-one radio single.

It was a lethal book-album combination that had never been tried before, and in the end, whether it sold or not, it was a first and it touched a lot of lives.

So we made cool music to go with a cool book and everything was cool. Funny how life works. Money always clouds people's judgment, especially in big companies. I understand there are a lot of asses on the line but if you're a record label or publishing company, just seek out the quality, look for the very thing that made you wanna do what you do in the first place, and don't worry about what others will think. I like to say, "What people say about you is none of your business," even in business.

So now here I sit. Typing mostly, but also writing by hand some personal lessons on life, musings on sobriety, music, photography. I am grasping for newness and gasping with excitement as James, Dj, and I travel what some would say are fearsome waters. At this we laugh. The only thing to fear is fear itself.

This album is wonderful. As James announced to the room (meaning me and Dj), the lyrics on "Oh My God" are *important*, and as Dj was digging deep into himself to pull out that magical countermelody he always finds, I knew we were together for a reason.

Funny Farm is at this moment buzzing with music, the sound track for the book you are currently reading, and I am about to photograph us for the album cover. Life is perfect in all its imperfections. What's next for us, I do not know. But I am sure it's gonna really be fucking fun.

Why I Invited You Here | Look Thru My Cracked Viewfinder | Life's Not Always Beautiful | Ghosts Inside Me | This Is War | One Man, Two Bands | Killer's Instinct

Help Is On The Way | Tale Of The Siamese Twins And The Black Rose Tattoo | Rock N Roll Will Be The Death Of Me | The End, Unless It's The Beginning

Today I am in the studio with James and Dj finishing work on twenty songs. Some were inspired by my photography, some have inspired photography, some will stand on their own. We are in the same free-falling zone we occupied right before the *Diaries* sound track was written. Just following our demented little hearts. Step-by-step, not looking forward or back. I can say I don't have any expectations for this album. I just love what we are writing right now. It's different, as it should be. It's magical as it only can be. It's real and that makes us proud.

What will happen to us? someone asked me recently. And I said what do you mean?

They said, well, you haven't really toured as a band, you don't make conventional music, and your lyrics, even though they're inspirational, are so raw and real, it's got to be hard for the masses to swallow.

I said, "Sounds like Sixx:A.M. is right on course then."

I Also Play in Another Band You May Have Heard Of . . .

Tommy Lee has never been to my new house.

Neither have Mick Mars or Vince Neil. I've never invited them, and they've never offered to come over. It's been this way for years. I don't really understand how we went from being best friends in a garage band to not really knowing one another and living in mansions.

I don't think it's as easy as *"one day we just didn't get along."* If I try to unravel the situation, it would be like pulling the intestines out of this bloated rock n roll war machine. There are so many layers to the putrid onion that I am afraid it may fall apart if I start now.

We've been together thirty years. I look at my hands as I write this, and tattoos cover most of the scars, but they can't completely hide time. I don't see the age on my face, but I see it on theirs. (Do they see it on mine?) But I imagine my heart is twice as beat up as any of theirs. The only thing bigger than my love for this band is the heartbreak it can bring me. I am sometimes surprised I am still alive, not from the drugs and the fast cars, the sex and the alcohol, but from the shit this band has put me through. I wonder if I didn't hold the reins whether it

would have slipped from the lip of some cliff long ago. I am not a king holding on to his crown, just a man who loves his band even when it doesn't always love him back.

I laugh at our own folklore, half truth, half lies, and some of the murkiest of cocktails ever tasted. It's dirty in these waters and only the strong survive.

Of course, some things never change. When the four of us are together in a rehearsal room, it's always the same. If you could peer in on any given day, this is what you might see . . .

Vince is always early, Tommy is always late, and Mick and I are always on time. I busy myself with set lists or organizing this or that. I don't think anybody has ill feeling toward me but when I come in, I mean business, and sometimes to a fault. I can go from prankster to overly serious at the drop of a hat. I haven't changed much over the years. I wish I could say I've made more progress in this area of my life. Honestly, it's just not my nature to hang out and waste time. I have empires to build and rivers to cross (at least in my own haunted head). I always make sure to say hello to the crew and shake everybody's hand and pass out hugs . . . but quickly after that come the set lists, rearrangements of songs, lighting cues, meetings with the production team, merchandise approvals, et cetera. For all the image of reckless danger that Mötley Crüe wears on its bloody sleeve, it is also in need of a business brain, which is my job.

I sometimes wonder what the guys really think of me. My insatiable desire to push us to the next level is almost obsessive. As soon as one song ends in rehearsal, I'm already barking out the next song or a key change. I show up, suit up, and wanna go for it. Sadly, I think this may be my part in the breakdown of our relationships. I fatigue myself, too. I am without a doubt a fucking workaholic. Maybe that's why I don't really see them or even hear from them much outside of work.

The thing of it is, I don't think they really know how funny I can be. When I'm away from the band, I spend more time laughing than anybody I know. But when it comes to Mötley Crüe, I am dead serious. Prankster yes, always up to no good, but war is war and I am the general. I wonder at times if I don't take this job too much to heart.

Vince fidgets, rummages through lyrics, organizes his space. He tends to love repetition. He always needs the same brand of water, his throat lozenges, and his stool in the exact same place. When we play

live, he's no different, and maybe worse. He will say the same things in the same spots at every show. If he does something and it works, he will do it again, night after night. It's frustrating to me at times because my jones is to not conform to format and Vince's is to stick with his routine. There you have a small rub. After thirty years of it, even the lightest touch of sandpaper can feel like something's ripping open your flesh with a rusty hacksaw. I sort of love his quirkiness, if truth be told. Vince's voice is the sound of Mötley Crüe.

But in the end, no matter how I want to be closer with Vince, he seems surrounded by walls, miles high, and nobody is gonna break them down until he is ready. I feel like I've tried. I know what he's gone through. I cannot imagine how the hell you survive your daughter dying. The hurt and the sorrow he experienced can never be erased by sex, booze, or success. The other painful thing is that no amount of disconnecting from me, Tommy, or Mick can make him feel better about leaving the band years ago. Sometimes being brothers is about learning how to fight and forgive. Being in a band isn't unlike being in a gang or a family, and we are brothers to the end.

The one thing I hope Vinnie knows before Mötley Crüe drops to its knees and dies, blood staining the stage as we wave good-bye for the last time, is that nobody has loved him as deeply as I have. I hope he can feel that someday. But that day is not today. He doesn't even know where I live.

Mick Mars has always been all about two things: tone, and no bullshit. I can't really think of a time when the band members weren't waiting on some "parameter change" he was doing to his guitar rig. He will flat out stop playing in the middle of rehearsal if it doesn't sound big enough to him. As much as it irks me, sometimes I find it comforting (like Vince's idiosyncrasies). Mick knows that his guitar sound is the wall of madness that supports Mötley Crüe, and he'll be damned if he will ever let it be anything other than massive. It's interesting that while he is a guitar player's guitar player, he doesn't respond well to jamming. As Vince fidgets and I organize, Mick will just start playing. I hear that and run to my amp and grab my Thunderbird, just in time for Mick to stop. Or sometimes Mick starts playing and Tommy jumps in. Those two together are monsters. Again I run over, jump into the water, and Mick pulls the plug. It's like he does it to tease me, but after thirty years of the same thing, you'd think I'd get the joke or he would stop telling it. But it still happens. Mick

always calls me a filthy bastard and in fact I know he loves me deeply. I was there when we thought he was dying, held his hand through recovery, and have always had an ear for his crazy ideas. We have something I can't put into words. I truly love that man, to the point where I got his portrait tattooed on my right leg, forever keeping him near. But obviously, not so near that he comes to my house.

Chain-smoking, bouncing off the walls, biting his nails, always with a smile on his face, Tommy is about eleven years old on a good day. I think his boyish charm is my favorite part of him, yet on a bad day that equals temper tantrums and the inability to get the big picture. Highly creative, highly energized, he can be intoxicating, and my drinking and partying days with Tommy were some of the funniest of my life. He could always count on me to do the most outrageous things based on alcohol and my "I don't give a fuck" attitude, and the two of us together were toxic trouble spelled with capital T's. The sheer volume that comes from his drums continues to baffle me. People tend to forget what a great drummer he is. I think the worst part for me is seeing Tommy getting lost in the press, a tabloid misfit, losing his identity as one of the best rock drummers of all time. Does he thrive on the media attention, or does he die from it? Maybe even he doesn't know.

But when Tommy sits down behind his drums and I pick up my bass, and Mars plugs in his guitar, something happens. It's like the air thickens with excitement. I can't put my finger on it, but it's like a weird kind of electrical humidity. You don't just hear it, you feel it. Then Vince blurts out the first few words of the song and all I can say is, "We're home." I am fifty-one years old and some days I feel eighteen. This band has outlived wives and girlfriends, managers, record companies, agents—everything but itself.

It all made a ton of sense to be locked in a garage band together, connected at the hip, but we have become different people as the years have passed. I don't feel the desire to do things I used to do just to fly the flag of rock n roll. I feel more honest in my separation from the bullshit. I am not tired of the music. In fact, it still gives me everything I could ever wish for. But the lifestyle that comes with it bores me now. The creative part is just as important as ever. The songs still are the core of everything. But drinking, girls, clubbing, and hangers-on just aren't my bag anymore. I'd rather shoot myself. Maybe that's why nobody comes to my house.

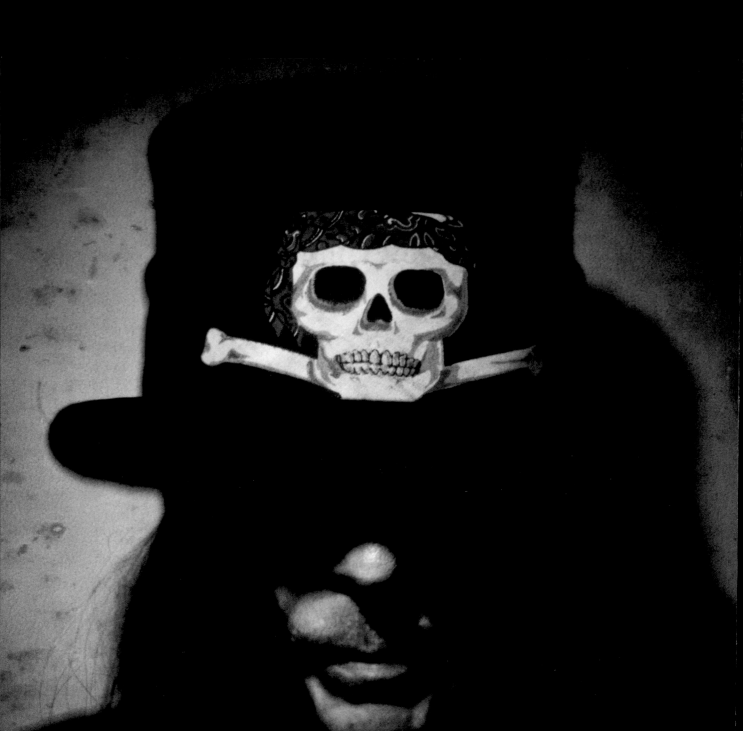

A Painful Postscript with Mick Mars

As the years have set in, Mick's health has waned but his spirit has strengthened. There is a freedom found at death's door that reignites your zest for what is now running out quickly . . . time. I see it in the shadows, waiting for us all. Death is real once you hit fifty. Lemmy told me recently that at fifty it all started to fall apart. I agree, so I fight it.

Mick is no different, but there was a time when he had given up. I had been hidden away on my Malibu ranch, working nonstop. I had done a side project or two and when it came time to resurrect the Mötley machine, Mick was nowhere to be found. It's always been Mars riffs meets my pop and lyric sensibility that was the core to the songs in the Crüe. Now he wouldn't answer his phone or the countless notes I left at the security gate at his private estate. I was not only worried about writing music without a partner, but I had that gut-wrenching feeling that something was wrong. Finally, I left the following message: "Hey, Mick, it's Sixx. I am coming over to your house; I'm gonna smash through the security gates and kick in your front door in exactly thirty minutes."

Mars called back within thirty seconds. I told him I was scared something was wrong and he said, "OK, just come over, I'll open the door." What I saw haunts me to this day. A frail man of eighty, maybe ninety pounds, shaved head, gray skin, with a beard to his chest. I stood there in shock. It was my dear friend, Mick Mars. He was dying, addicted to painkillers, brought on by a disease called ankylosing spondylitis. His bones had been fusing together for years, and the rest of the band never saw it coming. One year of being off the road and Mick had fallen apart.

I immediately got on the phone with our manager, Allen, and started a mission to save Mick's life. First thing was the crazy girlfriend. She had to go. Not only was she feeding him pills by the bucketload, she was spending his cash faster than anyone could imagine. In the living room was a pile of designer clothes that almost touched the ceiling. Nearly all of them had the price tags still attached. It looked like some kind of pathological hoarding that I read about. Sort of leaves you feeling cold to see something like that happening right before your friend's eyes. He was definitely in a fucked-up situation with this chick.

Next came the fact that Mick's house was infested with mold, which was infecting his lungs. He needed to move out right away, so I

took him under my roof for a few months. His head had been shaved due to the fact that his hair had become so knotted from not showering for almost a year. So Mick Mars was living in my guest room, kicking prescription meds, girlfriendless. It didn't look like a Mötley album was going to happen anytime in the near future for sure. After we had settled into a routine came the doctors, one after another . . . day after day . . . until finally Allen found the doctor who got Mick sorted out. Mick not only had to deal with his spondylitis, he had to have his hip replaced. The saddest thing for me came while sitting in the hospital next to Mick after he had kicked the drugs and had his hip replaced. I asked him, "So did Tommy or Vince come hang with you today?" He looked down and said, "No." They hadn't visited him at all. *This band runs on rock n roll, but sometimes I wonder if there is any soul in it . . .*

VINCE & ME
GERMANY
fig. b41s

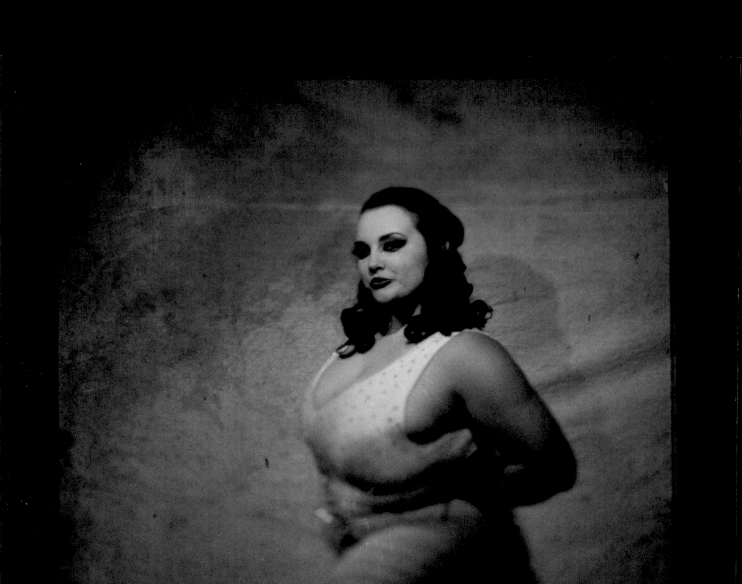

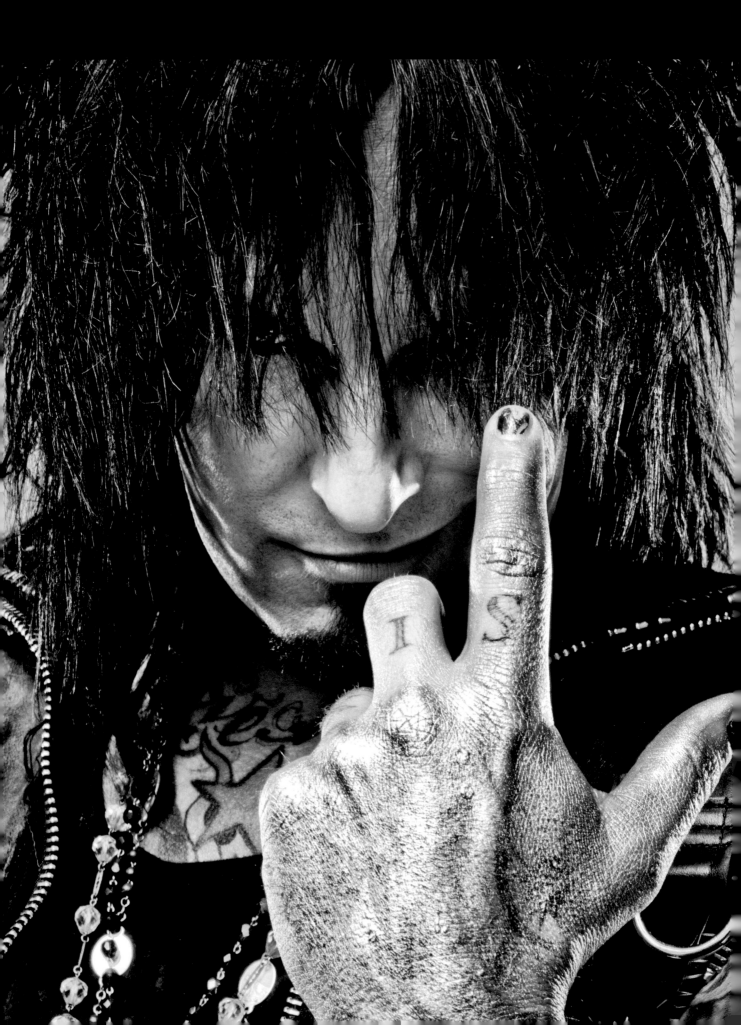

Why I Invited You Here | Look Thru My Cracked Viewfinder | Life's Not Always Beautiful | Ghosts Inside Me | This Is War | One Man, Two Bands | Killer's Instinct

Help Is On The Way | Tale Of The Siamese Twins And The Black Rose Tattoo | Rock N Roll Will Be The Death Of Me | The End, Unless It's The Beginning

and the things I have seen don't matter to. Hate and violence are all computer to me. It was hard work, but it was pure. It looks like nothing but violence and tragedy. I spend my days it battle in the war, a people driven by fear and loathing. I have seen terrible things in my life, and it seems that the more the stakes are been held the stranger it becomes.

Look, I don't know why I keep writing these things down... I suppose I will. You know that I'm not one to preach. I'm going to speak in parables you may get it or I won't. I know it can be rough on those of you that read it... but the words are there and hidden in the back of my mind.

When I battle, I wonder deep, and I know just one thing. I'm pushing you over the edge with everything I have. This is how I move myself, one step at the time. So you're telling me that someday this same war will come to an end and the world will be different when I'm no longer alive.

I do not and will not count it a win. I've lived life in the middle of chaos. It's goddamn sick. I've come to realize the only thing that doesn't change, that brings change, that can it has to do, that way thing that stays the same for stay the strange. I know life is a process of growing. And now death is what the growing leads to. I'm just tired and being wasted on the youth and this I say is true. Time and time again I try to get through my life, that I did the best that I could do it.

So we fight the battle, wake up, sharpen the blade, and see if anybody is out there on the battlefield ready to die. A kill for a living, but I do it with a honor. I will carry this lead like a trophy, but this is what other warriors that accept can't see this.

Lawyers would compare themselves to soldiers, and these puppets couldn't fight. Somebody that loses their way will wind up in the alley and forgotten.

Today is one of those murderous days. As I write, my hope is to not get too much blood on my computer. I guess that I am off. I've softened over the years. Now I think before I swing through it all. Some times that were that I am either a killer or...

May God be with you and be with me, he will only slow me down. Now get off your ass and change what you can! This time in your life. You get what you focus on. Trust me on this if nothing else. I am living and dying. I out.

89

Cemetery
Milan, Italy
fig. mi47

Why I Invited You Here | Look Thru My Cracked Viewfinder | Life's Not Always Beautiful | Ghosts Inside Me | This Is War | One Man, Two Bands | Killer's Instinct

Help Is On The Way | Tale Of The Siamese Twins And The Black Rose Tattoo | Rock N Roll Will Be The Death Of Me | The End, Unless It's The Beginning

HELP IS ON THE WAY

My first taste of therapy came when I was sent to the principal for knocking out a kid with my lunch box. I went to the office, and the kid went to the nurse. I felt justified due to the months of torture I endured on the bus rides to school every day. I would climb aboard the bus and two older boys would tell me I couldn't sit down unless I gave them my lunch money. Even when I did, they would abuse me, pushing me under the seats and sitting on me for the twenty-mile trip to school.

Having no luck asking the driver for help, I decided one day to fill my metal lunch box with rocks. When the usual happened, I handed over my lunch money. As we pulled up to school and exited the bus, I called out the kid's name (I can't remember it for the life of me), and when he and his friend turned around I swung my lunch box and hit that motherfucker in the face with everything I had. Blood splattered everywhere, and he hit the dirt with a thud. As I wound up for another swing, to level the second bully, he took off in a dead sprint for the nearest teacher. They told me I broke the first bully's nose, and now all the other kids were scared of me.

The principal asked me how I could do such a violent thing for no reason, but what really stung was when he said, "What's wrong with you?" It's a question that has come up more than once since then. At the moment there was no leather couch for me to lie down on as I told of my wretched life, or a $350 bill owed at the end of the session. There would be plenty of time later for that.

Somewhere inside, I have a fantasy that I can create something to help people change their lives. But maybe like a self-help book as written by William S. Burroughs. The sneer and snot of rock n roll is as much a part of me as the tattoos on my arms. Still, showing how I got here alive might make a positive difference in somebody else's struggle, just like certain books helped me through mine. That hope is a big part of what this book is about. It's what makes me passionate about getting it right.

Writing for me is therapy, like self-help with a pencil and the nearest tablet or notebook to write it all down. My life is on the pages of a million journals, scraps of paper, computer files. I've even been known to write on myself. It's like WWF wrestling with a schizophrenic. After the second or third round you go back to your corner, rethink what you wrote, then rewrite it again and again, all whilst taking uppercuts and flying arm bars from yourself.

Since *Heroin Diaries* came out I have heard from thousands of teenagers and others who say or write things like, *"Nikki, your book inspired me to do better things with my life than waste it on drugs and alcohol, thank you . . ."* I am so glad something I wrote could help them.

Many of those kids are probably like me as a teenager. Back then I was an eyesore with a dream. It took a lot of crazy, angry, self-destructive behavior over a lot of years to get me from there to here. I had every right to be pissed off—at my family, at my tormentors, at the world. It was the kind of rage that can kill you.

Today I always say you're allowed to reevaluate your thoughts, opinions, or stance on anything, and I know I do it. (It's a man's prerogative to change his mind.) I used to say it's easier to apologize than ask for permission. I now think I wasted too much time with drama when I did that.

So this process continues, over and over, until the paper, the pencil, and I are all lying in a crumpled mess in the corner, worn out yet content with the answers to the questions that were clawing at my head. It's like seeing a guy on the floor, sweat pouring off his face like Niagara Falls, gasping for breath, and you ask, "Are you OK?" and he says, "Yeah, I just had the best workout of my life."

I have been through two divorces and have done my best to keep the drama quiet. It hasn't always been easy, or even possible. Divorce

Why I Invited You Here | Look Thru My Cracked Viewfinder | Life's Not Always Beautiful | Ghosts Inside Me | This Is War | One Man, Two Bands | Killer's Instinct

Help Is On The Way | Tale Of The Siamese Twins And The Black Rose Tattoo | Rock N Roll Will Be The Death Of Me | The End, Unless It's The Beginning

devastated me on many levels, but how I handled it set the bar for how I believe things should be handled. I am a smart-ass, big time. Love sarcasm, and when I say I have a sharp tongue, we're talking straight razor. To hold my tongue is sometimes like holding a hand grenade. It ain't always easy to muster up the maturity to not lob that fucker back. The old saying "restraint of pen and paper" should say "restraint of pen, paper, and send key."

I'm getting better at it. When we got off our second Crüe Fest tour, the singer of a particular band complained, moaned, and bitched about *everything*. And, of course, he loved to tell anybody who would listen about how his band was blowing our old tired asses off the stage every single night, and naturally he shot off his mouth online, too. Those who know me expected me to crush him as I have others in the past.

But I thought about it first. By then we had had around twenty bands on that tour, hundreds of road crew members, hundreds of thousands of fans at the shows, and millions of radio listeners, and the only person to complain was this one singer in one band. That thought made me laugh so hard I could barely contain my giddiness. Before the tour the same guy was on the phone begging to be included. Now this. Sometimes the guy holding the grenade pulls the pin without knowing what to do next. That's the guy who blows himself up.

I've been a lot of people in my short life—the dumb guy, the angry guy, the guy with a mission, the smart guy, and the guy with the hand grenade who is too stupid to throw it. Now I am the who I am today guy. (Please don't count my multiple personalities in there.) And that guy is one happy, creative motherfucker. By the way, thank you for putting up with me while I exorcised my demon right before your eyes. I think I am all better now.

A Brief Interruption: Nikki Being Normal

Not that I have completely conquered my inner asshole . . .

Today I woke up excited. My little community is having a neighborhood parade and, believe it or not, I'm tickled pink to take my family to watch.

Of course, we came unprepared. The neighbors had lawn chairs, coffee, donuts, juice, and bagels. Some were playing music and huddled under trees in their pajamas, laughing and socializing.

Life is good. Life is funny, and as one of my favorite Spanish

poems says, "I am exactly where I am supposed to be in the universe."

My days of raucous anarchy are long behind me; I am mature in my life and so secure that I don't fly off the handle and/or sever the nearest throat when agitated.

I'm just a dad taking his kids to see a parade.

Pulling up and parking curbside, front and center, greeting my neighbors with glee.

In the distance, bicycle horns and children laughing. In the air, excitement.

Coming up the two-lane blacktop road, kids, dogs, and a unicyclist. Antique cars and the local marching band. Banners for the neighborhood vet and housewives running for office. Candy being thrown from every vehicle as kids scamper to get that all-important Tootsie Roll.

"Maybe there is a God," I say with a sigh.

A guy walks up to me and says, "Whose car is this?"

"It's mine," I say. "Is there a problem?"

"Yeah," he snaps, "people like to stand here and watch the parade."

Feeling somewhat foolish and ignorant in the ways of parade parking, I say, "I'm sorry, would you like me to move?"

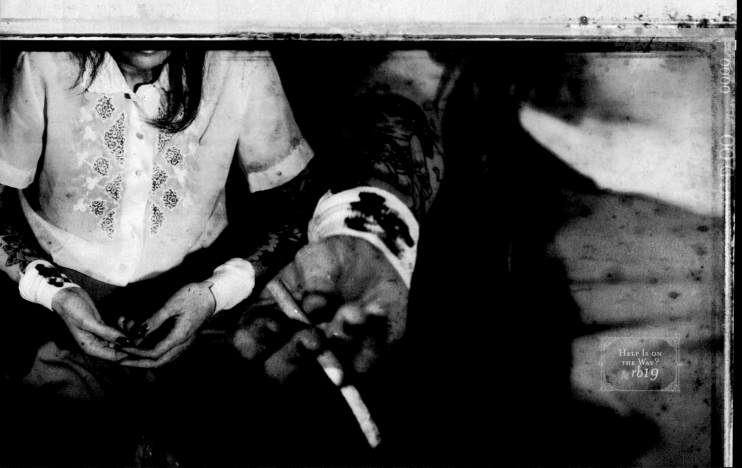

Help Is on the Way? *fig* rb19

He rolls his eyes and says, "Well, you better. You never should have parked here anyway."

Now I'm walking around to the driver side. My ass has started to burn, but I just suck it up. Then his wife says, "Anyway, you're a rude and inconsiderate person."

I stop in my tracks, knowing it's too late to stop what's about to rocket outta my mouth.

Razor blades and fireballs . . . boom, direct hit.

"Well," I say to her, "good fucking morning to you, too." To which I add, loudly, "You know what? I am gonna park here every year, right here, on this corner, every year . . . until you DIE."

Then there is that uncomfortable silence I have grown to enjoy, even as I thought I had maybe outgrown outbursts like this one.

We watch the rest of the parade and I go home content.

I can't wait until next year. I'll have to leave home extra early to make sure I get that parking spot.

. . . Anyway Where Was I?

Twenty or so years after my first therapy session with the school principal, I stepped up to the real thing. This time it was an actual professional. After all, by then I was a professional drug addict; it would only make sense to level the playing field.

Mötley Crüe had found a band counselor. His name was Bob Timmons, and he had been brought in after helping Vince get into rehab in 1985. Vince had been charged with drunk driving and vehicular manslaughter. He was but the first band member to go down in flames—first rehab, then jail, and Bob had a lot to do with saving Vince. Bob then had the pleasure of dealing with the mass dysfunction known as the Crüe. We were hitting the skids on drugs, crashing and burning, only to come back phoenixlike time after time, but even the most glamorous rock n roll debauchery doesn't sit pretty when people die. The band was right behind Vince in needing to be saved from the flames.

After "Girls Girls Girls," it would be my turn in the same Van Nuys facility that helped Vince. To be honest, part of me liked it and part of me (the scared part of me) hated it. I ran out of rehab, literally. But Bob was there for me, taking me to AA, CA, and NA meetings. I found a sponsor and started working through the twelve-step program.

Amazing what a little light at the end of the tunnel can do for you.

I think for the first time since I was a kid I was thinking maybe I wasn't quite as fucked up as I'd been told. I had wounds, but wounds heal and turn to scars. That saying "You know a man by the scars he has" is true for me. I have a saying too: "I never trust a person without some kind of baggage." Because those of us who have been through the war of life and survived usually have more heart. If you have heart and are honest, you have probably worked on yourself and therefore are trustworthy. I want someone like that in my foxhole. That is the man I was turning into, but I wasn't there yet.

Bob arranged band meetings with a therapist who would take us through the AA steps. We would go around the room and share our *feelings*. To be honest, I would have called it bullshit except I had been working on myself away from the band, so it wasn't completely foreign to me. Mick wasn't gonna have any of it, but Mars always will take a bullet for the team and so he sat there and steamed, but he sat there. Vince had seen and heard all this before, so he was acclimated. Tommy was open to these meetings because he believed it would help the band.

After a time I saw a change in the band and myself. It was actually working. It was like couples' counseling, talking it out with one another and clearing away a lot of the old hurts in our marriage. Mötley Crüe wasn't about to get a divorce. We had way too much fighting left to do, with one another and the world.

Around this time Tommy went to rehab, and so we all went and did group therapy sessions with him. Vince has been back a few more times, and to be honest I can't really even remember half the stuff that was said in those rooms over the years, but I know it changed us individually for the better, and I know it changed the band, too. After that, the question was whether the world was ready for a sober Mötley Crüe, and whether I was ready for a sober Nikki Sixx, and the answer in both cases was yes. And so began another chapter.

I feel as though my addiction and the band's craziness have been covered a million times, and I won't do it again now. But I do find it interesting to see how my personal struggles connect with my creativity. My younger days formed the adult me and also fueled all my creative endeavors, even today.

The misery that drove me insane as a teenager inspired the monstrous imagery of the photography in this book, as well as a song like "Shout at the Devil."

###

Korea Town
fig. kt61

Shout at the Devil was a film that came out in 1976. It was also a Mötley Crüe album and a song that came out in 1983.

Originally it was called "Shout with the Devil."

After the song had become a mainstay on the lips of millions of teenagers, I researched the movie of the same name. This is what I remember finding.

Lee Marvin and Roger Moore both starred in this war film loosely based around "a girl." The weakness for alcohol only equaled the obsession with greed and violence. All this was a nice side dish to the plot, but in the end it still seems to really be only about "a girl."

If I had seen this movie (and I probably didn't), it could have been the blueprint for my love life. All the toxic elements are there.

Like I said, it was 1982, maybe 1983, and I had a fervor for sticking my opinion in your face like a threat to cut your jugular, but with a pen instead of a straight razor.

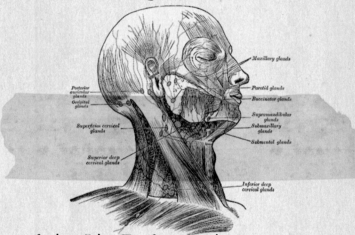

I was dating Lita Ford at the time.

I remember sitting in Lita's mom's kitchen (Lisa Ford, R.I.P.) in Long Beach, California, acoustic guitar in hand. Lisa was cooking up some Italian masterpiece as I wrote my own. "Shout, shout, shout with the devil," I sang (for my supper), dripping with hate for politicians (or any authority figure), even though I didn't know any. I figured they were all corrupt and didn't have America's best interests at heart. (Like I was any different.) To be honest, I didn't know what I was talking about. I was young. I was dumb. I was pissed.

In retrospect, I didn't write that song, it wrote itself. I was just the messenger. I knew what I wanted the Crüe to look like. I knew what it needed to sound like. But I didn't know where all that information

was coming from. Some would say from hell; others just said that we were going there. Nonetheless, like a huge bolt of lightning, creativity comes down from the act of imagining, every time, for me.

Messages are like this. Signed, sealed, and delivered to us from some far-off, distant dreamland, these little "awareness pills." No prescription needed. These are well-earned life lessons. Gobble them up, I say. After all, you paid for them.

Now, if you're smart enough to have listened to the elders, you can take the shortcut and save yourself a lot of time and pain. Most of us aren't so wise when we're young, so we trudge through the darkness until we smash face-first into a cement wall. Only then do we ask, "Anybody got a light?" If you can imagine that lightbulb turning on, that's how ideas pop into your head. It's that simple.

That day you learned another simple little lesson, you grew another inch, and you couldn't imagine why you had done what you did. Ideas come out of adversity plus dreaming. Key word is ideas *come* to you. Now, to put them into action, that's the part that distinguishes the men from the boys, the girls from the women, and the idiots from the geniuses.

When you imagine something, you see it, you taste it, and you feel it. If you're that clear, it becomes real. It doesn't matter if you know why. Like magic it will appear right out of your imagination.

Albert Einstein said, "Imagination is more important than knowledge." I believe this works with both good and evil. If I can imagine the demise of a villainous enemy hard enough, I guarantee something will happen to him. (Some call this voodoo.) Negative energy is equal in power to positive energy. It just takes twice as much time to dredge up the darkness as it does the light.

I have received in my life everything I have ever imagined, positive and negative. Can you imagine how crazy my brain is at times? It's a full-blown nuclear power plant brewing up enough sewage to destroy the world (or at least a few innocent bystanders).

In my twenties, I pumped out so much sewage from my brain that I think I alone am responsible for 90 percent of all the smog in Los Angeles. (To the clown in the back of the room who called me a narcissist, that was a joke.)

Now that I am able to redirect the energy into massive amounts of positive energy, I feel like I could light a city with just my heart. Seven words I believe to be true: "We who are awake need less sleep."

Shout at the Devil was a film that came out in 1976.

It was also an album and a song that came out in 1983.

Originally the song was "Shout *with* the Devil." I changed it, but that didn't stop the press back then from saying that we were on the devil's side, shouting alongside him. But we weren't.

Imagine that.

He's the wolf screaming lonely in the night
He's the blood stain on the stage
He's the tear in your eye
Been tempted by his lie
He's the knife in your back
He's rage
He's the razor to the knife
Oh, lonely is our lives
My head's spinnin' round and round
But in our seasons of wither
We'll stand and deliver
Be strong and laugh and

Shout at the Devil

He'll be the love in your eyes
He'll be the blood between your thighs
And then have you cry for more
He'll put the thrill back in bed
Sure you've heard it all before
He'll be the risk in the kiss
Might be anger on your lips
Might run scared for the door
But in seasons of wither
We'll stand and deliver
Be strong and laugh and
Shout at the devil

If Red Light Is Flashing . . .

I remember being a teenager when, as I mentioned earlier, my grandmother Nona sent me a book, *The Autobiography of a Yogi*, and I drank it up. There was a fleeting moment after reading that book when a calmness came over me. Of course, it wouldn't stick, but that doesn't mean that on a cellular level I didn't take some of it in.

I think every day that there is something positive to learn, and the experience is usually right in front of our eyes. I don't think it's a one-shot deal, more like a repetitive action. You have to force yourself to get into the game every morning. It builds us up spiritually and emotionally. It's like going to the gym, it doesn't happen overnight, but one day you wake up and see a change. Likewise, when you don't go, it doesn't take long to lose most of what you have worked for.

I have days, bad fucking days, depressing days. Days when my band is busting my balls so hard I just wanna call it quits. There are days when as a parent, as a boyfriend, and as a partner in so many exciting ventures, all hell breaks loose. Those are the days I get to measure, "How much of a man am I?"

I was in an elevator in Calgary, Canada, while on tour with Mötley. As much as I love touring, I hate leaving my family. It was a day off, which to me means a wasted day of my life. It was fifteen below outside, and I wasn't about to grab my camera and hit the local skid row. Katherine and I were on the skids, and to be honest, I wasn't fucking happy to be there. So I decided to go to the hotel gym and work off some of my self-pity and pull the stick out of my ass. When I got into the elevator and pushed the button for gym, I saw a sign that said, "If red light is flashing, help is on the way." I pushed the cancel button, went straight back to my room, and wrote a riff that I sent to James over my iPhone. Magic happened once I got out of my own way, stopped sitting in my own shit, and left my room. All those years of therapy, self-help books, and rehab meetings—and maybe that book from Nona—paid off at that moment. I sat down and wrote music and lyrics and jammed with James.

When I hung up, I looked out over the frozen tundra of Canada and thought, yeah . . . help is on the way, always.

Why I Invited You Here
Look Thru My Cracked Viewfinder
Life's Not Always Beautiful
Ghosts Inside Me
This Is War
One Man, Two Bands
Killer's Instinct
Help Is On The Way
Tale Of The Siamese Twins And The Black Rose Tattoo
Rock N Roll Will Be The Death Of Me
The End, Unless It's The Beginning

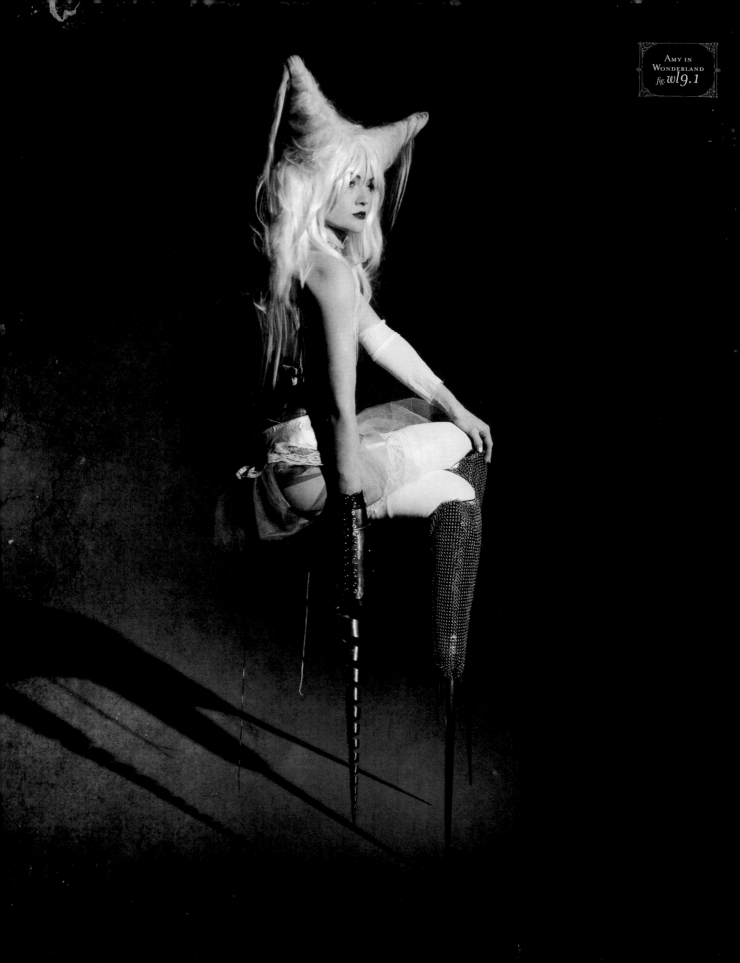

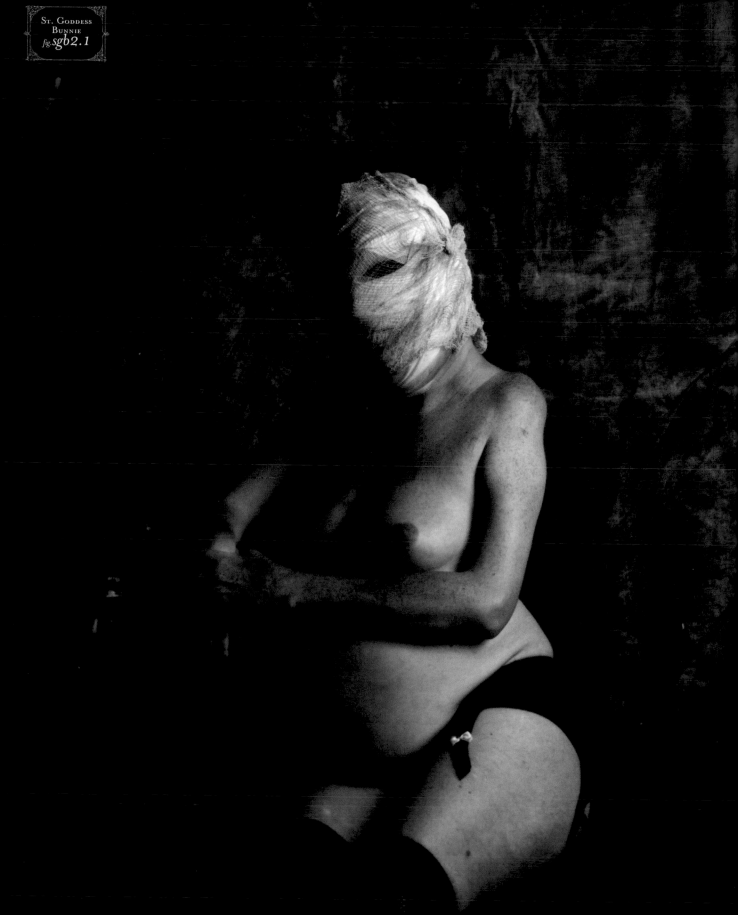

What the Fuck Did You Say?

I heard her clear as a bell but I couldn't believe my ears. Mouth slung open, gaping, I said to my therapist, "What the fuck did you say?"

So, as she has had to do a million times in our sessions, she repeated the words to me slowly so I could take it all in. Like I am some kind of idiot or something. Politely she repeated herself, "Just because she's your mom doesn't mean you have to love her." I looked at her, then out the window, then back at her, and said, "Thank you." I finally got it. It had been more than forty years and billions of miles, tears, fistfights, outbursts, overdoses, crashed cars, smashed hotel rooms etc., etc. Not to mention two divorces and over $10 million in legal fees and I finally fucking got it. Man, maybe I am an idiot.

So if I don't *have* to love her, then I don't *have* to love my fucking father, either? Oh shit, that means I don't have to be angry and resentful? I don't have to seek and destroy, rape and pillage, pine to kill, seethe, pout, and stomp my feet anymore either?

Oh shit, *now* what am I supposed to do with all this spare time?

But for real, what am I supposed to do with this bag of shit I've been carrying around with me all these years? It fucking stinks, and to be honest I think the bottom was about to fall out of it anyway.

I sat up (I must have lost track of time), then stood erect and hugged the hell out of my therapist. I went to my car and drove home zombielike. I was probably smiling like a man who lost his mind and found his soul all at the same time. I went straight to bed and slept sixteen hours that night. That was the end of the beginning for me. That was truly the beginning of forgiveness for me too.

Quickie Life Lesson: *Don't Judge Me by the Color of My Skin*

Walking along the pier in San Francisco I heard someone say, "Hey, Tattoo Man." I looked over my shoulder to a black man, very large in stature but worn down by life.

He looked as though a killer he was and soon a victim he will be.

He was obviously homeless and suffering with some serious health issues.

After the multicolored racial slur of "Tattoo Man" came the next question, "You have any money?"

I walked over to him and said, "I'll do you a favor if you do me one." He jumped at the opportunity and said, "OK."

I said, "I'll give you some money to help you out if you help me out, too."

He said, "Anything."

I said, "Don't judge me by the color of my skin, OK?"

He just said, "Wow, I am sorry."

I smiled and said, "It's OK. Happens all the time."

To which he replied, "Yeah, me too."

From Hell to Transcendental Meditation

As I rumbled down the street with music blasting from my '32 Ford, it would have been obvious to anybody that I was a man in shambles. Too much information being shoved down my throat with the helping hand of managers, agents, divorce lawyers . . . Things were not 100 percent with my girlfriend, Katherine, and I felt like my heart was stuck in a meat grinder. Alcohol was no longer an option to kill the pain. I was fifty years old and had the world by the balls, but on that day and the days and months building up to it, life felt more like a kick in the balls.

Katherine had suggested that I meet Nancy. Somebody else had advised the same for Katherine. People like Nancy de Herrera are not in the phone book. It's word of mouth, or maybe word of heart. Today as I sit here writing, I am grateful the good news found its way to me.

It was a quaint little home in the hills off Laurel Canyon in Beverly Hills. Even though her house was nestled in a neighborhood on a public street, it still felt like solitude as I pulled up. I had only spoken on the phone to her one time. She gave me directions and told me, "Simply bring seven flowers and three pieces of fruit." I scratched my head, shrugged, and did as directed.

When Nancy opened the door, I felt like I was going to be catapulted somewhere. Her positive energy was overpowering. She looked at me with blue eyes and shouted, "Nikki, I have been waiting to see you." Then she looked deeper into my eyes and said, "Please come in; let's have some tea."

As she poured she said, "I feel like I know you. You remind me of someone but I can't put a finger on who." I was anxious and excited to learn what she had taught so many before me. In the 1960s she had traveled to India with John Lennon, Paul McCartney, Eric Clapton, Donovan, and a handful of others to meet with the Maharishi Mahesh Yogi. She was there when the '60s erupted, led by the Beatles and their message of love. To be honest, it was the Maharishi Yogi's message and

WHY I INVITED YOU HERE | LOOK THRU MY CRACKED VIEWFINDER | LIFE'S NOT ALWAYS BEAUTIFUL, GHOSTS INSIDE ME | THIS IS WAR | ONE MAN, TWO BANDS | KILLER'S INSTINCT

HELP IS ON THE WAY | TALE OF THE SIAMESE TWINS AND THE BLACK ROSE TATTOO | ROCK N ROLL WILL BE THE DEATH OF ME | THE END, UNLESS IT'S THE BEGINNING

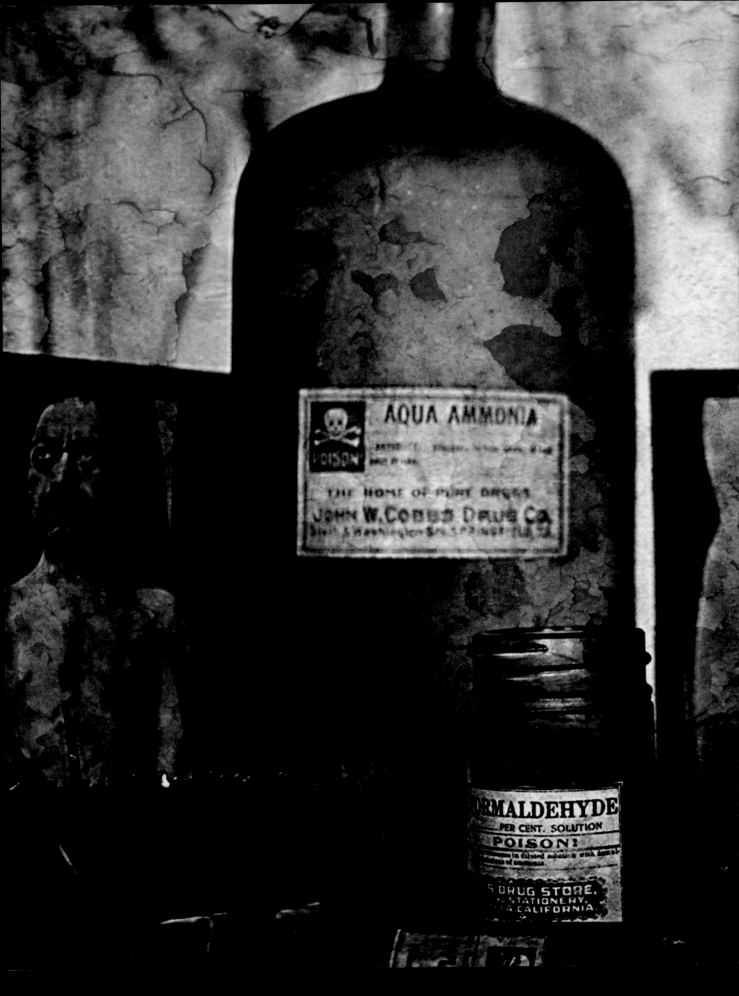

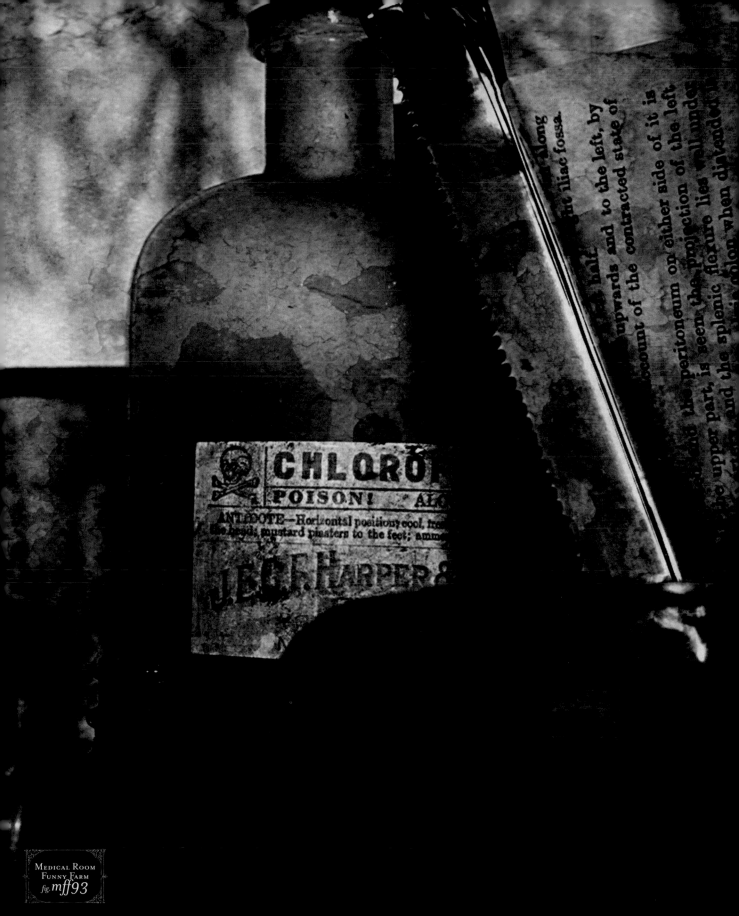

CHLORO
POISON! AL
ANTIDOTE—Horizontal position; cool,
the head; mustard plasters to the feet; amm

J.E.F.HARPER 8

the Beatles were the carriers to the rest of the world. That made it theirs and that made it ours . . . All great messages should be so blessed.

All you need is love, indeed.

But for me, on that day, I didn't know what I needed. I sat there and started to cry into my tea. I told her I was about to break, and I couldn't stop the slow painful cracking before the final snap. She looked at me kindly, absorbed my words like a Mother Teresa, or maybe Mother Nature. She told me when the Maharishi was sitting in my very spot, sipping from that very cup, he said, "Life is not always perfect."

That day Nancy taught me transcendental meditation (TM).

I can tell you how important that day was a hundred thousand times over, but unless you experience what I'm about to explain, it won't make complete sense. So I will simplify.

You have noise, it's in your head, and your system is breaking down from it. I see it as poison darts stabbing into your nervous system. They feed on your anxiety, they thrive on your inability to sit still, and they get fat like rats on your rotting soul.

To "simplify" your life into a mantra is to call in the noise patrol. Meditation is simple. We think our lives cannot be. They can if you call on the noise patrol.

Simply said, simplify.

It's so easy to get overwhelmed daily. I don't need to tell you about your daily overdose of traffic, cell phones, e-mails, kids, texting overload, work, bills, and the five, six, seven, eight, and nine o'clock news. And somewhere, sometime, maybe a doctor screams out to the patient (you and me), "Give that guy some Zoloft. Better yet, a double shot of Wellbutrin with a Prozac back."

Western medicine has its place. I use it (I was on Prozac and then Zoloft for years, too), but this is for your soul and there is no medical procedure for your soul that I know of.

Since that day I use TM daily. Like a meditation junkie I need my fix. (Man, life sure is a roller coaster of changes, isn't it?) Unbelievably, it both rests and reignites you at the same time. You will feel like you have slept a full night with just twenty minutes of meditation. You will *not* be required to sit in a Buddha-like position, arms extended, om sounds coming from your chest. I'm not making fun of this. I am only trying to explain to you that transcendental meditation is different. You can do it anywhere, anytime. I have done it on planes, dressing rooms, backstage, in the middle of recording and photo sessions, and even in a crowded, crazy subway station.

I won't go on and on about TM (like I usually do). I only share this because of how important it has been in all aspects of my life. I notice a closer relationship to my family and friends thanks to TM. I see a difference in how I handle all the crazy-makers and emotional terrorists who come with the life I have chosen.

Nancy called me today and asked if I would pop over for some tea. I smiled and simply said, "Yes."

The Devil Goes to Washington, D.C. (Goddamnation)

A day doesn't go by that someone doesn't curse me to hell. Damn me, so to speak. The dictionary tells me that if I am damned, then I am doomed.

And so it begins, another day being condemned by my neighbors for living life out loud and damned by the international metal community for not making *Shout at the Devil* eight times in a row. Or cursed and thrown under the nearest bus for selling too many albums of *Dr. Feelgood*. Thrashed for having too many tattoos, then ragged on 'cause I've become conservative based on the success of *Heroin Diaries*. I am a sellout for standing in front of Congress in Washington, D.C., and a has-been for even being. Such is life.

Oh, did I forget to tell you about the time I was sitting with Patrick Kennedy in the halls of Congress?

Doe-eyed and smart as a fox, he actually considered my proposal, I believe, as I sit here today. He also considered his job, his family's reputation, and our country. I sat there patiently, straight razor in boot, impatiently praying, "Dear God, if I may have just one kill, one free pass, can it be this one?"

As usual, God takes his dear sweet time. With my foot tapping in time with my escalating heartbeat, and my eyes darting back and forth, I tried to keep my focus. Watching his eyes, his mouth, even listening to his breath for some kind of sign. I knew it was a long shot, a Hail Mary pass. Behind his head was a wonderful picture of his uncle, John F. Kennedy, being sworn in as our president, Jackie Kennedy by his side, and the most beautiful American flag tilting toward us from behind his desk. It's like the flag was in on the decision and, to be honest, I am sure it was. I had an agenda to get something done for Americans, and I'm sure, like the number of stars and stripes, there were different ways to see what my plan would or wouldn't do for our great country.

Just as the problem with gun laws aren't the guns, it's the people who do stupid shit with guns . . .

WHY I INVITED YOU HERE | LOOK THRU MY CRACKED VIEWFINDER | LIFE'S NOT ALWAYS BEAUTIFUL | GHOSTS INSIDE ME | THIS IS WAR | ONE MAN, TWO BANDS | KILLER'S INSTINCT

HELP IS ON THE WAY | TALE OF THE SIAMESE TWINS AND THE BLACK ROSE TATTOO | ROCK N ROLL WILL BE THE DEATH OF ME | THE END, UNLESS IT'S THE BEGINNING

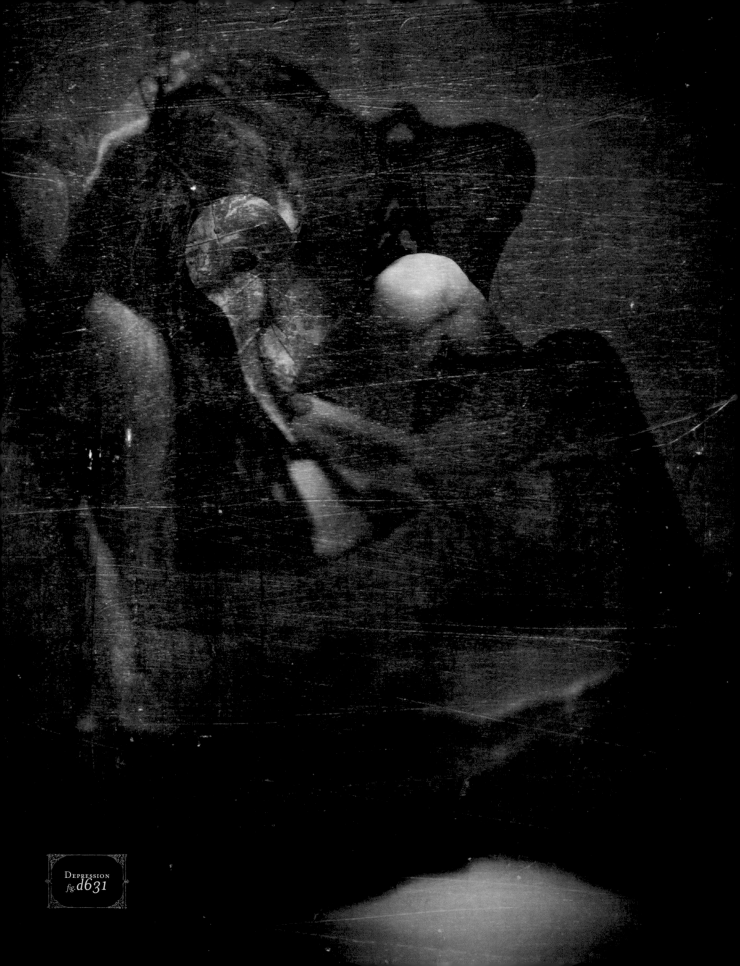

Depression
fig. d631

Why I Invited You Here | Look Thru My Cracked Viewfinder | Life's Not Always Beautiful | Ghosts Inside Me | This Is War | One Man, Two Bands | Killer's Instinct

Help Is On The Way | Tale Of The Siamese Twins And The Black Rose Tattoo | Rock N Roll Will Be The Death Of Me | The End, Unless It's The Beginning

. . . the problem with letting a rock star into Congress is, well . . . You get the point and so did Patrick Kennedy.

Intuition was slowing my heart rate. He reached for my book and like a great man, looking me square in the eye, he said, "You know, Nikki, you're 100 percent right, but my job is not *this* job. We agree with you, but we can't help you. If you go on this journey, you must go it alone."

I knew he was right. I knew it all along. He has other jobs in Washington to do, people to motivate, bills to pass.

This whole thing started as a meeting for us to work together to pass something called the Parity Bill, which would have forced health insurance companies to recognize mental illness and addiction in a similar way as physical illness. Until then, people wouldn't be able to get coverage from their insurance companies for a wide variety of mental health services and/or rehab, and this legislation sought to rectify that.

The meeting somehow turned into me wanting to call the president of the United States of America an alcoholic. Wow, some days I even surprise myself at the sheer size of my own balls.

Of course, the answer was no and rightfully so. But goddamn it . . . this is my goddamn nation, too.

Too Fast for Love?

We were young and we didn't know what we were doing.

We wanted it all, but we didn't know what it all was.

The good and the bad and the price tag that came with it would take us years to understand.

We had been blessed with resilience. We were the cockroaches that wouldn't die.

But we weren't Too Fast for Love because we were *in* love, or at least in love with anarchy.

Too Fast to Settle for Mediocrity wouldn't have sounded nearly as good as the actual title of Mötley Crüe's first album, *Too Fast for Love*, so there you have it.

What I do know is that back then I used to hang around a prop house in Hollywood. I was intrigued by how sets were built and even more by the small pyrotechnics division in back. I wanted to steal the props, but I was scared if they caught me I couldn't come back.

From time to time they would shout out, "Hey, kid, come over here; wanna see something cool?"

I was on a mission to learn how to blow up a stage, and I needed weapons. In my life, I always put education first, of course.

That day they showed me multicolored pyro powders.

I asked if I could hold some as it burned, and they laughed. They said if I put it into something and cupped it in my hand, I could. So I did. The smoke filled the air for as far as I could see. I was amazed and knew I had to get my hands on some of this for a photo shoot for the album.

Looking back on the *Too Fast for Love* photo sessions with me holding that pyro powder, smoke billowing from my outstretched hand, I laugh. We were loving living fast—too fast. And the moment passed, but history reminds me as I remind you:

Live in the moment. Moments make history.

I Was a Homeless Teenage Arsonist (Sorta)

Somewhere else in this book I told you about the time I accidentally burned down the house where I was living in L.A. I was a self-indulgent teenage arsonist or, more accurately, an irresponsible, candle-loving pyromaniac, and thanks to that, basically without a place to live.

I guess we are all just one blazing curtain away from being homeless. Sometimes mishaps flatten us and, with no backup plan, you land on the street.

I didn't end up homeless that day, but I was on a slippery slope. After running away from my mother's home in Seattle, I did sleep in the park and in abandoned cars. I was spared a permanent residence on the streets only by friends and eventually by my grandparents, who sent me a Greyhound ticket to Idaho.

That little taste of homelessness was a bitter enough flavor to stick with me till this day.

I know there are different scenarios on how kids become homeless. But once they end up on the street, they usually fall prey to prostitution, drug addiction, gangs, violence, and the slow, torturous, downward spiral into hell. I remember being in Boston years ago and looking down a long alley, seeing two kids maybe nine and twelve years old digging through an overstuffed Dumpster. I looked around for parents and there wasn't a soul in sight. I walked down and asked what they were doing, to which they replied, "Looking for something to eat." I gave them some money and asked where their parents were. They told me, "In jail," and nothing more.

Eventually the younger homeless kids will get picked up by

authorities and placed into some kind of system, maybe juvenile detention or foster care. As much as that seems like a blessing, it's only a Band-Aid, as they have to address the bigger problems they developed early in their lives. After foster care, the system really breaks down, as these poorly prepared and helpless kids age out and end up on their own. They are released (if they last that long) when they are eighteen with little education, no job skills, and no family support.

When I was writing *Heroin Diaries*, I wanted someplace to send the proceeds. We checked into a lot of programs, but Covenant House completely blew me away.

The organization not only houses kids with no place to go, it has a system in place to help better them. There are many pieces to a puzzle, and Covenant House figured that out. Its staff has organized a way to put Humpty Dumpty back together again.

First they use an outreach program to find homeless kids and get them food and shelter.

Once in touch, they have a medical facility, a program to educate the kids on addiction and recovery, even a graduation and job placement. Most of the people I've met through Covenant House are healthy, balanced, and ready to succeed in their lives. They even give back and help others less fortunate than they are now. Covenant House is a lifesaver for these kids. It gives them hope and the chance to turn their lives around.

For me, music was a huge part of avoiding homelessness. Having burned most of my bridges, with no real education (other than in rebellion), I was destined for a very unstable life. Music saved me. It gave me a reason to wake up, an outlet for my creativity, a shot at financial stability.

So it was an easy decision to help create Covenant House's music/arts program.

I met with executive director George Lozano and we devised a program for kids living in the Covenant House Crisis Shelter. They love it. The program gives them a chance to explore their musical talents, have fun, feel good about themselves, and express themselves in ways that other therapeutic services couldn't do. I helped them build a music studio and got them basic instruments, amplifiers, and software. We hired instructors to teach the kids to play their instruments, record, edit, and even entertain.

With added support from music companies and personal donations, we have been able to give hope through music to these kids.

Why I Invited You Here | Look Thru My Cracked Viewfinder | Life's Not Always Beautiful | Ghosts Inside Me | This Is War | One Man, Two Bands | Killer's Instinct

Help Is On The Way | Tale Of The Siamese Twins And The Black Rose Tattoo | Rock N Roll Will Be The Death Of Me | The End, Unless It's The Beginning

We're just getting started—there are a lot of kids still on the streets and a lot of music to be made.

The program is called "Running Wild in the Night" after a lyric I wrote for a song of the same title. It ended up being used in another song, "Save our Souls":

Black angels laughing in the city streets
Street toys scream in pain and clench their teeth
The moonlight spotlights all the city crime
Got no religion, Laugh while they fight.

Funny, growing up, I never thought I would.

The Resurrection of Nikki Sixx

Along my journey, I've seen so much: birth, death, those who cherish life and those who cherish death even more.

Point being, I create some version of reality that others see as fantasy. Or maybe it's the other way around. Maybe there's a monkey on my back, or maybe there's a dented halo floating somewhere above my disheveled head. Maybe I don't even know, but I have to give everything I have in whatever I do, or there's a torturous, gnawing fear that tears at me. I always ask myself this simple question: "Did I do my best?"

It all started, like so many things, in a book I read that pretty much changed my life. This particular one was titled *The Four Agreements*, by Don Miguel Ruiz. In photography, like life, there are four agreements. I try to use them as my daily mantras, my all-purpose rules (or some say nonrules).

Ruiz's four principles to live by (as interpreted by me) are as follows.

Why I Invited You Here | Look Thru My Cracked Viewfinder | Life's Not Always Beautiful | Ghosts Inside Me | This Is War | One Man, Two Bands | Killer's Instinct

Help Is On The Way | Tale Of The Siamese Twins And The Black Rose Tattoo | Rock N Roll Will Be The Death Of Me | The End, Unless It's The Beginning

1. Be impeccable with your word.

If you say you're going to do something, for God's sake do it, no matter what. It can be a threat or a promise, but do it. Your word is who you really are. Always keep it, and use your word to motivate yourself to higher levels.

So, if I promise to kick your ass, trust me, you're gonna get your ass kicked. Just as I say this: I will leave my mark on the world of photography, and I will do it on my own terms just like I did with music, and I promise you it's gonna kick ass. I knew it the day I did the "You Will Not Grow" photo sessions, and I still know it now.

2. Don't take anything personally.

When I was in high school in Seattle in the 1970s (best time for music *ever*), the school districts had just started busing. For those of you who don't remember, busing was a way to break down the racial barriers in big-city school districts. There still were predominantly white or black schools at the time, and to be honest I thought that making them more integrated was a wonderful idea. The only problem is kids are kids, and kids from different backgrounds don't always understand anybody else's reality. (Man, we haven't really made much progress in that area, have we?)

Anyway, I would walk down the halls of Roosevelt High wearing these tall, clunky platform boots. At the time I was so into David Bowie that I would emulate my hero by wearing vintage men's suits three sizes too small and usually smelling of dead people. I had this wild, shagged-out, overdyed, crazy hair. (Man, I haven't really made much progress in that area, have I?) Of course, there was the makeup and the nail polish, and my new schoolmates did not get this at all.

So came the insults. "Hey, it's Alice Bowie!" or "Is it a he or a she?" Or the usual one that started the downward spiral and eventual black eye: "What are you, some kind of faggot or something?" Then came the fistfights, bloody noses, and, of course, being thrown out of school.

What's my point? Well, I didn't take any of it personally, because I knew they were idiots. I might have been a drug dealer and a bit of a punk, but I wasn't destined to spend my life in San Quentin. These guys were real tough motherfuckers with even more fucked-up childhoods

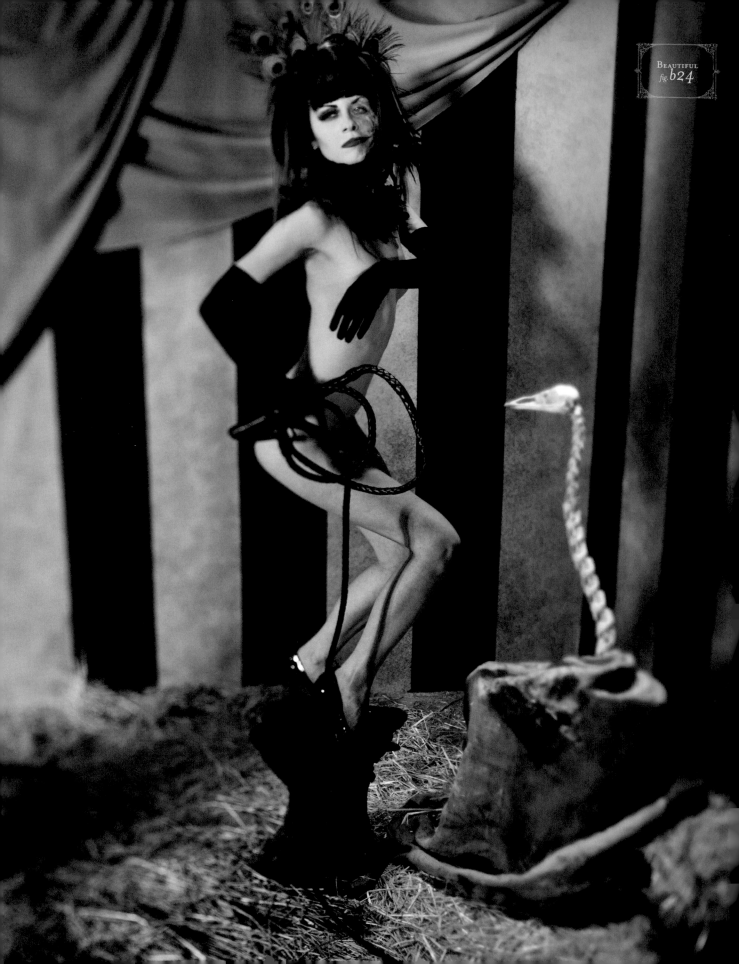

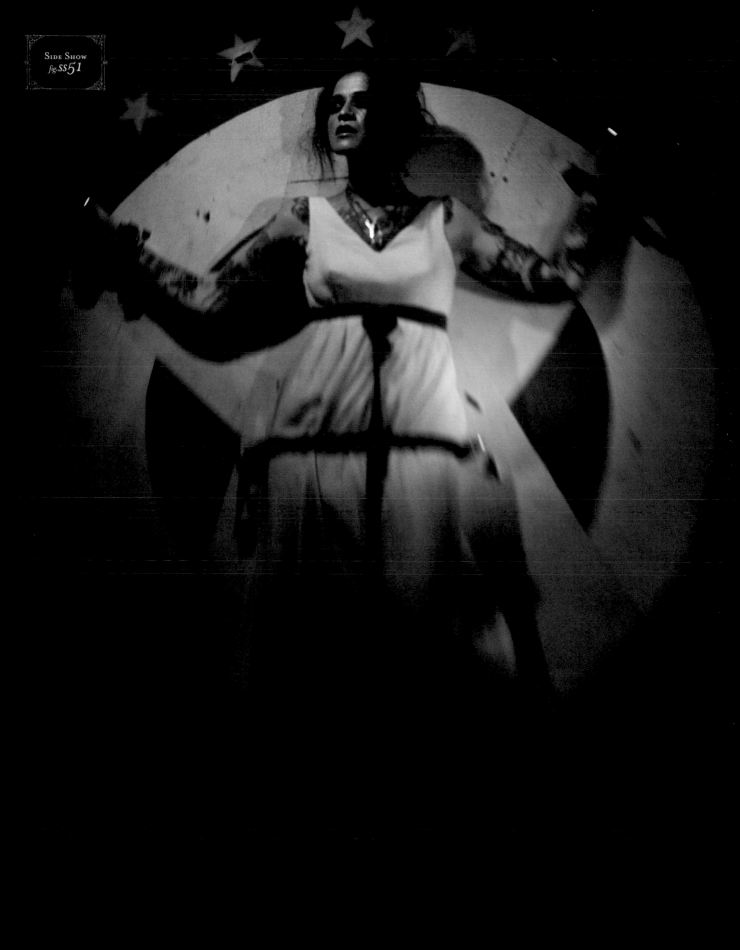

than mine. I was just an eyesore with a dream who gave them an excuse to blurt out bullshit. I was just another reason for them to gang together and pick on the weirdo. It made them feel good and, to be honest, maybe I was doing them a service. (Even though the time I slammed a guy's tooth through his lip he didn't thank me.) They couldn't help themselves, just like I couldn't help myself. "You gotta do what ya gotta do to get ya through," I always say. To this day I don't take it personally, like a million things in life that crossed my path and pissed me off or maybe even bloodied my nose. I ain't renting out space in my head to anybody. It's too crowded in there already.

3. Don't make assumptions.

You know the old saying—I still remember hearing it as a kid: don't assume, because you make an *ass* out of *you* (or *U*) and me. It stopped me dead in my tracks.

I think that's right. I have walked a rocky road at times because I assumed she was a bitch, or they didn't like it, or, worse, that nobody loved me. The lessons don't stop just because you get kicked out of school, so I sit here pondering old decisions . . . old assumptions.

When I was younger, I always assumed that not too many people would ever really get me. I spoke my mind even when I was told to hold my tongue (remind me to work on that), and I did what was right even when I was told it was wrong (remind me not to work on that). I guess I just assumed that because you didn't get me, you were fucking with me. I assumed that I would exist in the dark underbelly instead of where the normal people live. I assumed I wouldn't live to see thirty. I assumed a lot of stuff that never came true. That's the embarrassing part about assuming: you're almost always wrong, or at least I have been.

Of the four agreements, this has been the hardest to live up to. I have to work on this daily, even minute by minute sometimes. It must be a form of rebellion that lives in my DNA. For example, I assume for some reason that nobody will really get my photography, so I feel the punk-ass fucktard inside me start to flare up. It happens so fast I can barely catch it, and then it goes away in a flash. Some parts of us never change. But maybe we get just a little more of ourselves under control as we work on this stuff in our lives.

4. Always do your best.

Believe it or not, I don't have too much to say about this one. I mean, if you're not already doing your best, then you're just flat-out stupid. (I'm now doing my best not to laugh at how ridiculous and rude I am sometimes, though I am doing my best here to make you think.) Life is like a huge opportunity to change the way we think and see things. I hope the way I see things (in photography and life) might make you think, and maybe you will pass it on and so on and so on. Consider this: I am doing my best to write my second book even though I was asked not to return to high school. If an illiterate rock musician can write a book, then you can do anything you want, too. Maybe just follow your heart. And these four simple principles.

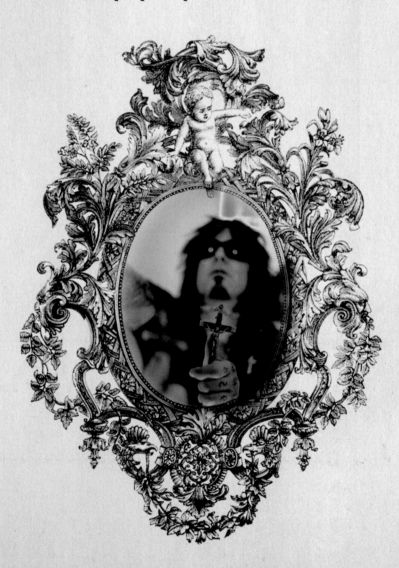

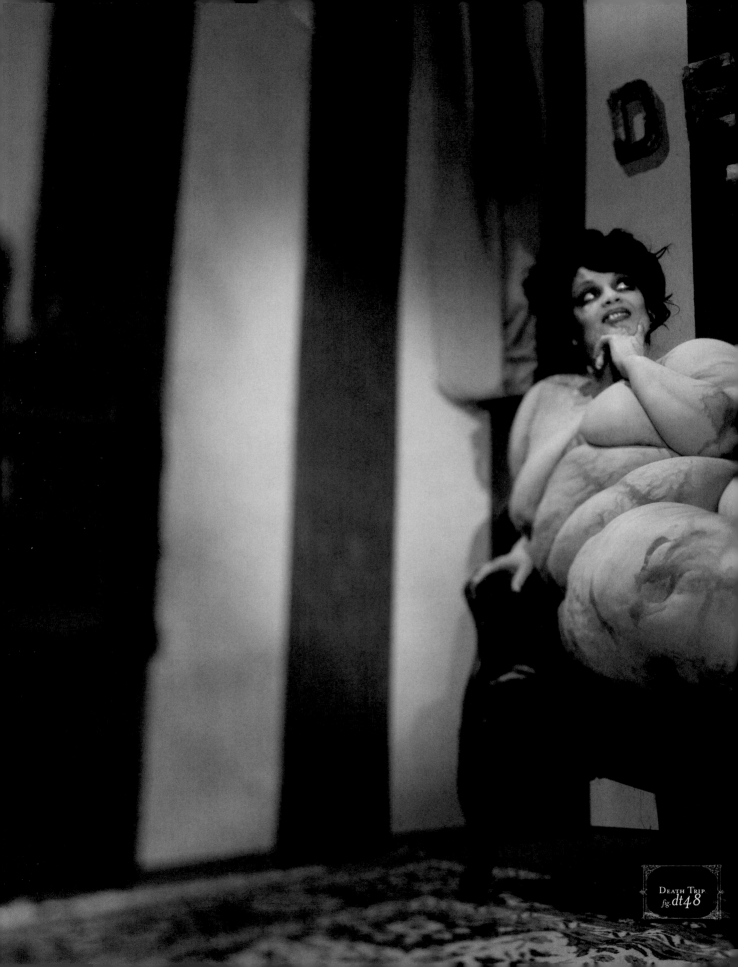

Death Trip
fig. dt48

SKIN

Paint yourself a picture
Of what you wish you looked like
Maybe then they just might feel an ounce of your pain
Come into focus
Step out of the shadows
It's a losing battle
There's no need to be ashamed

They don't even know you
All they see is scars
They don't see the angel living in your heart
Let them find the real you buried deep within
And let them know with all you've got
That you are not your skin

When they start to judge you
Show them your true colors
And do unto others as you'd have done to you
Just rise above this
Kill them with your kindness
Ignorance is blindness
They're the ones that stand to lose

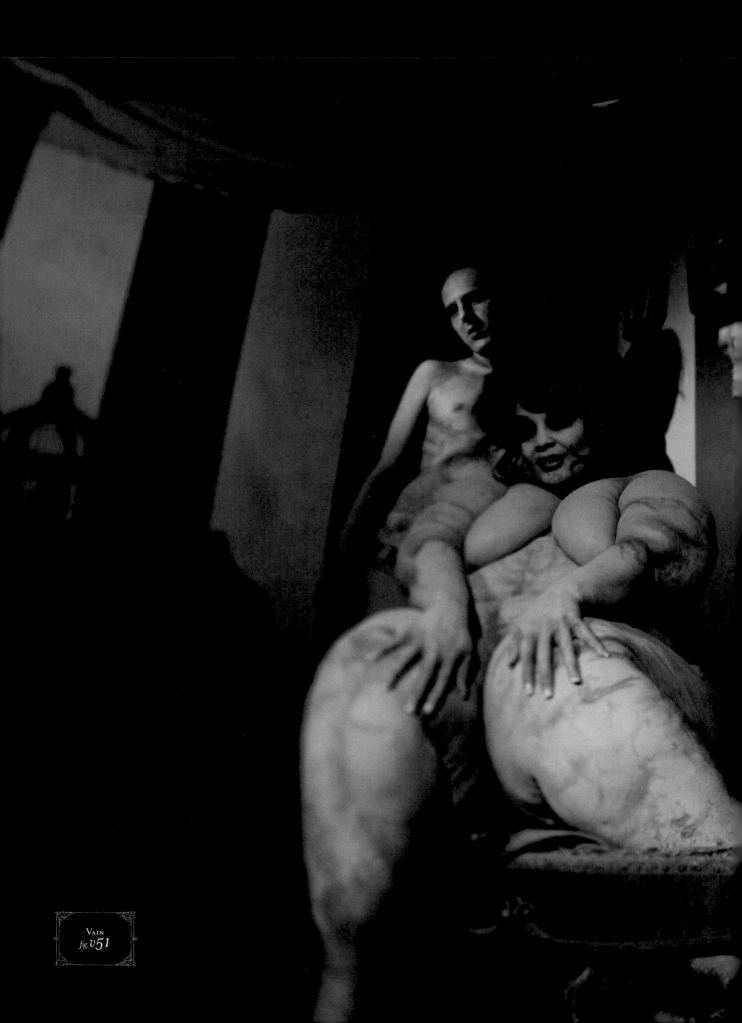

A Self-Help Mantra of My Own

Dead on arrival, overdosed on heroin, cocaine, pills, and alcohol. Dead to the world and a thousand other true stories and maybe a million clichés. Yes, I was *that* rock star with collapsed veins running up and down his arms, underweight and overinflated with ego, fear, and greed. They say I was flat on my back on a gurney, popping a wheelie headed straight to hell. I may have been damned, but I'd be damned if I was gonna die a millionaire junkie that night (or anytime soon after).

So after I crawled down from my own personal crucifixion came the awakening and finally the resurrection of Nikki Sixx. I climbed up that wooden cross years before, the weight of the world bearing down on my soul, nails and hammer in hand so I could crucify myself. I needed no help, yet I felt it was my duty to scream all the while that I was the victim. Self-inflicted nails drove deep into hands and feet as a thousand needles plunged into my arms. I would blame it on my mother, my father, my fame, and anybody or anything else in line of my adolescent fire. I had taught myself that disconnecting from society, friendship, and love was the best way to deal with my abandonment issues. I won, you lost, and I paraded the body bag of victory around for the whole world to see.

But it was me in that body bag, not anybody else.

Funny how long we can carry some of this stuff around. I mean, I don't know how much stamina you have, but a dead body is heavy, especially when it's your own.

I am without a doubt the luckiest man on earth, and I think anybody who read *The Heroin Diaries* might agree. I do not want to relive my final night too many times other than to remind myself that I am without a doubt a drug addict and an alcoholic. Yes, I am in recovery from my disease, but what I really get high on is my recovery from being an asshole.

At times I've wondered if that isn't the core of my disease anyway. Once I didn't drink or do drugs, I still needed to resurrect and eject the poison from my soul and my brain.

Recovery comes in many forms, but for me it mostly comes in gratitude and awareness. We use these to mirror our lives and hope it rubs off on the nearest passerby.

We live by example, and here are a few that have been negotiated in my brain since sobriety. Either that or I have stumbled upon them accidentally in the last few years. Whichever, these are my own personal principles to live by.

1. You can always renegotiate your life.

Nothing is written in stone until you die. You absolutely can renegotiate with yourself. You are allowed to change your mind. At any given time. Meaning:

You don't need to live where you live.
You don't have to be unhappy. (Nobody is holding a gun to your head.)
You don't need to stay married if you want a divorce.
You don't need to keep up with the Joneses and you don't need to feel bad about not liking where you have ended up in life.

Just renegotiate and change the facts.
Or, in other words, grow some balls.
Get on with it already. If you obey every time someone says you can't do this or you must do that, you will become the person you
NEVER WANTED to be.
Simply renegotiate.

2. Love the ones who hurt you.

Love those who hurt you the most, because they are probably the ones closest to you.

They, too, are on a path, and just like you they are learning to walk before they can fly. Imagine if everybody you hurt in life turned their backs on you? You would be playing a hell of a lot of solitaire.

Love them no matter what.

3. Be inspired by all walks of life.

I will open a book, any book, on any given day and turn to a random page. Blindly point and start to read. I will finish a paragraph and then stop. That will be my inspiration for the day. Dictionaries are wonderful for randomly finding new words. Use it and you will be inspired, and you will inspire others.

I wake up and the first thing that pops into my brain is "I can't wait to see what happens today!" I am always amazed at the little adventures that happen next. I used to miss these moments because I was so up in my own head that I couldn't see what was happening right before my eyes. Now, I'm always ready to be inspired. And when that happens, a lyric or an idea for a photo usually come to mind.

4. Pay attention to your instinct.

A killer instinct will save your life. Instinct will navigate you through life until the final bell rings.

Learn to trust it. It is your friend.

Shut out the noise in your head and you will hear what your gut is telling you. Instinct never lies. Though sometimes your head does. I know we all have the ability to tune into ourselves. Some of us use it to our advantage and some use it to other people's disadvantage (yes, I'm back to the killer's instinct analogy, but can't that be positive, to know that monster inside of you?).

5. Don't neglect your death.

Need I say more? OK, I will. Without living life to the hilt, death will be a huge waste of time. (That's sorta funny, actually.)

Don't waste your death on a half-assed life.

Go for it.

Be a rock star or a plumber.

Be an athlete or a TV repairman.

Live on an island and sell hot dogs, or live in New York City and run the biggest investment bank in the world.

Do what you want. Not what your mom, your wife, your dad, or your friends want.

If you truly are happy in what you do, you're gonna kick the living shit outta life, and death will be a happy, well-earned sleep.

Every word I read, every breath I take, every moment of every day always somehow inspires me and eventually turns into a song or a photograph. Either the ones in these pages, the ones in my vault, or the ones in my head that I haven't shot yet.

Are you feeling inspired by your life? It's funny what can inspire you. The fateful night of my near-fatal drug overdose years ago, and my recovery, have shown me how fragile life really is. I love to pass on my passion for it whenever I can and show people how to squeeze every last drop outta life.

Again I ask, are you feeling inspired by your life?

Why I Invited You Here | Look Thru My Cracked Viewfinder | Life's Not Always Beautiful | Ghosts Inside Me | This Is War | One Man; Two Bands | Killer's Instinct

Help Is On The Way | Tale Of The Siamese Twins And The Black Rose Tattoo | Rock N Roll Will Be The Death Of Me | The End, Unless It's The Beginning

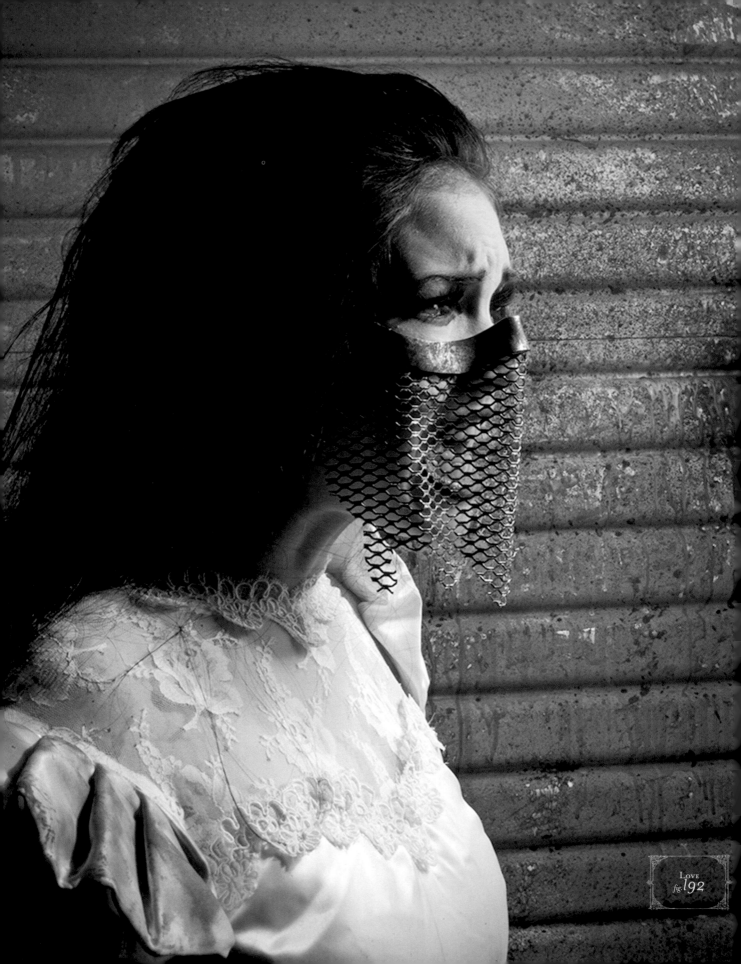

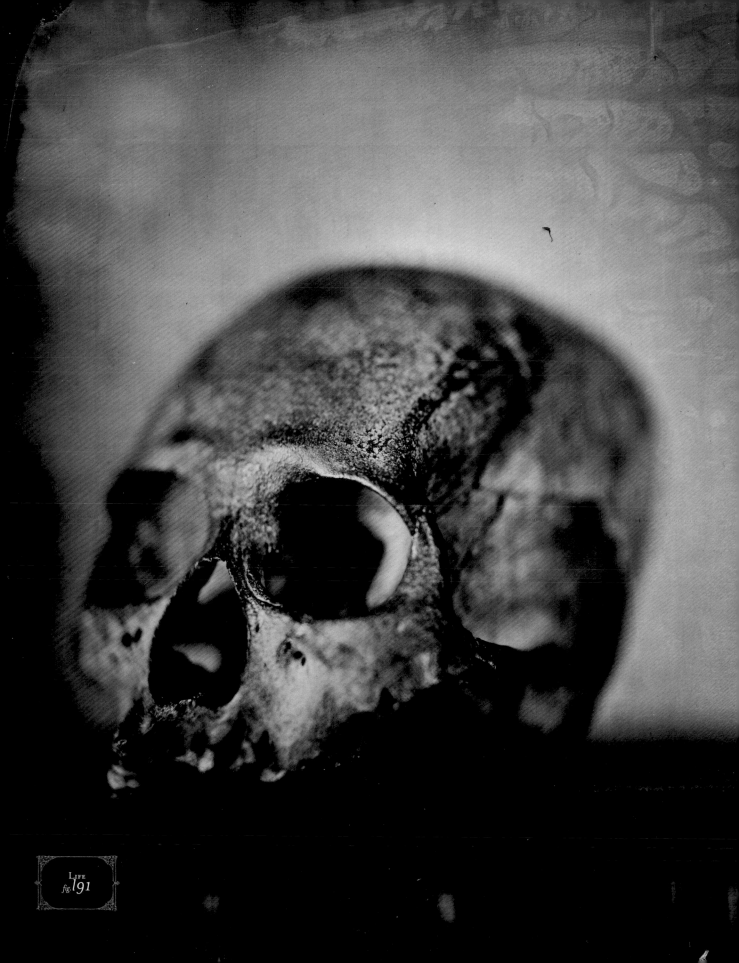

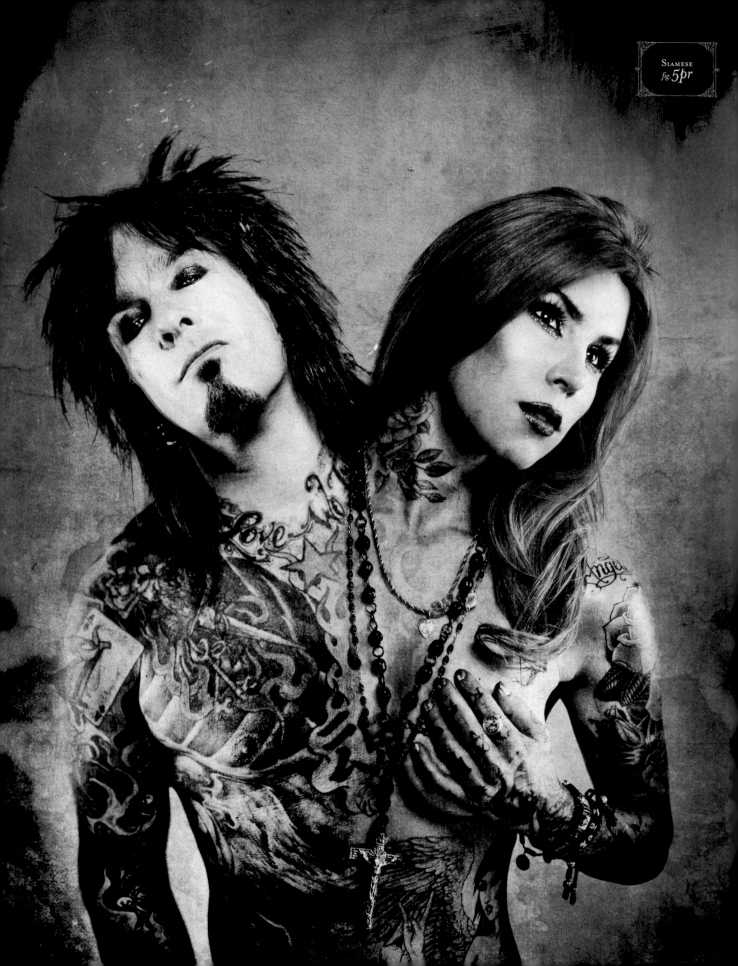

TALE OF THE SIAMESE TWINS
AND THE BLACK ROSE TATTOO

My first tattoo was a black rose on my right arm. The year was 1981.

Years later, a friend named Pearl Aday (Meat Loaf's daughter) asked if I wanted to meet a tattoo artist named Kat Von D. She said we were so much alike that even if it wasn't a love match, we would be great friends. I said, "No thanks, love stinks," but took her number anyway. Maybe someday I'd need another tattoo.

Katherine von Drachenberg was unattached at the time, not that this was the point. I never called her, nor she me. But I did text her here and there—friendly, nothing more. I found her witty and interesting, and we were in the buddy zone for sure.

Divorce completely eats up your time (and money) and I was knee-deep in it, as well as in *Heroin Diaries,* both book and album. Royal Underground, the clothing line I had started, was growing slowly and needed tons of love. Unlike me. Or, if I did need love, I didn't notice. My family always comes first, then work, then me time. And there definitely wasn't any extra time on the clock then, for me or anybody else.

So one day I was texting Katherine (as I call her). At this point she was happily in love with a boy, but even though she and I still had not met, I sensed something was wrong. I asked if everything was OK and she did as she always does, saying, "Everything is fine." I knew it wasn't, and yet I also knew it wasn't my place to probe.

A few weeks later I planned to finally visit her shop on La Brea in Hollywood. I had heard what an amazing tattooer she was, truly one of the world's greats, and, being a lover of fine tattoos and artists, I asked her if we could collaborate on a design for me.

Why I Invited You Here · Look Thru My Cracked Viewfinder · Life's Not Always Beautiful · Ghosts Inside Me · This Is War · One Man, Two Bands · Killer's Instinct · The End, Unless It's The Beginning · The End, Unless It's The Beginning · Rock N Roll Will Be The Death Of Me · Tale Of The Siamese Twins And The Black Rose Tattoo · Help Is On The Way

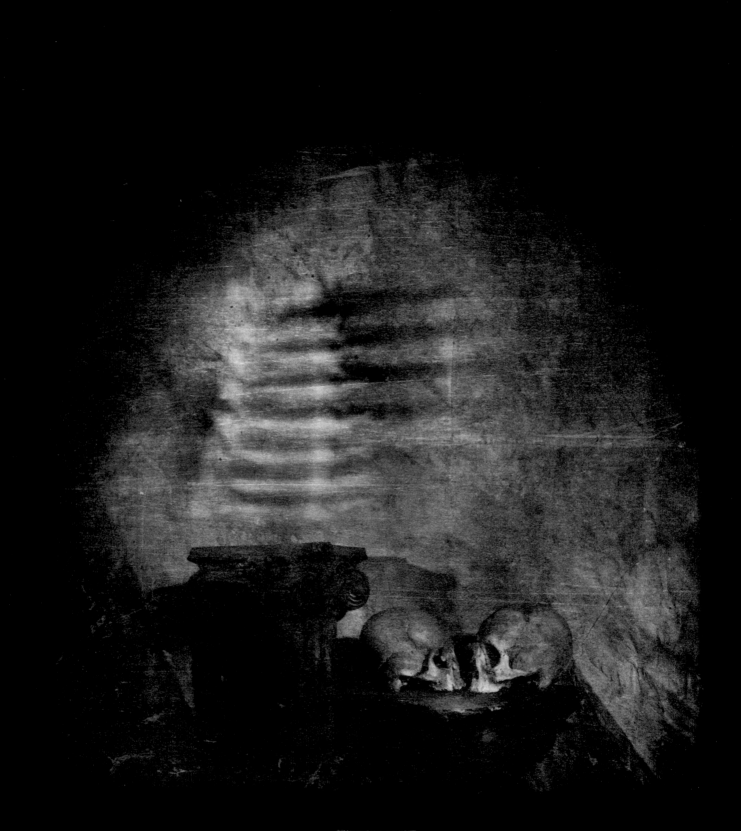

TILL DEATH
DO US PART
fig. ny291

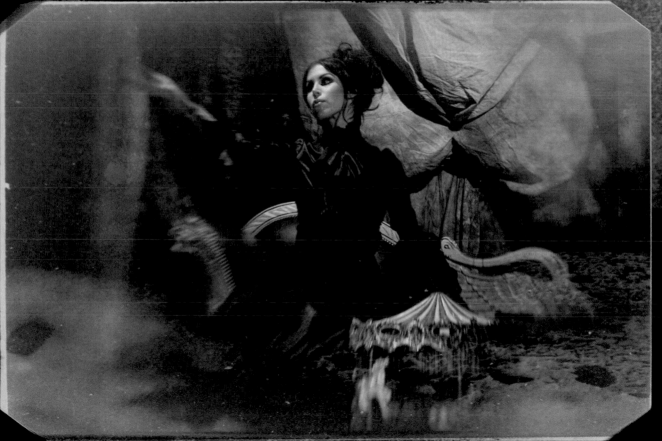

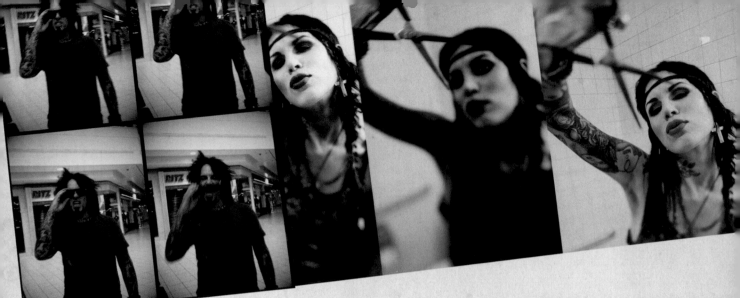

Dj Ashba and I had spent the day at a music convention, signing autographs and looking at new recording software. The convention center hot dogs and Red Bulls were wearing off fast, and we were starving. A few quick text messages to Katherine while we were heading up the 405 and dinner was set. We would pick her up at her shop and head to The Lodge in Hollywood for steaks galore.

This was the first time I had met her face-to-face, and the first thing I noticed was how beautiful she was. Striking like a movie star from the '40s coupled with a tall and imposing presence. We had become friends through technology, and I had no intention of it being anything else. I do not believe she did either. She had a boyfriend, and I had a huge mistrust of women. It seemed like a friendship forged in perfection. Dj will tell you sparks were flying but I didn't see any. I am also blind as a bat when it's convenient.

At the restaurant, sitting with her and Dj, I pulled out my business card and handed it over.

I had grown so sick of people asking me, based on how I look, if I were "in a band" that I just would say, "No, I am a tattoo artist." At first, people would go "Oh," then shrug and wander off, uninterested all of a sudden. That worked until *LA Ink* and other tattoo shows started popping up on TV. People began equating tattoo artists with celebrity and would ask me where my shop was or if I was on a show. Some even had begun to ask if I had a card.

So, long before I met Katherine, I had some business cards made up that said:

God's Tattoo Shop
"Get some god under your skin"
GOD, *Proprietor and CEO*

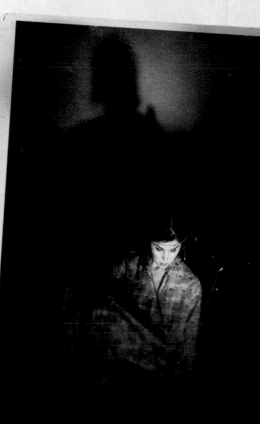

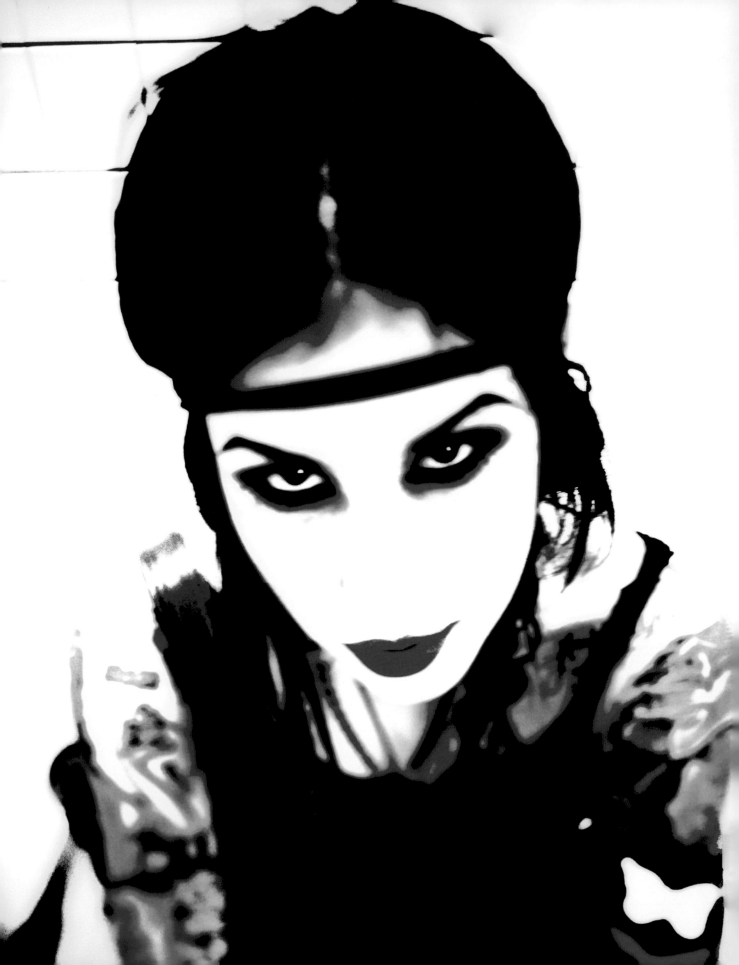

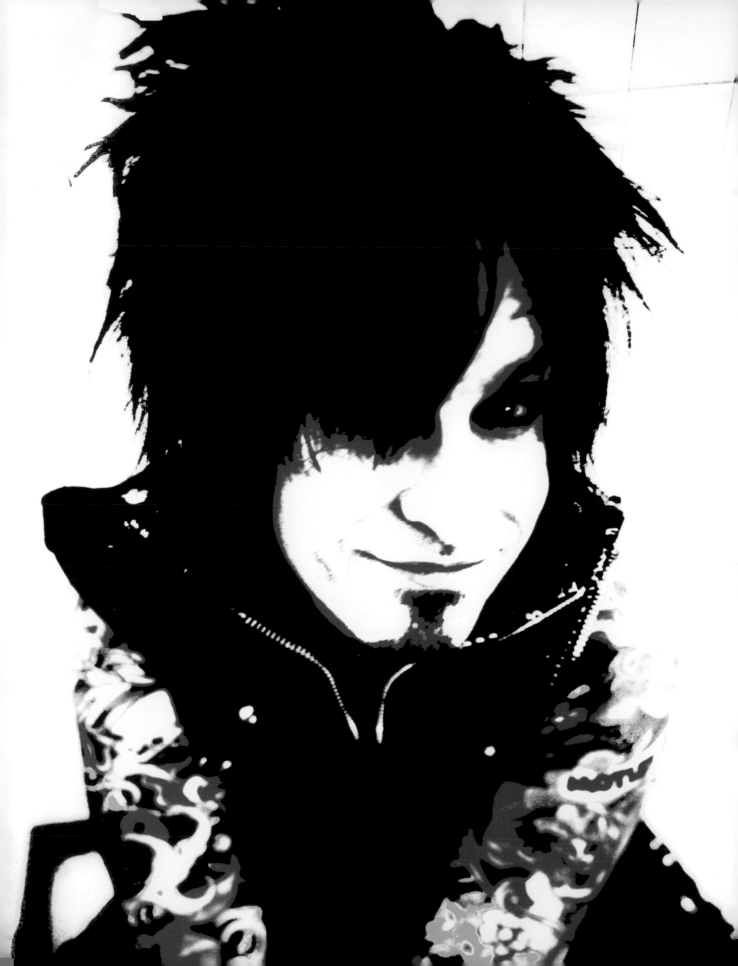

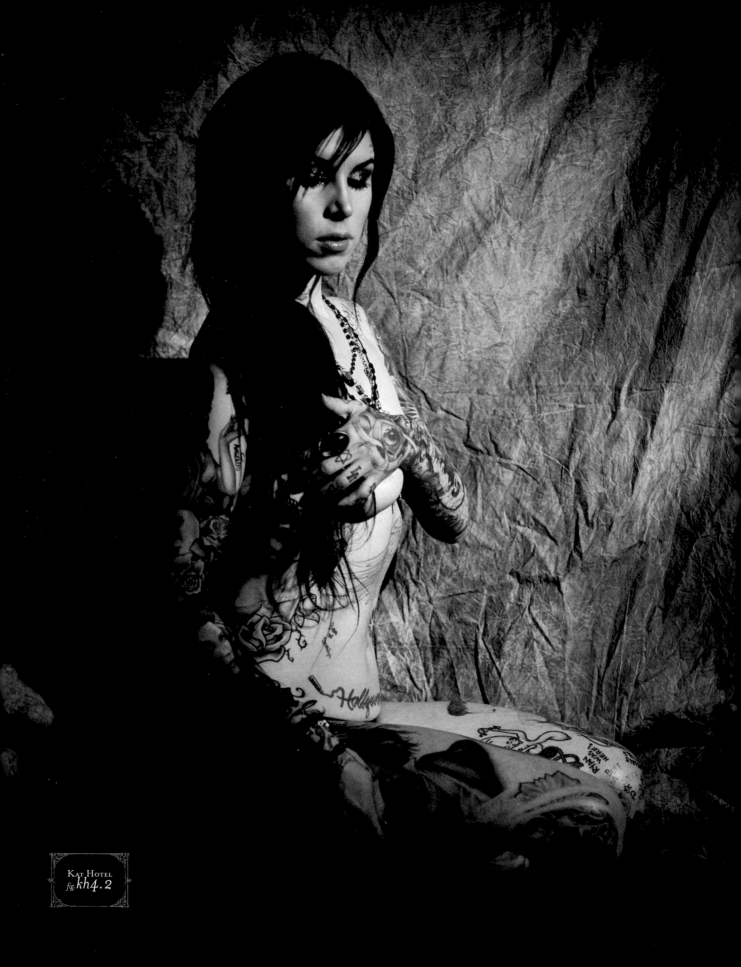

KAT HOTEL
fig. kh4.2

There were two phone numbers, one East Coast, one West. Both connected to a voice-mail message that said, "The person who gave you this number never wants to see or hear from you again" or something like that. My thought was that if you're too stupid to get the joke, you have it coming. I thought it was clever.

She laughed and said, "One problem. The picture on your business card isn't God, it's Jesus."

I said, "Aren't they the same guy?"

Dj just scratched his head. Sparks, maybe.

I asked if she was up for inking my tattoo idea. She said yeah.

But I still didn't know where on my body I wanted it. The tattoo was to be a handwritten prayer:

God, please forgive me for my sins . . .
And the ones I am about to do, too.

She said if I wasn't sure where I wanted it, then we should hold off until I figured it out. I thought she was right but was somewhat taken aback by this young filly telling me what to do. We ate our steaks, laughed a bunch, broke the ice.

After dinner, I dropped her off at her studio, and Dj and I drove away. We were in the middle of recording the *Heroin Diaries* sound track and needed some beauty sleep before our morning session the next day.

I remember driving home thinking that Katherine von Drachenberg seemed like a very cool person.

Months and months pass, we're busy as bees, building empires and masquerading as vampires. Having a go-to text buddy who got my dark, demented, self-loathing humor was cool. Someone who mentioned artists I had never heard of and was too busy to hang out most of the time. Funny as it seems, she was exactly like me. I never really had a female as a friend before so this was uncharted territory. I didn't know it was possible. I remember the day she said she broke up with her boyfriend and my first thought wasn't "Fuck, yeah!" It was more like concern. I didn't plan on trying to date her. I think we both just planned on hanging out. That lasted until the night we decided to go to a movie at the Arch Light in Hollywood.

I picked her up at her studio and we drove off, excited to see *There Will Be Blood*. I told her I hadn't seen it because, to be honest, I had

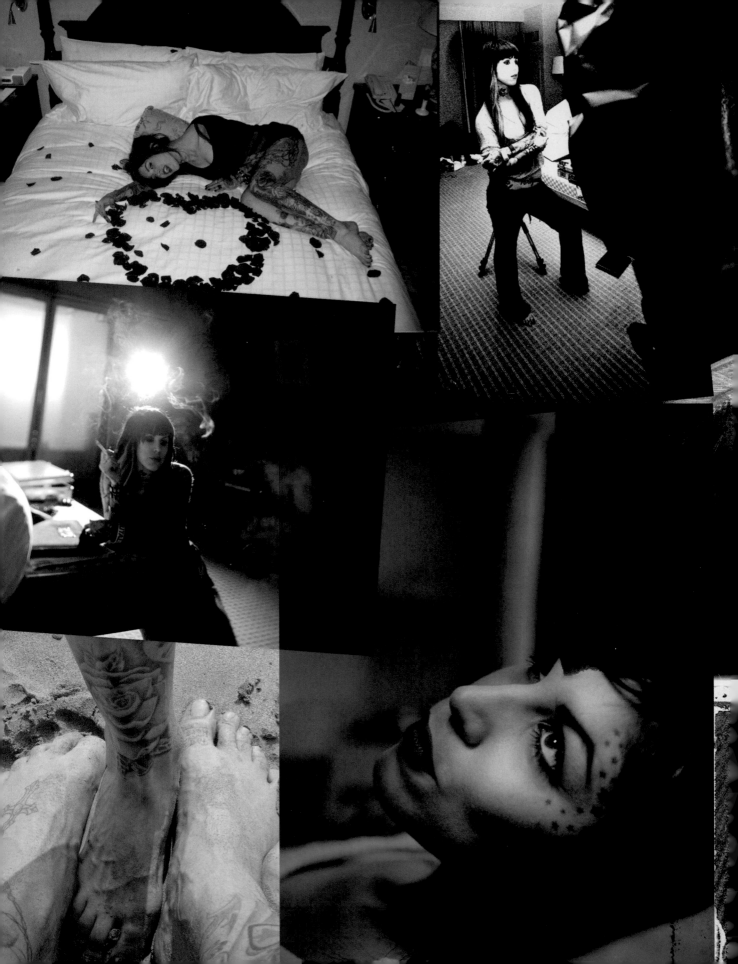

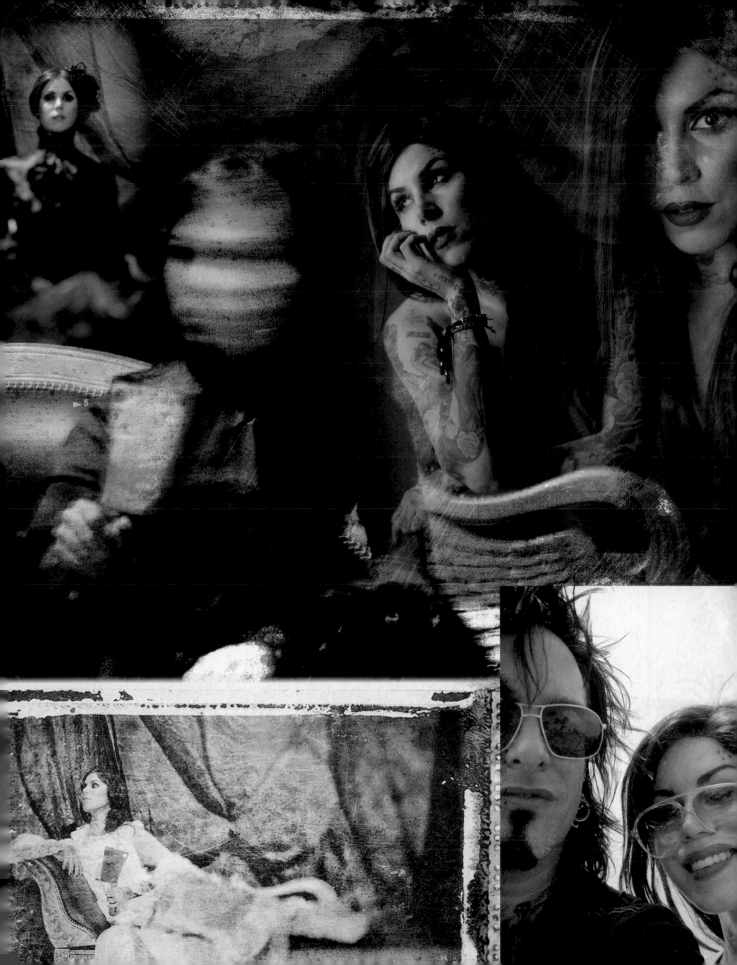

only seen half. I figured half a lie was not really a lie. Ahh, to manipulate the situation in your head is something we men are all so grand at doing.

So, guilt free, we went ahead and parked and then it happened, by accident. We were walking toward the theater, and my hand somehow landed in hers. That uncomfortable feeling of "What is (he or she) doing?" blushed over us. It felt like fire running up the inside of my arm, and I took the pain, excitement, or confusion in one full gulp. Down the hatch, smoke shooting out of my ears, and eyes rolling around in the back of my head like black marbles.

Oh, shit, said my heart, *now what?*

After the movie we headed back to her shop. I came in to hang and for some reason only known to my heart, I tried to kiss her. In response, she tried to karate chop me. I laughed. What the fuck? That was a new one.

So I lurched forward and that was it. I could go on and on. That day, we laugh, I lost a leg and she lost an arm. In our broken little way of seeing life, that is romantic to us. She bought me a prosthetic leg once to remind me, and I still get goose bumps when I remember that first kiss. I think of us as Siamese twins. So close we are one and the same. Sometimes when you're that close you fight and get on each other's nerves. Sometimes you are willing to die for the other to live. This is how I want it to be. All or nothing. Giving, breathing, and exhaling magic.

Life is full of twists and turns and surprises. I am sober today, and if I hadn't been, if I hadn't changed my life years ago, if I hadn't been willing to face the demons, then I wouldn't be so lucky to love an angel now.

Katherine von Drachenberg has changed my life. She has inspired me to be more than I believed was ever possible. She has listened to me as if I am her muse, and I have swallowed her words and experiences much the same. She supports me as a father, knowing it is the most important thing in my life. She told me she would never lie to me and I could trust her with my heart, and I knew it was 100 percent true. At that moment I let down my guard, which had been tightly in place for years.

All these wonderful experiences are happening right now because I allowed sobriety and spiritual growth into my life. Thank you for letting me gush about her. If I am gushing over something so magnificent, it is my hope that you are gushing over someone or something, too.

Love is grand...
Love is the reason...
Nothing else really matters.

My first tattoo was a black rose on my right arm. The year was 1981. It seems like a lifetime ago. In fact, it was.

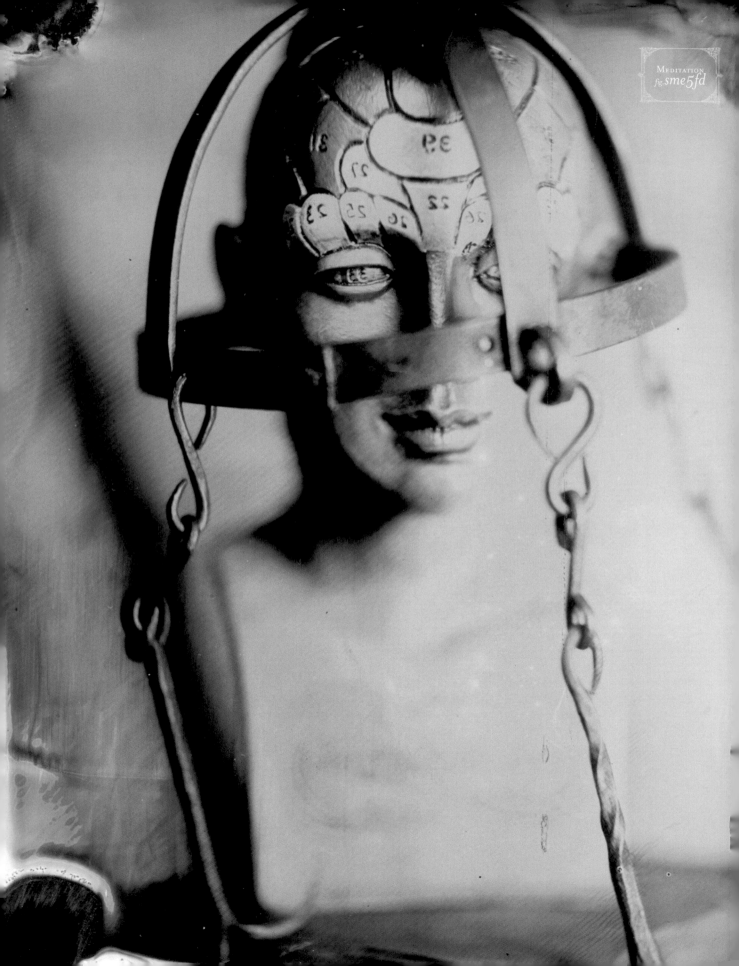

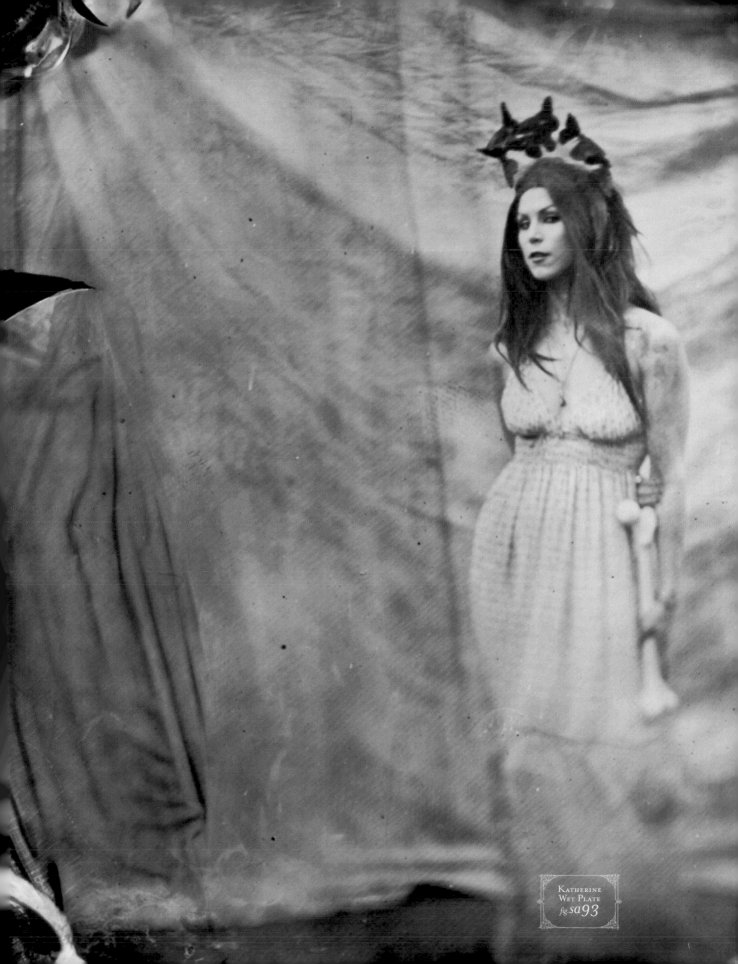

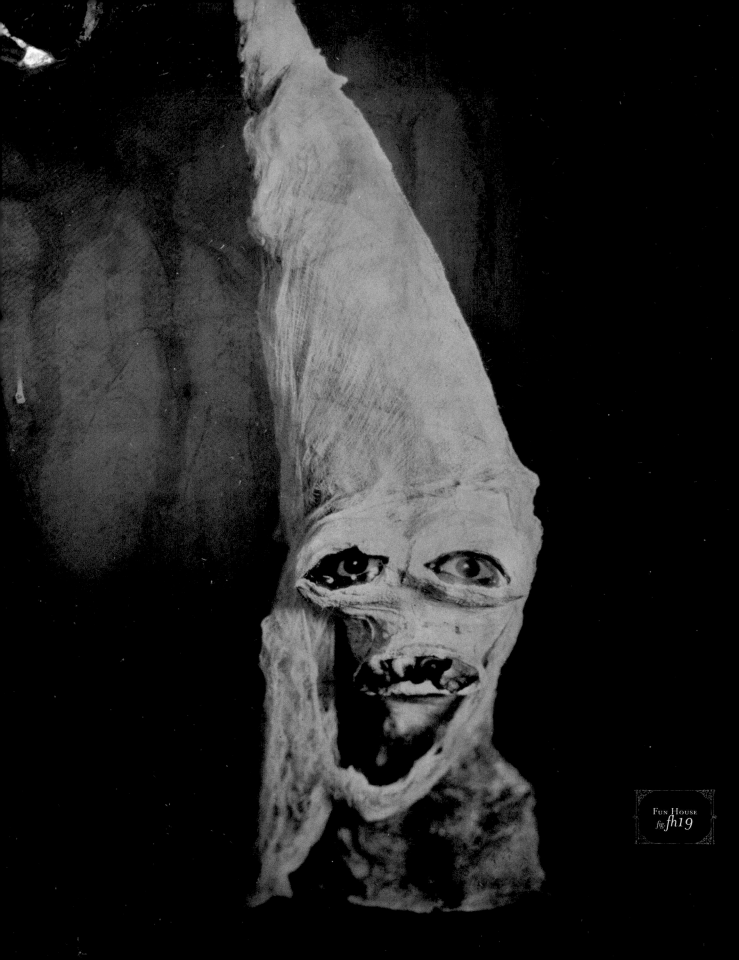

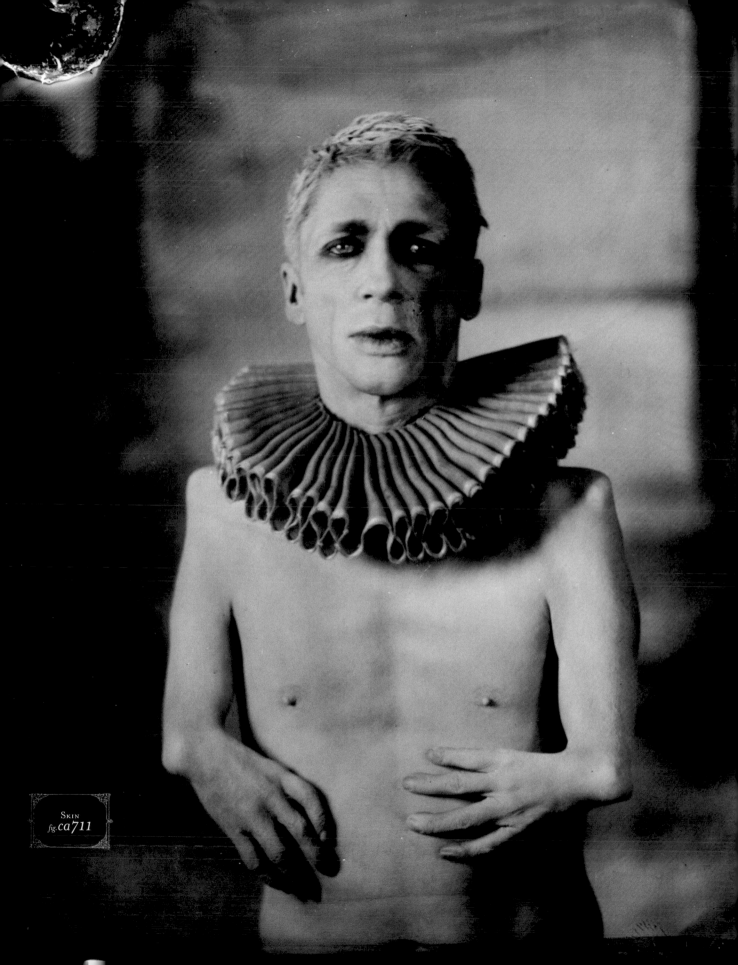

Skin
fig. ca711

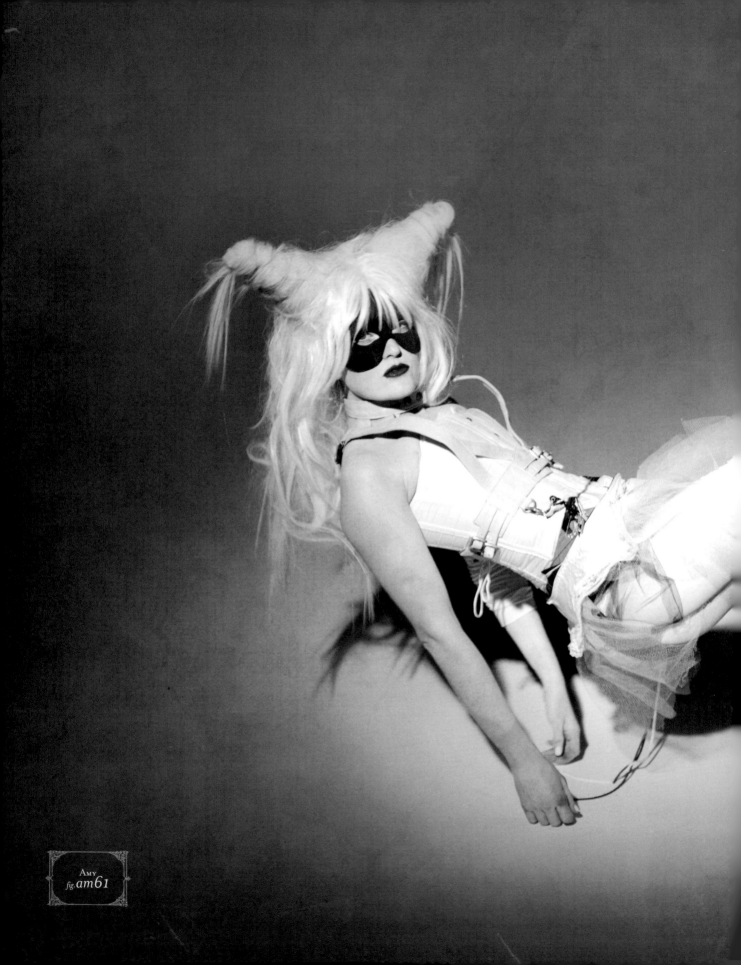

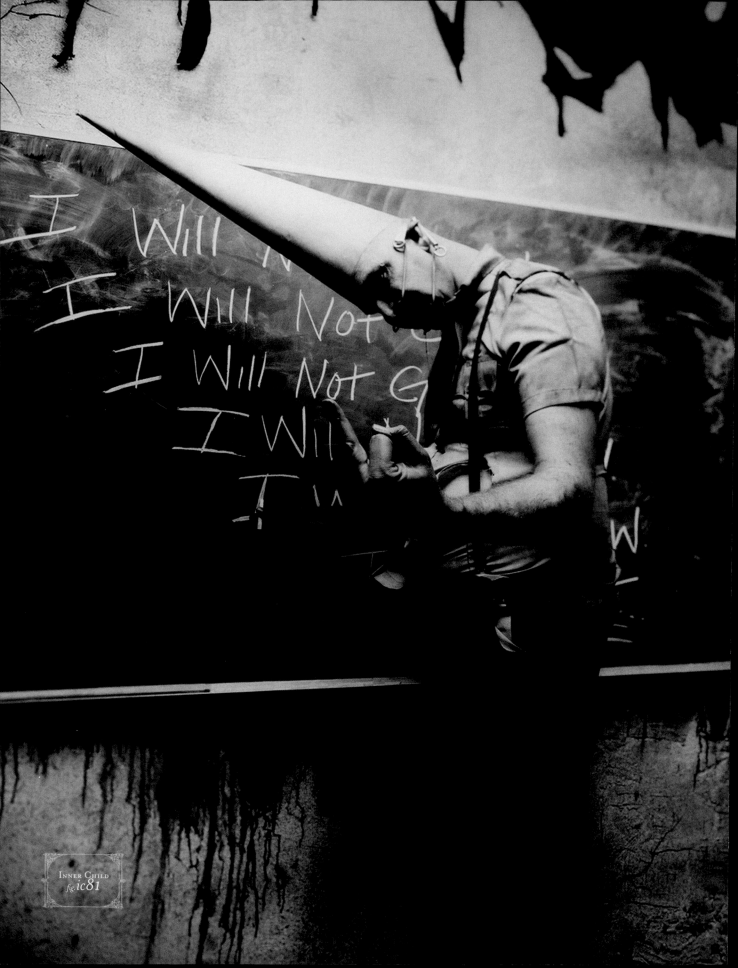

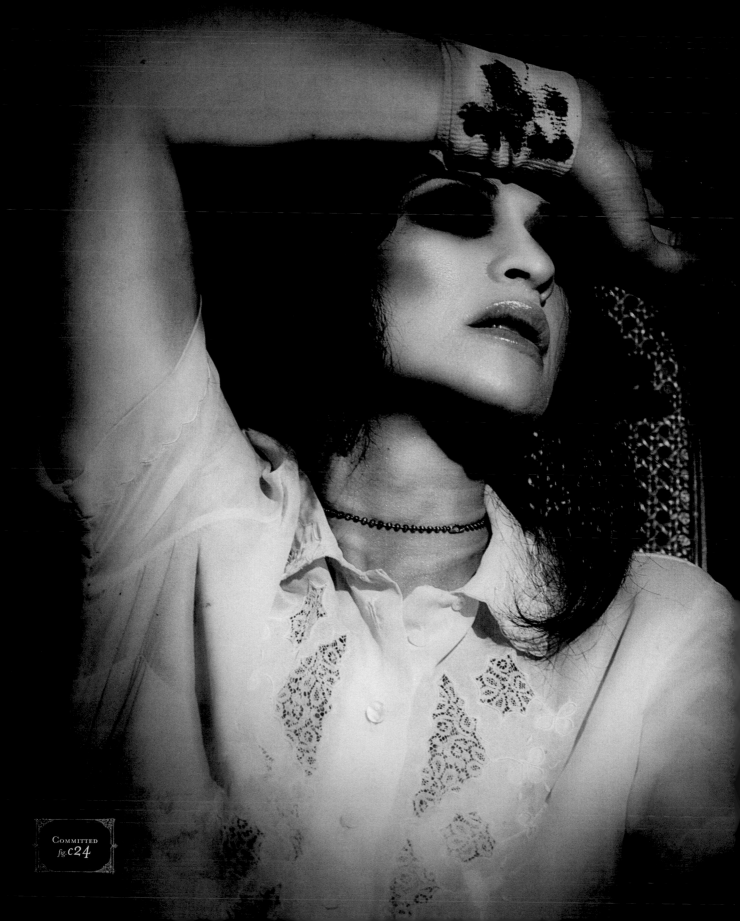

COMMITTED
fig. c24

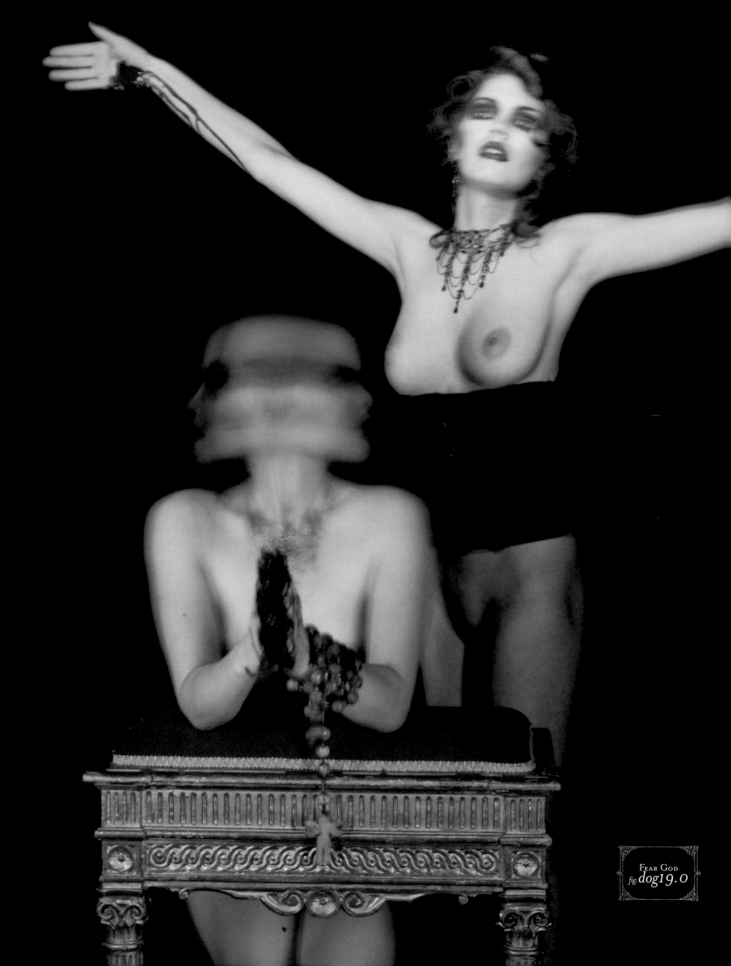

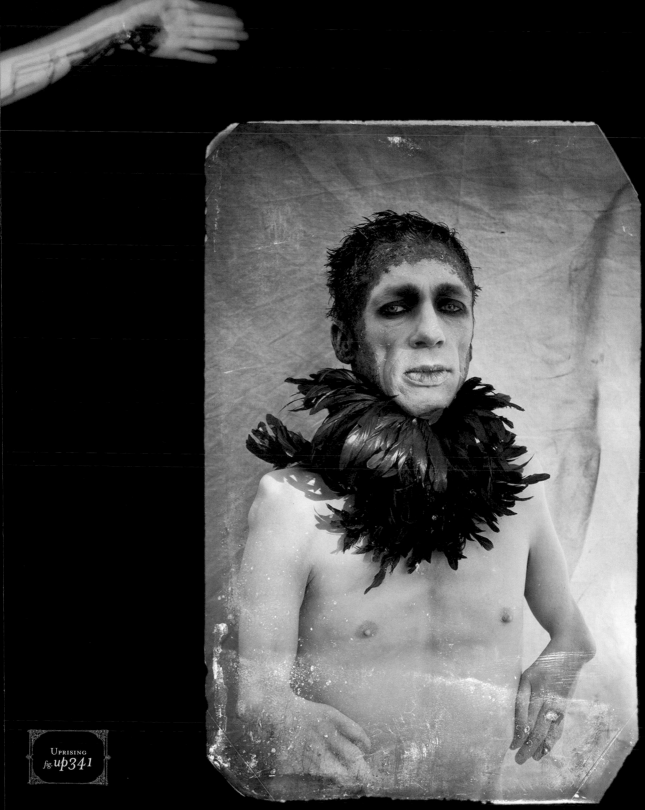

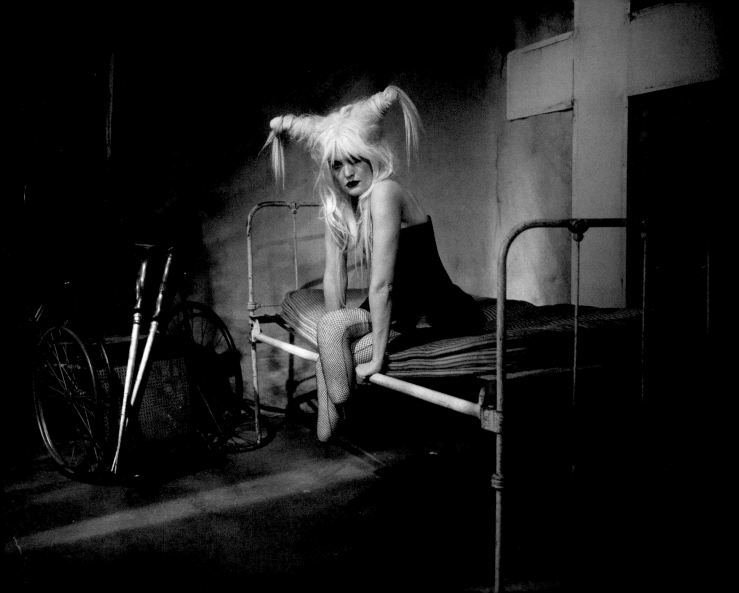

WEAKNESS
fig. 319w

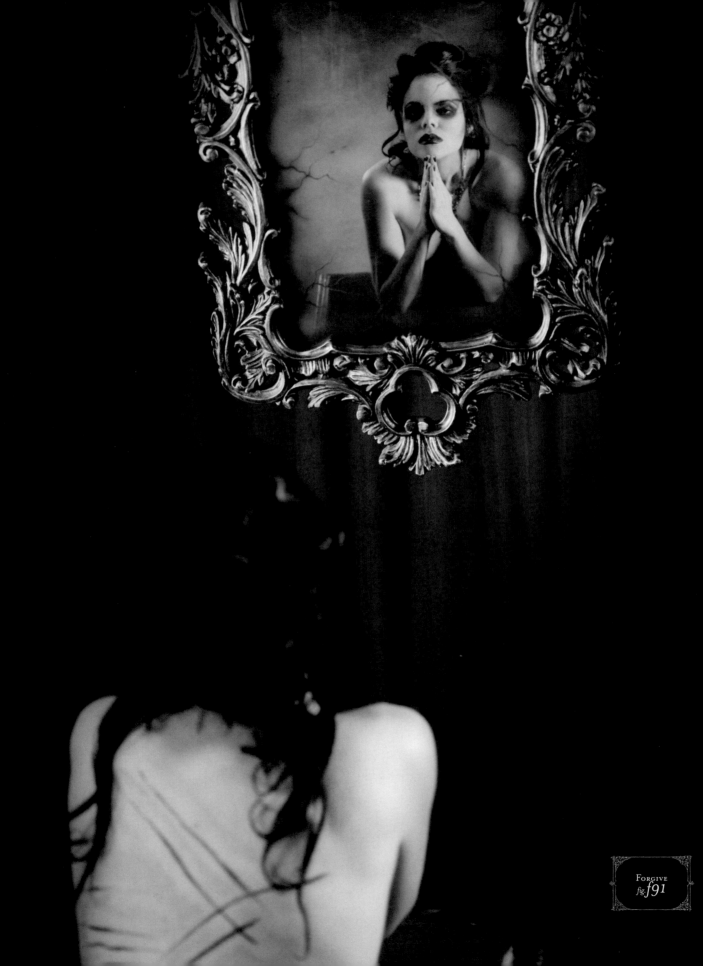

Forgive
fig.f91

Forget
fig. 8f?

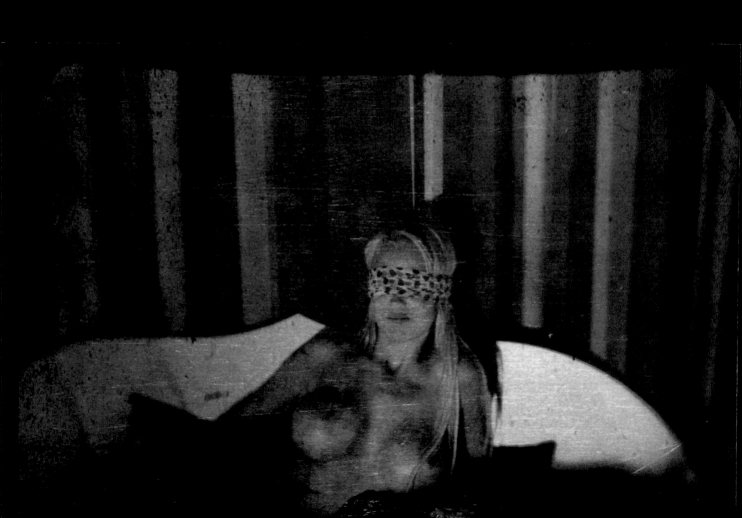

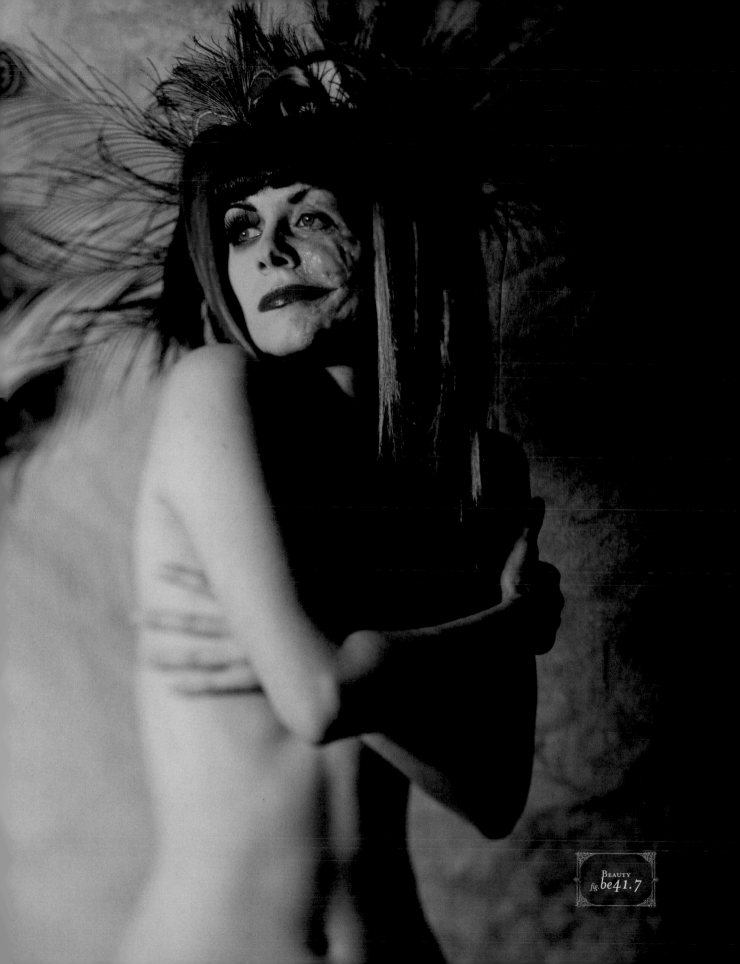

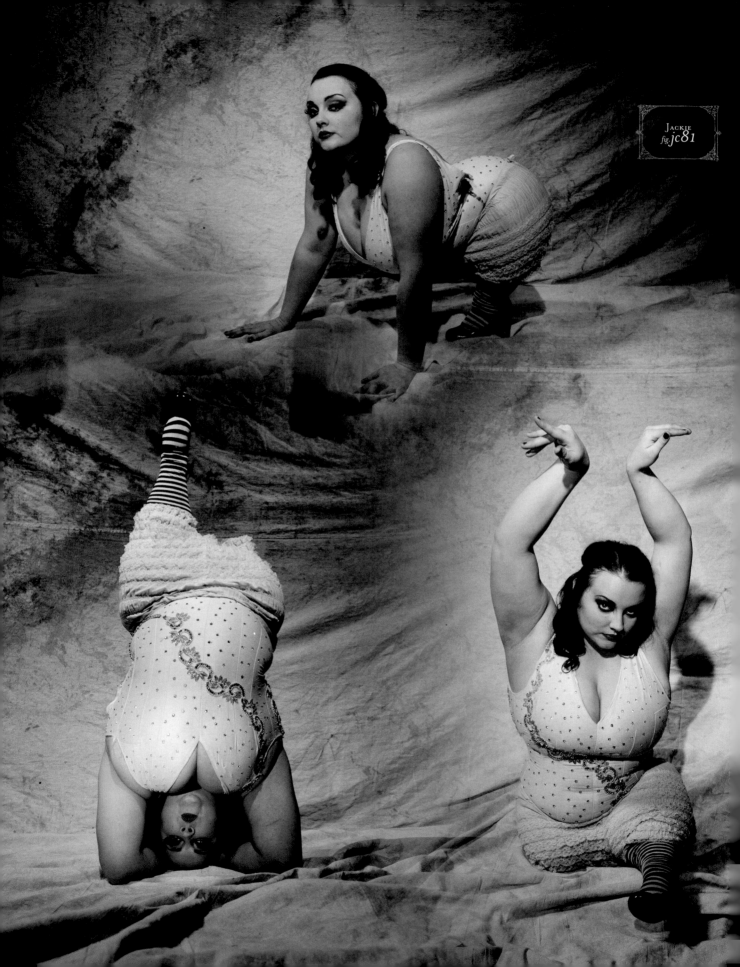

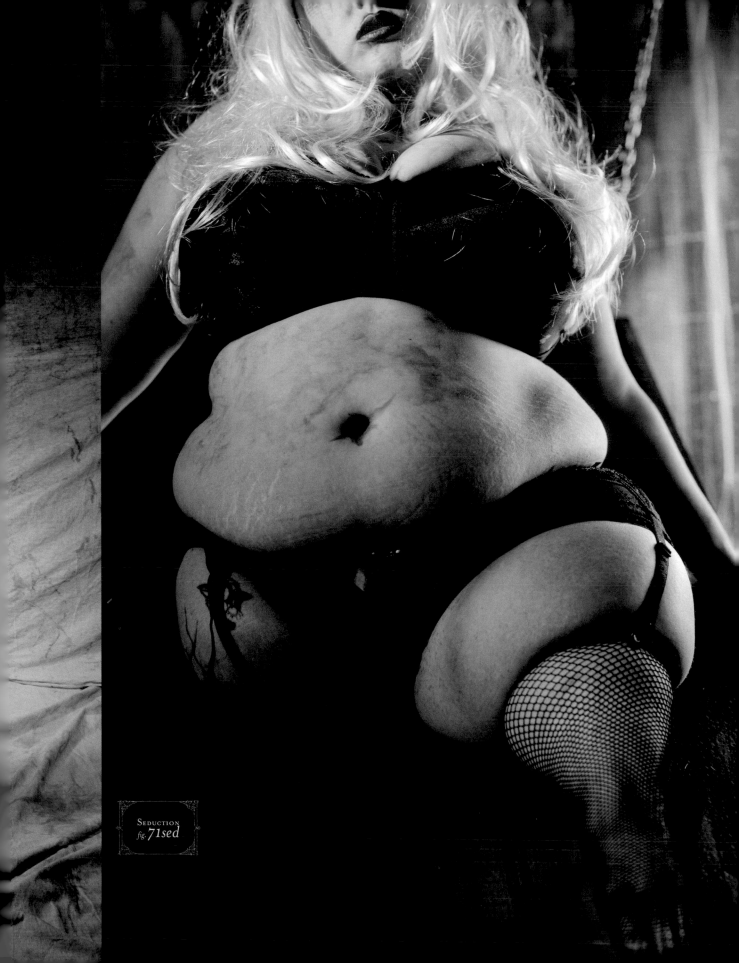

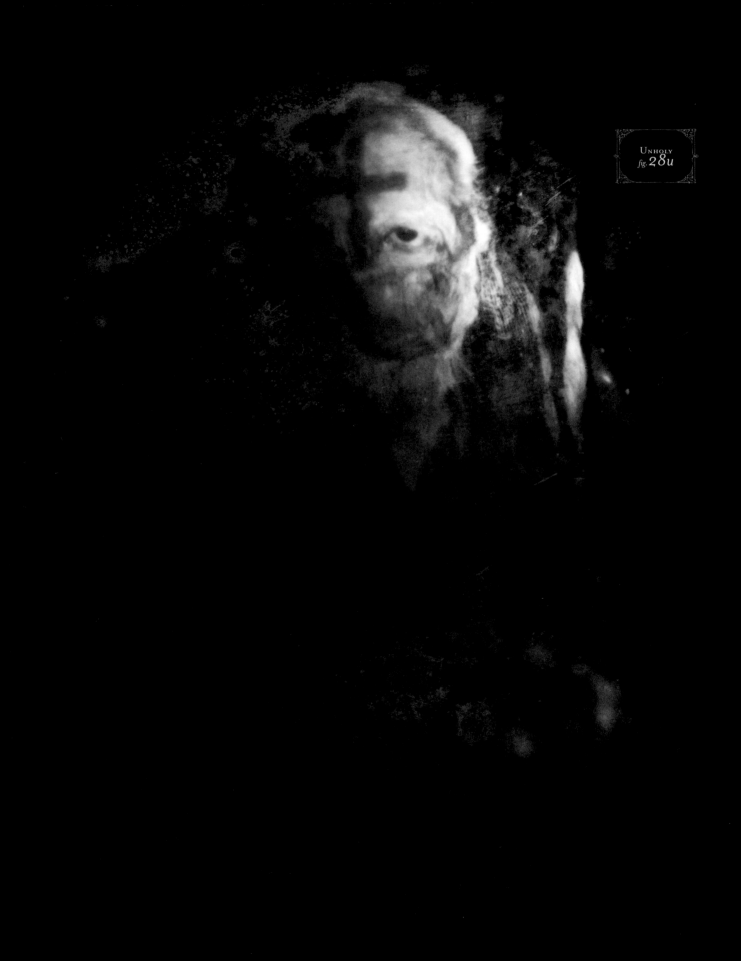

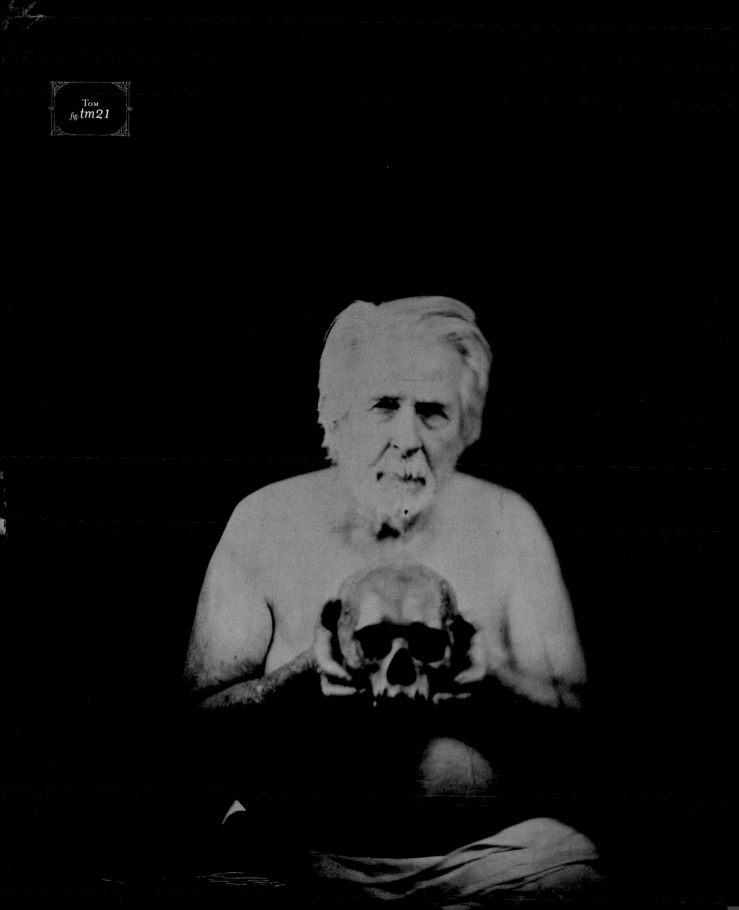

VI

ROCK N ROLL WILL BE THE DEATH OF ME

"I do not wanna go" is all that could be heard for miles around as I spoke into the phone.

"This is a band, and bands are more than one," I heard back into my earpiece. "You have one vote, and sometimes it just plain sucks to be outvoted, Sixx."

"Choose one," I said. "Either we go to Europe or we do our American Crüe Fest 2, but I'll be damned if I wanna do both."

Especially not with just nine days between them, I didn't. I am not in my twenties, high on fame and drunk on money. I don't need either one and so I was putting my foot down firmly, some might even say stomping it.

Fast forward: October 2009.

It's chilly outside and everybody is still asleep. I just put a fire on, to match the radio that's been on low all night. Coffee in hand, I write. It's a Sunday and life is perfect right now.

As I sit here I know I have all my kids' unconditional love and they have mine. I know nothing will happen to them in this life or once I am gone that they cannot handle. I work harder and harder every day to make sure of that. Little lessons and messages I hand out to them like Halloween candy. The biggest gift I can give is listening to how bad it hurts when they fall down. Not always saving them, maybe just holding them, emotionally and physically, too. Being a father is the biggest challenge and greatest reward I ever have received.

Nothing compares to this.

I promise you this: if you're not a parent yet, with the birth of a child comes a haunting of your mortality.

It didn't happen upon my first child's birth but soon after. That's why there are wills and trust funds. After the diapers are gone, "We the Parents" have to still cover their asses.

We the Parents of the United States of America realize what we never knew before: not everything is about us, and there is a reason to be alive other than our own needs.

Note to self: get back to writing book.

Sometimes we have to do things we don't want to do. Not because they're too hard to handle or because someone is holding a gun under your chin. Because that's life.

Life is not always about you, as hard as that is to guzzle down.

"Ego is just fear in action," I've heard slurred so many times at AA meetings. As I like to say, "Your ego is not your amigo."

My ego was in high gear the day of that phone call. "I am not going on tour," I said, but such grandiose statements almost always fall short. You end up feeling defeated because you couldn't cut the head off that poisonous snake, your ego, no matter how hard you swung the machete.

Ego overtakes the idea of God.

I say the *idea* of God, because I have a hard time with "God." I like to say "my understanding of a god," or my higher power, something bigger than myself to believe in. Karma even falls under these Sixxism-type guidelines.

A sliding scale of your spirituality is better than a complete, grandiose statement that nothing exists other than yourself. Earn it as you learn it. Fake it till you make it. Shake it but don't break it. (OK, not that one, but you get the point.)

Note to self: stop rambling.

I did go on that tour of Europe. I did then return home for only nine days with my family and Katherine before leaving them again for the American Crüe Fest. I didn't like it, but I am part of something bigger than myself. I did it with a good attitude and to be honest, as hard as it was, I had a good fucking time.

Last note to self: think before you pull the trigger. The head you blow off may be your own.

Here are some of the ramblings I committed to my journals during those two tours.

Europe Goes to Hell
FLIGHT TO MOSCOW FROM LOS ANGELES
MAY 30, 2009

There is something to be said about having a simple deck of cards, a quiet moment (maybe at sunrise or sunset), and a vigorous game of solitaire.

Now, I am being partially facetious but, at the same time, honest and introspective. Just take a moment to look at this through the eyes of a trailer-park-trash high school dropout world-traveling Zen-type O-negative (and positive), grade AAA personality.

You have to go out and get yourself a deck of cards. Hopefully, they will already be well worn, but new is good too. In the end, all that really matters (whether they're those cheesy strip poker cards or a standard deck from your local 99-cent store) is that you have fifty-two cards.

I used to play with my grandmother's cards every day after school, and one day I asked how many cards were in a deck. She said, "There would be fifty-two if you hadn't lost ten of them building that house of cards." So there we have it. She gave me unconditional love even when I lost ten cards from her favorite John Deere deck. That meant I had been playing the game all along with no chance of winning. She knew that the whole time. That woman was wise. She was so wise that she probably knew she would be teaching me this lesson thirty years later, once she had graduated to the next level.

OK, so now that I am older, I get it. (Thank you, Nona.) I see that it doesn't matter if you win or lose in solitaire. It's the game of repetitiveness that untangles all that is in you and is balled up into a sphere of stress. Unnecessary anger, scattered thoughts like a random, out-of-control, emotional roller coaster that rides through your mind, or the need to be more than you need to be.

Solitaire says, "Stop, enjoy the kiss, the sweet succulent flowers, and your child's smile or the roar of a plane overhead, even sirens in the distance. Life is just life."

I like getting to that place in life, that perfect moment in an imperfect world. Being in a moment is not easy, because we make it that way. This is not hard work, even if at times it hurts to just be in the moment.

I could go on for hours, if you're still awake. So, just in case

WHY I INVITED YOU HERE | LOOK THRU MY CRACKED VIEWFINDER | LIFE'S NOT ALWAYS BEAUTIFUL | GHOSTS INSIDE ME | THIS IS WAR | ONE MAN, TWO BANDS | KILLER'S INSTINCT

HELP IS ON THE WAY | TALE OF THE SIAMESE TWINS AND THE BLACK ROSE TATTOO | ROCK N ROLL WILL BE THE DEATH OF ME | THE END, UNLESS IT'S THE BEGINNING

you're zoning out, let me take you back to the rough-and-tumble world of solitaire! Do you have your cards yet?

First, you lay them out before you, and immediately it seems like you're facing an impassable enemy. An army of suited-up warriors ready to defend their ground and take yours if need be.

And then it starts, the war, the battle. Somebody is going down and you pretty much know the cards are stacked against you. After all, if you're lucky, there are fifty-two of them and only one of you. (Unless you're a bipolar borderline zooid-type personality.)

But like life, you have to go into this battle. Now, how do you go? Do you slowly flip over the cards and pray for the right one to appear? (As some do in life. I used to.)

Do you flip over the cards and get frustrated (maybe even let out a little grunt or curse the deck) when the card you really need is just under the card you don't? (I've done that, too, and I wasn't the smartest guy in the world to be cursing at little pieces of paper.)

Or do you flip them over, look at your cards, look at your opportunities (or maybe the lack thereof) and either make your move or flip over the next batch, and so on and so on?

I will tell you this, you're either going to win or you're going to lose, and it's not the end of the world either way, my friend. But it is a lesson in how we should live. I taught my kids that losing is actually cooler than winning. I remember one of their voices answering back, "Dad, that makes no sense," and I said to them, smirk on my lips and deck in hand, "It will in thirty years."

You see, to win, to conquer, to activate the loss of others, to crush and destroy can seem wonderful, but isn't the hunt as invigorating as the kill? Once you get what you want (the new car, the new girl, the new computer, the new house), we feel the game has to start over. I don't know about you, but I love looking into the mouth of the lion. I smell my own fear when I get that close. That fear is high octane on steroids and it's 100-proof poison . . . It will shorten your life, if you care. So, as I age, life has given me some other, introspective ways to live, too . . .

Just let it happen and, I promise you, all that is magic will appear.

Or leave your mouth open long enough and, I promise you, a bug is going to fly down your throat and you're gonna choke to death. So shut your mouth, open your eyes, and play along with life. And stop waiting in line to win, mouth gaping, panting, outta breath . . . you

forgot to breathe because you want it so bad. You can't will life. It will kill you. There is more of it than there is of you. Just wait in line patiently to see what's going to happen. I promise you, as an individual—a solitary person—you will get just what you need, win or lose. I promise a fairy-tale ending and you will be the champion of the world.

I say this as I play solitaire forty thousand feet above Europe, heading toward Russia for the first time in twenty years. I wonder if it has changed as much as I have. Funny how life has simplified itself down to just a deck of cards and a fleeting thought of my grandmother. Seems as though I am right back where I started . . .

P.S. When I said there are fifty-two cards in the deck, don't forget the two extra cards, the jokers. There are always jokers in life.

solitaire |ˈsä-lə-ˌte(ə)r|

noun

1. any of various card games played by one person, the object of which is to use up all one's cards by forming particular arrangements and sequences.

ORIGIN early 18th cent.: from French, from Latin solitarius (see solitary).

MOSCOW, RUSSIA
JUNE 1, 2009

The first thing I noticed flying in over Moscow was how green it was. It seemed to go on forever into a new kind of green that I didn't remember from when I was here in 1989. I thought maybe I was just coming down off the drugs then, and my eyes were still fogged over or something, but when I was in the van going to the Mötley Crüe press conference, Tommy noticed the same exact thing, saying, "Can you believe how green it was flying in?"

Last night I went for a walk to Red Square, where the first thing I noticed was the cobalt blue sky jumping up from behind these huge red buildings. The courtyard, twice as wide and deep as a football field, was slowly draining of tourists. It was 10:00 P.M. and the sun was still somewhat out. I noticed police drinking from bottles of something that appeared to be vodka. Not far off in the distance, leaning against the Kremlin walls, were Russian girls, smoking, laughing, and showing off their long legs and short skirts. The tourists were all but gone by then, except, of course, for me . . . I am always finding myself in the weirdest places at the wrong time. I guess I didn't feel like I was in enough danger so I ventured up the side of the buildings and made my way around back. I climbed through trash, shattered glass, and the remnants of someone's makeshift home but there was nothing back there worth pulling out my Nikon for. No characters to shoot. It had been abandoned for one reason or another. (Maybe the vodka-drinking police were rousting the ratlike humans out of boredom.)

So, on worn Chuck Taylors, I did an about-face and headed toward the prostitutes, who quickly stopped laughing as I approached. It seemed like they were scowling at me more with every step I took. I had a pocket full of rubles so I figured I would get them to pose for a few portraits, but it wasn't me they were getting pissy about. It was my camera. In a deep, loud, Russian voice the brunette said something to the crack-whore-skinny blonde who then yelled it to the drinking cop who then barked something at me that didn't sound anything like "Welcome to Red Square."

Being alone, I thought it better at this point to come back with an interpreter. On the way out of Red Square, I encountered a man outside a church asking for money. He had the hardest face I've ever seen, like an oil painting that had started to crack. I so wanted to shoot him, but he said "No." Finally, I found this old woman hunched over,

Why I Invited You Here · Look Thru My Cracked Viewfinder · Life's Not Always Beautiful · Ghosts Inside Me · This Is War · One Man, Two Bands · Killer's Instinct

Help Is On The Way · Tale Of The Siamese Twins And The Black Rose Tattoo · Rock N Roll Will Be The Death Of Me · The End, Unless It's The Beginning

lurking in the shadows of a doorway. You could tell what she was thinking, but I just pulled out five hundred rubles and held up my camera . . . and said please . . .

There was no light to be had and the lens I had wasn't the fastest, so I aimed and took the shot, and she said thank you. But the picture was completely black. Shit, five hundred rubles for one underexposed image. (Now that's inflation.) So I pointed to the darkness and then pointed to a streetlight a few feet away and said, "PLEASE" while sort of asking her with my hands to move toward the light. As she said yes, I adjusted my lens, pulled her into focus, and she smiled with her eyes. She said something that sounded sweet, grabbed my hand, made the sign of the cross over me, and said, softly, in English, "I bless you with God."

That was it. I was happy. My first picture in Russia may not be the biggest concept piece, but the biggest heart piece, like rays of light coming from the eyes of this woman, who has seen this country's biggest changes; from bad to worse and now from worse to wonderful. Moscow is alive with architecture, fashion, metropolitan high-rises rubbing shoulders with historical cathedrals. This simple moment, this simple moment at 10:00 P.M., May 30, 2009, Nikki Sixx captured her reason, her life, hopefully a piece of her soul.

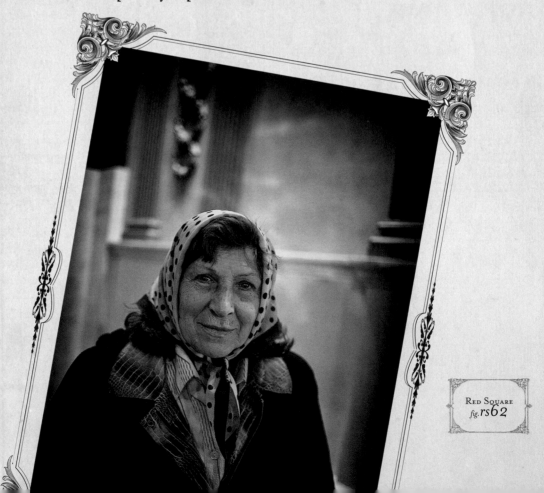

RED SQUARE
fig. rs62

ST. PETERSBURG
JUNE 4, 2009

She leaned heavily onto my ear and said something in Russian. It didn't sound nice and when I jumped, she responded with, "Nyet." Now, the only things I know in Russian are yes and no and this wasn't yes. Large and strong like a bull, her name might as well have been Olga. I guess I had fallen asleep on the massage table and she was telling me to roll over. Communication breakdown number one, but I figured it out and at the same time figured I probably shouldn't tell her I'm running late to meet Andrei, my interpreter and photography tour guide for the day.

After the brutal beating Olga administered to my body, I headed for a quick steam, only to find myself face-to-face with what looked like an old-time Russian criminal, and in the sauna no less. I've seen so many Russian criminal tattoos that one could only assume he was either one now or used to be. I, of course, find these situations very inspiring and immediately tried to talk to him. Again, "Nyet, nyet, nyet . . ." Communication breakdown number two . . . I soaked up the steam and headed to my room, grabbed my cameras, and went down to the lobby to meet Andrei.

He was born and raised in St. Petersburg and knowledgeable in all things having to do with this city. I felt like I had probably struck a gold mine of information so I tested him and it seemed like he was gonna pass with flying colors.

The pure size and girth of the buildings humble you. As we were driving through the city, Andrei would say that building was built in 1724 or 1873 and so on and so on . . . Amazed by the sheer beauty of the city, I still ended up asking where the broken-down and the mentally ill people were, or the false storefronts with junkies flipping tricks in the alley behind, or dealers giving kickbacks to the police.

All I got were vacant stares. I asked Andrei if he understood and he went into a rant in Russian to my driver whose fingernails were way too long and whose smile was somewhat crooked. Finally I got my answer: No.

Some days it's just too hard digging in the trash for gold. Communication breakdown number three wasn't going to get solved that day so I blurted out, "Stop." And we did, on a dime. All the contents of my camera bag flew through the air and landed facedown in the van. I grabbed my camera, jumped out the door, and took five quick pictures of her. I don't know her name, but again, she could have been named

WHY I INVITED YOU HERE | LOOK THRU MY CRACKED VIEWFINDER | LIFE'S NOT ALWAYS BEAUTIFUL | GHOSTS INSIDE ME | THIS IS WAR | ONE MAN, TWO BANDS | KILLER'S INSTINCT

HELP IS ON THE WAY | TALE OF THE SIAMESE TWINS AND THE BLACK ROSE TATTOO | ROCK N ROLL WILL BE THE DEATH OF ME | THE END, UNLESS IT'S THE BEGINNING

Olga, too. Robust and dirty, with a million miles of hardship on her face. I handed her a hundred rubles and she smiled, putting the bills into her sock and keeping the change in her little plastic bowl.

Fifty yards up the path, across from a gothic Christian church, sat another lady whose story probably didn't differ much, but the look in her eye was anything but pleasant. I felt as though I was face-to-face with the beast that inhabited Linda Blair in *The Exorcist* and at any moment I was about to be hurled on with some nasty green pea soup just for saying hello. Always one to do the wrong thing at the wrong time, I went ahead and asked, "May I please snap a picture?" Now, all I understood besides *nyet* (which was repeated at escalating volume) was the Russian version of "Get the fuck outta my face you pompous overdressed smug camera-carrying fucking American." I told her I loved her, too, snapped a picture anyway, and gave her a hundred rubles, which didn't stop her from cursing me as I ran into the church.

HELSINKI LOVE LETTER
JUNE 5, 2009

Jet lag is a motherfucker and I often wonder how someone like our president or any diplomat who travels from continent to continent (sometimes on the drop of a dime) can keep their composure. I look like hell and feel even worse. No amount of coffee is gonna help this train wreck in the bathroom mirror today. The lines on my face are only matched by the strings tugging on my heart. I like to say there is no crying in rock n roll, but I feel on the verge of tears every time I get a text from my friends, my kids, or my girl. This isn't getting easier as I get older. In fact, it's now close to impossible to leave them at home.

The hardest thing in my life has been love. When I love you, it hurts. It hurts deeply to not be with you, around you. Even if only in the same area, time zone, or city. I am a romantic, and it just plain hurts. Ah, to be a vampire . . . To live forever with the ones you love . . . I spent most of my life trying to kill myself and now I wanna live forever . . . God help me, I am insane.

Adversity isn't something I thought I'd be dealing with now because, to be honest, my life seemed somewhat blessed. The drugged-out, alcohol-guzzling, womanizing, lying, confused, and abused life was over. I have a wonderful family. I'm healthy, strong, emotionally balanced, and have the most amazing girlfriend ever . . . Well, that all came to a crashing halt right before I left for this tour.

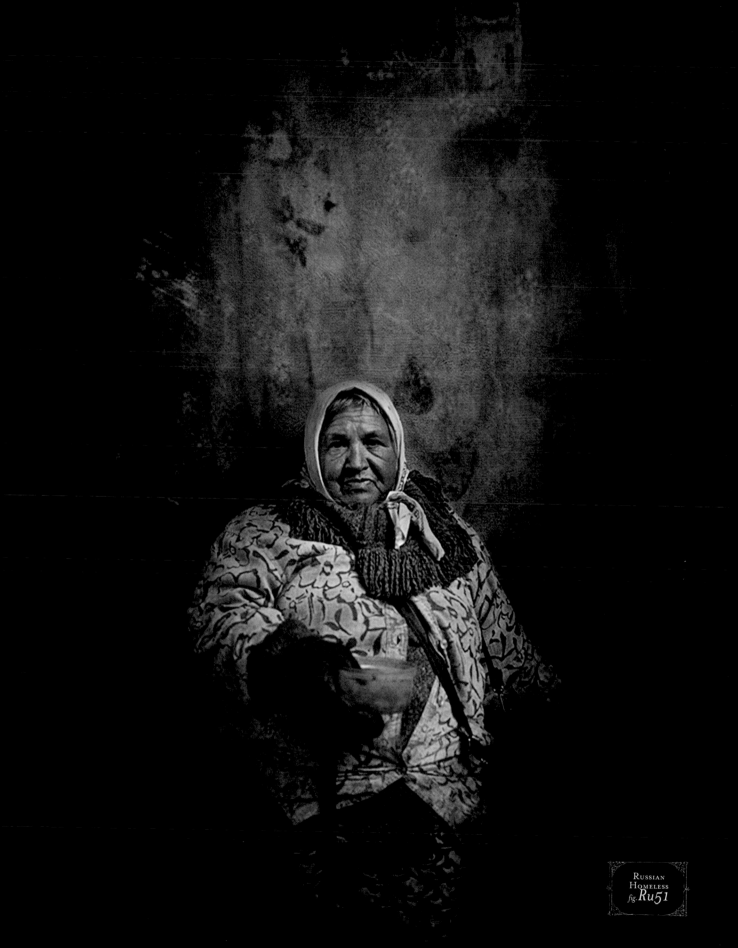

RUSSIAN
HOMELESS
fig. Ru51

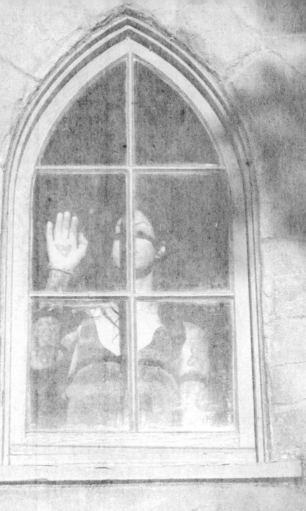

She had been hinting. I thought I had been listening. Then WHAM! Like a ton of bricks. And my heart is broken. I feel like I am dying inside, sitting here with wounds that I thought had scarred over, now bursting open. I feel like a man trying to plug up a hole in a dam and I'm running outta fingers and toes. Eckhart Tolle says in his book *A New Earth* that winning streaks come to an end someday and you will then have to find your life's purpose. I thought I had found mine in the relationship department. I didn't see us ever not being together . . . I am dealing with all this information whilst missing my family, missing my life as a whole, and missing her and what I thought "we" had.

Yes, I think I have finally had my heart broken. In fact, for the first time ever.

Isn't it amazing that every time I say or think something like "my life is great," I get my ass handed to me? Life is hard.

Back in L.A. seventeen days ago I tried my best to put pen to paper:

MAY 21, 2009

Sitting here at Funny Farm, sad, confused, and unmotivated. All the feelings Katherine was not associated with. I never felt sad, never confused, and was always motivated by her. We have broken up and I cannot figure out what happened. How did we go from madly in love, dying in each other's arms, to this? Everything reminds me of her and it seems I sometimes forget to breathe. A gulp of air and I know I'm alive 'cause my heart hurts like a thousand swords have been jammed into it all at once. What does a man do with such pain? I know I can't and won't drink and drugs are even farther out than a glimmer of a possibility. I won't act out, burst out, or smash the nearest thing in retaliation. I won't, and for sure can't blame. So what do I do?

It feels like death. I know this feeling and it hurts like hell. Yes, sometimes I cry at the drop of a hat because I hurt. It hurts so bad that I turn numb from moment to moment. I hate this but, I hate to say it, I am right where I am supposed to be. Nothing can prepare us for loss, death, and heartbreak. There is no amount of anything that can make it better. We don't own time so we can't fast forward it or ask it to come back later when the timing is right . . . So we ache at our core. We cry and sometime even scream out in horror of it all.

She is the best thing to ever happen to me and I will forever love her. I hope to never see her in the arms of another but if I do, so be it . . . Then I will hurt again. Our lives may be magical to you, but it's not all peaches and cream. Time is our enemy. It fights us, it wakes us up, tugs at us, rips at us, hour by hour, minute by minute, second by second until finally, like now, it rips out your fucking heart. I sit here with my heart slowly pumping on the floor of the studio. I am alone except for the haunting of her once smiling, cheerful presence. She helped me build this dream house. She gave her heart to me and now she wants it back and I think I am going to die. I can smell her on the sofa, in the air . . . And I can still hear her in the other room painting. But, you see, the problem is that she is gone and I don't think she is coming back. Even if she were to call and say, "I was just kidding" I know she is right. It's just not the right time. Our lives are just too crazy and Time, that fucking bastard, has beat us again.

I love you Katherine . . . I hope to have this all again one day with you . . . Until then, I will dive into my addictions of art and my kids and, if I'm lucky, maybe one day I will hear you painting in the other room . . .

I miss you . . . I love you . . .

Nikki

Why I Invited You Here · Look Thru My Cracked Viewfinder · Life's Not Always Beautiful · Ghosts Inside Me · This Is War · One Man, Two Bands · Killer's Instinct

Help Is On The Way · Tale Of The Siamese Twins And The Black Rose Tattoo · Rock N Roll Will Be The Death Of Me · The End, Unless It's The Beginning

COPENHAGEN, DENMARK
JUNE 10, 2009

Got in from Norway to dumping rain. Beautiful in its dampness, I still chose to sit in my room. Wrote some, read some, slept some, chatted on the phone some, texted some. And then some more . . . and then even more . . . the road. Today seems forty-eight hours long.

 1 A.M.
Show was intense and I'm wiped out.
Good night.

LONDON
JUNE 13, 2009

She gasped. I jumped, literally pissing on my own leg. "Oh my God, Mum, it's Nikki Sixx," she said. Like I said, I was literally caught with my pants down, peeing in the graveyard at Highgate Park. I didn't mean to be disrespectful, but it would've been worse to be lugging all those cameras around a graveyard on a hot English afternoon with piss running down the inside of my favorite pants.

So, quickly, I buttoned up and turned, somewhat red-faced, and said I was sorry (hoping I hadn't just urinated on her family plot) and scuffled off. I could hear the girl trying to explain to her mother what a Nikki Sixx was, but I wasn't gonna stick around and get an earful from Mum. After all, I had a whole cemetery to myself and forty-five minutes 'til closing. (Imagine being in a cemetery at closing time. Weird.)

The Highgate Cemetery is one I had wanted to visit for years but, between my past addiction and living in Los Angeles, well, let's just say timing is everything and the time had finally arrived . . . Even if it feels like it came on a slow boat outta hell.

One of my favorite pictures is this wonderful shot I took there of an angel statue. I was drawn to her hands. It felt so hopeful, for a tombstone, just by the fact that the hands formed a heart shape. The light cut through the trees just right, just for a moment, and I got it. Two seconds before or a few after, it would've been a completely different photo. That's the thing with photography—you can capture magic moments and, like this one, it seems like it was meant to be. Love is forever. Even in death we can be assured of that, if we have lived a full life.

All in all, another cemetery, another city, and another reminder of mortality with a double twist of humor.

Backtracking to the Download festival the night before—eighty thousand strong and the band was firing on all cylinders. We have never really been that big in Europe and rightfully so. We were too tired at the end of eight, nine, thirteen months of touring America to understand that Europe was not gonna wait around for us. Every year, same situation until one day we said let's go play Europe and they said, "OK, but you guys aren't really that big there." Imagine the faces on us. And then it sunk in. We owe Europe and we were now putting in the time that we should've done twenty years ago, and twenty years later we're finally about to be worth our weight in gold.

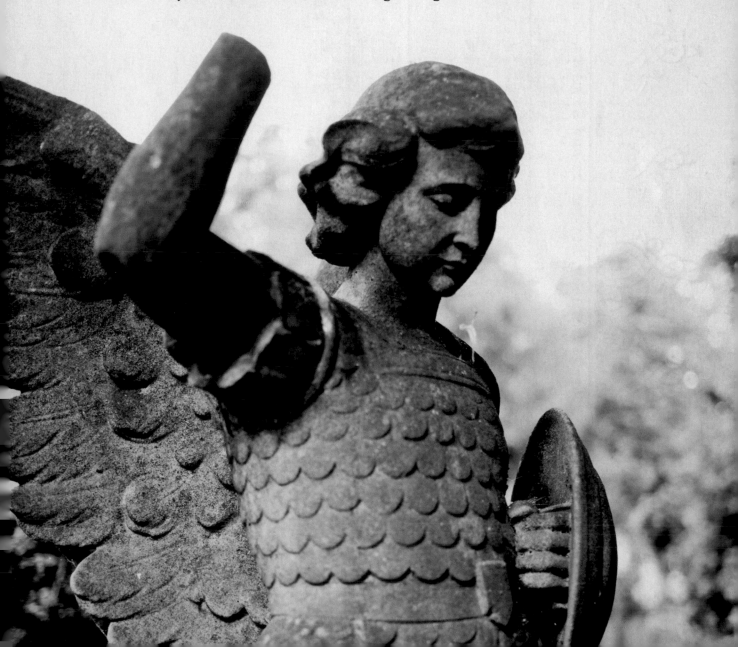

MUNICH & STUTTGART
JUNE 15, 2009

I have known our German promoter, Ossy Hoppe, for almost a quarter century. He was the first promoter to do Mötley Crüe and he has seen it all. What I didn't know is that Ossy grew up in the Russian circus. In our conversations in that tiny backstage dressing room, I learned about that life and, of course, I asked about where to find the old, tired, and broken down. I asked where they live, and could I shoot them? He said I was in the wrong city. They mostly lived in Hamburg. We agreed that my next trip to Germany would entail a Diane-Arbus-type adventure.

The show was good, but the language barrier had us wondering if they liked us or loved us. We were convinced it wasn't love because every time we spoke to them, they would stare back with blank faces. Of course, we needed to be reminded we have not been here in twenty years and maybe if we came more often they might know us a bit better. I accepted that lie as I collected my clothes and headed back to the hotel, only thinking of tomorrow's adventure. I mean, isn't this what I had been asking for?

Stuttgart, Germany, was somewhat better, but I am convinced they hated us, too. Tommy wanted to know the same thing, but when Mick stepped to center stage they roared. Vince said they just hate us three, and we all just laughed.

BERLIN
JUNE 16, 2009

I walked from the gig over to a cemetery a few minutes ago. Crumbling bullet holes hold rusted shells that are still buried in the sides of angel statues. Expired mortar casings kissing ever so softly up to mom and dad's tombstones. Life wasn't so grand in 1945 in Berlin when America invaded and conquered the Nazis. It was a country in turmoil and internationally hated. A country riddled with bombs, flamethrowers, and hand grenades. Overrun with tanks and leveled by U.S. bombers. Blown to pieces, then crumbled to its knees. For the grandparents of the kids waiting to see Mötley Crüe play tonight, life was so different. I can't even imagine what life must have been like here.

We are playing in a cement building that has all the markings of the same destruction bestowed upon the cemetery only half a mile away. I sit here in my dressing room and it's hauntingly quiet. Cement does that to a room, makes it like a bunker. It's as though I am in a cement casket right now, and I'm feeling claustrophobia sink in. I snapped a picture on my way out of here a while ago. A sign reading Stage with an arrow on the cement floor outside my dressing room. I am tired, tired of the road. Germany is one of my favorite places, and I'm having a hard time even enjoying it this time. It's beautiful outside, the weather is perfect, the people kind, and as always the food and drink are exceptional here. But I am worn out . . . If I could crawl inside one of those tombs I swear I'd sleep for a year . . .

At moments like this, I wake up and realize how ungrateful I probably sound. A kid from nowhere getting to go everywhere. A kid who had nothing, who now really has everything. Life is like this very moment if you're alive enough to take it in.

I realize I complain a lot about being tired. I know it sounds selfish and I know I repeat myself (a lot). Some days I'm like an automatic weapon rambling outta control. Like some kind of Rambo(aholic) with two AK-47s on full automatic. When I am in tune with my inner asshole, it feels like I am watching them destroy everything in their path and can't manage to take my finger off the trigger. It's some kind of an addiction to the drama in my own head. It must be a fucking nightmare to those around me, and to be honest, I make myself puke sometimes too.

OK, enough self-loathing for one day.

STAGE

I saw Lemmy in London and he just called and said he was in Berlin mixing some music. Nothing gets me outta my own way like Lemmy. I threw him and a few others on the guest list and I'm excited to see my friend. He has also become good friends with Katherine and that makes me happy. He is a "tell it like it is" kind of guy, and people like me and Katherine need that. In fact, so does Lemmy. We spoke deep into the night in London, telling torrid tales of truth and debauchery only to sometimes end the story being interrupted by the other saying "That ain't right" or "That's bullshit" or better, "I don't really agree, bro." (Not that I really remember Lemmy ever saying the word bro.)

Friends tell each other what nobody else is willing to tell you.

Now I have said my piece, may God bless these little Crüeheads in Berlin 'cause we're about to rock their fucking faces off. It's time to get ready . . .

P.S. Lemmy is here so I better play good tonight.

PRAGUE
JUNE 17, 2009

Ominous. That was the word that kept slipping from my lips. Prague, bittersweet.

Me and Katherine were supposed to come here for Christmas this year but as the time grew nearer I couldn't shake off my fatigue from touring. The thought of getting on a plane to Europe after being on the road so much that year almost brought me to tears. Unfortunately, my way of dealing with post-tour depression also brought my girlfriend to tears. Oh, she acted like it didn't matter. She smiled through it but, truth be told, in retrospect that was the beginning of the end for us. It was just one of many things that I would do to make her not feel special. Oh yeah, she has her part in it, too, but what's the point of me trying to clean up her side of the street when mine still needs a whole work crew?

HELLFEST, FRANCE
JUNE 19, 2009

Sitting on the second plane on the way to Nantes, France. We left early this morning from Prague. Tommy is asleep one seat over, and Vince is watching a movie on his computer behind me. If you have ever seen the movie *Planes, Trains and Automobiles*, you know today's story. We are

Why I Invited You Here | Look Thru My Cracked Viewfinder | Life's Not Always Beautiful | Ghosts Inside Me | This Is War | One Man, Two Bands | Killer's Instinct

Help Is On The Way | Tale Of The Siamese Twins And The Black Rose Tattoo | Rock N Roll Will Be The Death Of Me | The End, Unless It's The Beginning

going on tonight at 1 A.M. I think Heaven n' Hell (which is Ronnie James-Dio-era Black Sabbath, and some of the best Sabbath in my opinion) play first, as well as a few others. All I can say is, "What the fuck? Why are we going on at 1 A.M.?" We'll get offstage at around 2:45 A.M., then another hour's drive back to the hotel and up at 9 to catch two planes to make it to Spain for another festival, just to do this again . . . Hellfest is the name of this show and all I can say is that it's fitting.

Some days I don't care how hard I try to hold it together, it's hard to keep positive.

Let me try the old Gratitude list trick and see if this helps . . .

1. I AM STILL SOBER, EIGHT YEARS, JULY 2.
2. MY FAMILY IS ON THEIR WAY TO SPAIN TO MEET ME. (I COULD RANT FOR HOURS ABOUT THEM, BUT I CHOOSE TO KEEP IT LIMITED FOR THEIR PRIVACY. I CAN SAY I AM SOOOO EXCITED TO SEE THEM.)
3. I iCHATTED WITH KATHERINE LAST NIGHT AND IT WAS AMAZING. I FEEL I HAVE GROWN SO MUCH SINCE I LEFT LOS ANGELES. SOMETIMES A MAN HAS TO BURY THE KNIFE UP TO THE HANDLE, HITTING BONE TO FULLY FEEL THE PAIN OF HOW WONDERFUL HIS LIFE IS. I AM SUCH A MAN. HISTORY PROVES THAT.

NANTES, FRANCE 3:30 A.M.

I think me and Vince wound ourselves up so much about going onstage at 1 A.M. that we finally just got giddy. Of course, just when you think it's gonna be lame, stupid, or worse, and nobody will wait to see us, it turned out to be one of the best of the tour, if not *the* best. When this band is one, we're a monster . . . Tonight (or this morning) was one of those magical moments.

So again, I learn from my own outlook daily. In an AA meeting once I heard this old-timer say, "If I am thinking it, I am probably stinking it." It has taken me a long time to figure out what the hell that meant, or at least what I think he meant. When I was putting together *The Heroin Diaries*, there was a lot of looking back and using it as a way to move forward, however ungracefully at times. This man, a small-framed black man with abnormally huge fingers, announced this message to me after I shared some gibberish in a meeting about being stressed. He made his point by punctuating it with his chubby pointer

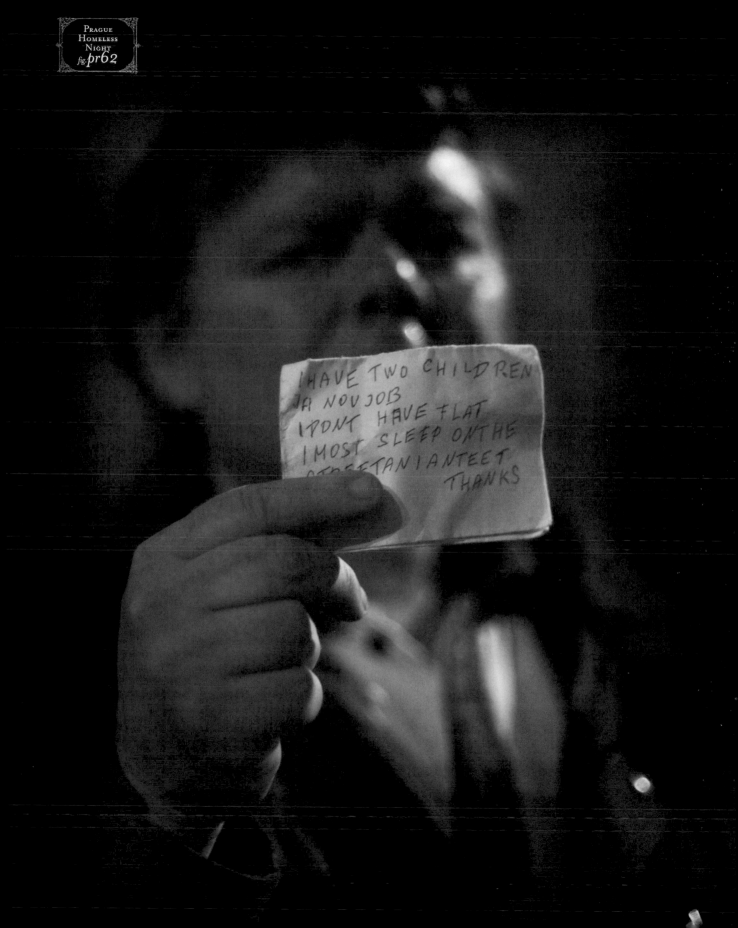

finger thrust in between my eyes. I can still feel his presence (and the emotional bruise on my forehead). And again I repeat his words, "If you're thinking it, you're stinking it."

I thought our show was going to suck; I thought my relationship with Katherine was solid—I thought it was perfect; a long time ago I thought drugs worked for me. I think a lot of shit sometimes, and I guess a lot of the time I am wrong. I think all of us humans are wrong a lot. Just look at the newspapers or, better yet, the Internet. Most of our actions and reactions are based on bullshit. Being wrong and admitting it deflates the balloon of ego and allows the path to be cleared.

In my case a clear path is perfect so I can create and love but also, in my mind's eye (the same one that damn finger poked), I know I am going to cause destruction and damage. Basically, I will make mistakes by thinking the wrong thing at the wrong time in the wrong situation. This is the course of human growth. I don't know if I would like the concept of perfection. I don't know if I would be OK at this time in my life without the need for growth.

Maybe when I become a monk (Zen Master Sixx) . . . but something tells me I am a long way from that moniker.

I must go to sleep. 4 A.M., and the luggage call for our flight to Spain comes early . . .

I am grateful. Are you?

SWEDEN
JUNE 25, 2009

This is the time in the tour where I lose all my Zen. This is the time where I try to remain composed, even if perched upon a branch like a vulture waiting for something to die. That something is my soul. I am reading as much as I can to keep away from the resentments of having to be away from home. I hate this. The only thing that makes it worthwhile are the fans.

Tonight's show starts at 1 A.M. We get off stage at 2:30 A.M. We then have a two-and-a-half-hour drive back to the hotel. This is fucking inhumane.

I will never do this again.

American Disorder
JESUS SAVES IN CLEVELAND
JULY 21, 2009

Three days into the Mötley Crüe tour and everything that can go wrong does. Faulty song endings, lighting cues outta time, pyro not going off or, if they do, all going off on the wrong song at the wrong time. You name it, it will, and has, happened.

Today was an early call from Cleveland to Chicago and, as usual, I was an airport security nightmare. I always have everything and anything that is guaranteed to set off security alarms tied to, stuck on, or sewn to my clothes and sometimes even my body. God save you if you're in the line behind me because, of course, God (or somebody even funnier) always has a cruel joke in store . . .

As I stripped off my belts, chains, wristbands, knife, rings, bracelets, boots, coins, phones, etc. and go through the (heavy) metal detector, I hear a woman's voice softly say to me, "That's a real nice cross on your bag." She was looking down at my custom Chrome Hearts brown leather shoulder bag and the oversized cross on it. I mutter "Thanks" and, of course, she says it again but now looking right into my tired and somewhat perturbed red eyes. This time I clearly say, "THANK YOU" but in a way that really means, "Please don't talk to me right now." Then it comes, the part of my day that I always laugh about later but never at the time. She looks at my bag and then at me and with cold, brutal aim says what's really been on her mind the whole time:

"Have you recognized Jesus as your savior?"

I sigh that sigh I do right before I do something I shouldn't, and I say, "Uh-huh," hoping she would just get the hint, but no. She had to repeat it. Then, "Have you met with Jesus?" Or something along the lines of that, and I just plain cut her off cold with, "Yeah, I met Jesus Christ a few times." "Really?" she asks and I reply, "Yeah, when I was overdosing on drugs."

She looked at me in shock as I asked her if she still liked my bag and she nodded, thinking maybe she was making some headway on saving my soul. So I turned my bag around and showed her the back. "How do you like that?" Her eyes opened wide as she read it. Inscribed in red leather, it plainly said what I wished I had said from the beginning: "FUCK OFF."

189

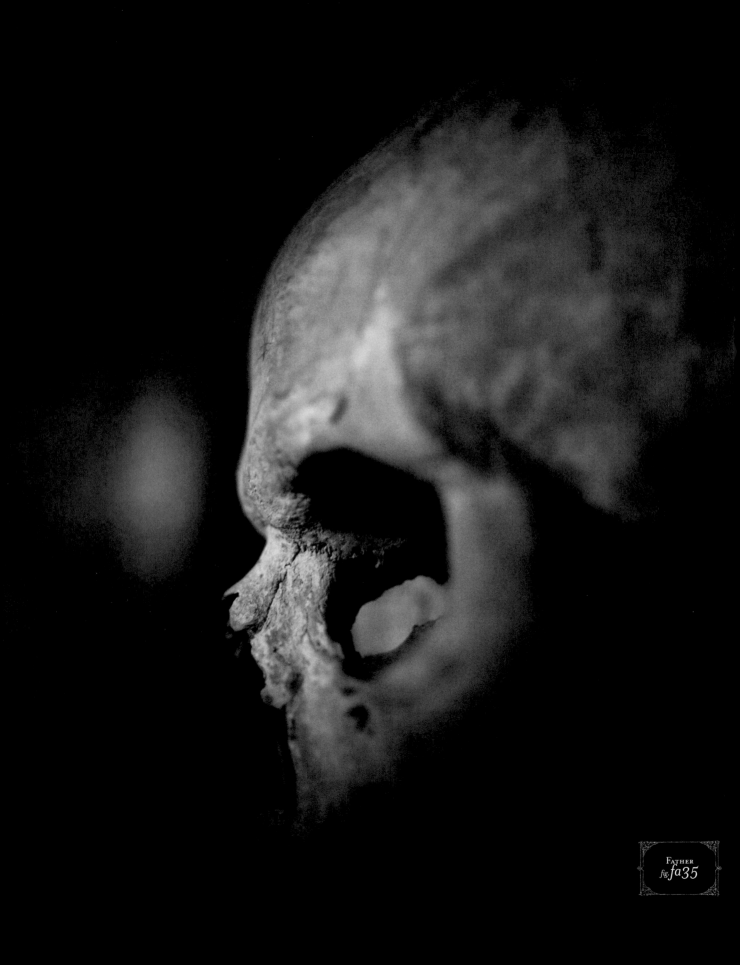

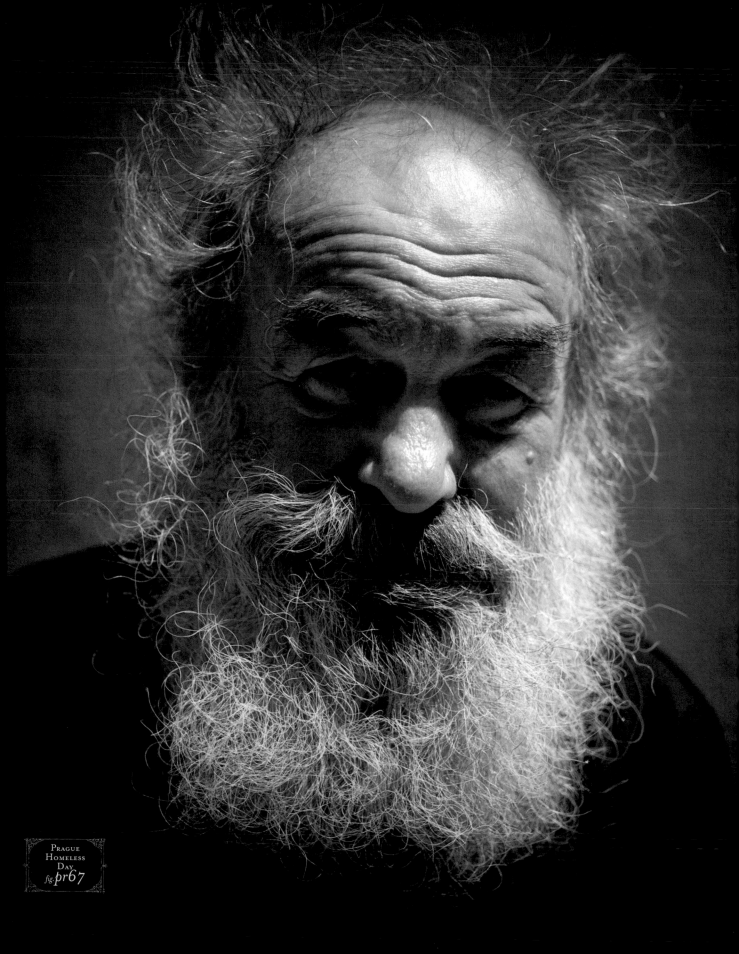

Prague
Homeless
Day
fig. pr67

I looked at her and said, "God bless you," as I headed off to the gate.

Once I was sitting on the plane and looked up, there she was again. She looked down at me and kindly said, "God bless you, son."

I replied, "Thank you, Mom," and that was that . . .

Some days, I really need my Midol.

JUVENILE DELINQUENT FROM SEATTLE
JULY 27, 2009

I am really still just a juvenile delinquent from Seattle. Once a drug dealer and high school dropout. A loser without a hope. Oh, sure, I had a dream but what the hell is that worth in Juvenile Hall? Maybe a ticket for a Greyhound bus outta Seattle and straight for Idaho, pulling the ultimate coward's move, running from my past and yet too stubborn to realize it had been stamped on my forehead like a brand for the whole damn world to see . . . Life ain't pretty when you're hand in hand with the devil, even for the pretty pretties. No hope and no way out yet I sit here thirty thousand feet high heading back to the city I ran from, maybe even emotionally crawled from, or, if you can imagine, crawled out of . . .

I'm headed back to meet up with my grandfather and my two amazing sons. Sold-out festival that we started a couple years ago. Ten bands in all. Sometimes I ask myself where home really is, Seattle or Los Angeles? Sometimes I ask how the hell any of this happened. How did I turn fifty? (How did I turn thirty, for that matter?) Life is an interesting journey once you open your eyes. Once you can clearly see past your own ego and self-serving self . . . Not to sound all new age Zen fucking Buddha, but I am really loving my life as it comes, inch by inch, step-by-step, moment by moment . . .

(As usual, my tour journals are random and chaotic, and I haven't written in a while. I would tell you why, but I have no excuse except sometimes I just forget to put pen to paper. I can't believe a whole month has passed. But it has.)

ALBUQUERQUE TO HOUSTON (MAGIC)
AUGUST 5, 2009

Woke up and rolled over, my face and hair plastered to the pillow that I had fought with all night. And then it began. The phone rings and

Broken
*fig.*br666

when I answer, I hear an automated voice say, "Good morning, Mr. Black, it's your wake-up call." . . . I knock the phone and a bottle of water off the table while trying to hang up fast so I can maybe pretend it never happened.

"Mr. Black" is the fake name I use to check into hotels on this tour, to keep a shred of privacy. I am on tour with Mötley Crüe, but James and Dj are out here with me, so we can write Sixx:A.M. music. I'm not working hard enough, right? Nothing like a wake-up call to start the day.

Thirty years, thirty fucking years, I've been doing this on one level or another and that damn wake-up call still annoys the shit outta me. Not for any other reason than I know it knows what's best for me. And I guess I knew last night, too, or I wouldn't have ordered for the damn thing. It seems that we always know what's best for us, even if it means we have to ask someone to jolt us from a comfortable spot.

May I repeat, I DON'T WANNA FUCKING GET UP.

So, I ask myself, what's new about this? I DID NOT want to quit drugs for the longest time but I finally had to GET UP. Wake up from that stupid journey. And, of course, there are other examples, but let's not get bogged down in the murky past this morning. Some days you just have to GET UP and smell the roses, the coffee, or whatever gets you UP. Some days when you get out of your own way, and just put one foot in front of the other, amazing things happen. Like in the past, in my life, and the future in yours. MAGIC.

Let me tell you about yesterday . . .

It started not unlike today. With a FUCKING wake-up call. Me, groaning, dragging my naked ass to the door to be greeted by James and Dj . . . Both foggy, both groaning, none of us having really slept the night before on the bus. But you know what? Within fifty-five minutes, our self-deprecation filled the air, the kind that spurs laughter from the deepest part of your stomach, the kind that hurts so good and inspires three friends masquerading as songwriters with five song ideas for Sixx:A.M.

We sat there drinking coffee, listening to the playback of a writing session we had done in Atlanta months before, mostly laughing at ourselves, but at the same time somewhat amazed at the amount of music that came outta that day . . . Between James, Dj, and myself, we probably have twenty songs . . . Amazing . . . So today, I wake up, groan, drag, and complain my way to the airport, where we three friends again will sit in a hotel and be amazed. I'm sure of it . . . because if I just get out of bed, it always happens . . . The magic . . .

About now, if I wasn't still in love with Katherine, I'd kiss the wake-up call girl. Not that she's a call girl. But, then again, you never know . . . There is a price tag on everything . . .

Except magic . . . magic is free.

BACK ON THE ROAD:
SONGWRITING IN SYRACUSE
SEPTEMBER 2, 2009

Some things ain't as simple as just pulling the trigger. You can't always expect the bullet to just do the job. A clean shot is an exception. Songwriting in Syracuse is like pulling teeth in Des Moines, Iowa, or, worse, living through a shattered heart on tour with Mötley Crüe in

Europe. God bless James for putting up with my lunacy this trip. I think he is secretly trying to have me committed. He kept leaving my room today, either to make secret calls to the local authorities or because he's just fed up with my constant laughing at nothing. (The first sign of men in white suits and I'm jumping out the window.)

James has been out on the road with me for a week now. I have to tell you, it's been so funny that sometimes I don't even know how to survive the laughter. We're writing lyrics, and Dj is back in Los Angeles. The three of us have written so many great songs that today James said this may have to be a double album. For some reason even that seemed funny to me. Again, the uncontrollable ramblings of a lunatic . . .

Two days ago, in some town I can't remember, we wrote a song called "Smile." The hotel was somewhat eerie in a *Shining* (the movie) type of way. All I remember besides the chorus to the song is that the hotel smelled like dead people and James and I got lost in the woods and thought for some reason that was funny, too. We both decided that our iPhone cameras were better than our Nikons and even further into lunacy came the comparison to my Hasselblad.

Clearly, it's time for me to go home. Insanity is contagious and now James has it bad too.

Friendship is like music, and sometimes it's like songwriting in Syracuse, New York. Nothing really gets accomplished except laughter. I smile at this 'cause, to be honest, we probably wrote more music talking than we even know. Music comes out in a lot of ways . . . Like our pictures taken with shitty cell-phone cameras when we were lost in the woods, or even the grueling drudgery of my high-concept photo shoots at Funny Farm. It's all about the feeling. In other words . . . inspiration. It doesn't matter where you get it. It could be on the six o'clock news or from the morning paper but you usually have to process things in your mind like film before it develops . . . It will come out if you give it time . . . Like life, right? If you live through all the pain, it will develop into inspiration and come out in all kinds of ways. Sometimes I see it in a smile. Other times I feel it in a song or when I have to hold back the tears when I watch a film . . . it all comes from somewhere deep inside somebody else. They are giving it to us to feel with them. These are life's gifts . . .

Like songwriting in Syracuse.

Why I Invited You Here | Look Thru My Cracked Viewfinder | Life's Not Always Beautiful | Ghosts Inside Me | This Is War | One Man, Two Bands | Killer's Instinct

Help Is On The Way | Tale Of The Siamese Twins And The Black Rose Tattoo | Rock N Roll Will Be The Death Of Me | The End, Unless It's The Beginning

Smile

Sixx:A.M.

As the light washes over the morning rise
You're still asleep and that's alright
I can be still, because you look so sweet
And beautiful next to me

And all my life I've been waiting for someone like you

To make me smile
You make me feel alive
And you're giving me everything I've ever wanted in life
You make me smile
And I forget to breathe
What's an angel like you ever do with a devil like me
You make me smile

Still in bed
Sun is beating down
In a hotel room on the edge of town
Wake up baby
There's three hundred miles to drive
And the truckstop preacher
He says "God is on our side"

And all my life I've been waiting for someone like you

To make me smile
You make me feel alive
And you're giving me everything I've ever wanted in life
You make me smile
And I forget to breathe
What's an angel like you ever do with a devil like me
You make me smile

OFF THE ROAD AGAIN: HARD TO DESCRIBE, HARDER TO SWALLOW

It's hard to describe the end of a tour. But as I sit here in my home in Los Angeles, I will try. It has been described by some as a sort of "post-tour depression" disorder, not unlike what soldiers experience after coming home from war. I can honestly say I've had it.

It's the feeling a fish probably has when it's out of water. There isn't enough sleep to rest your soul (if you even have one left after all the soul sucking on the road) or enough holy water to wash off the grime, slime, and disease that has somehow become your second skin. Like a lot of things, the end can be brutal. Like running a mile around the football field when you were a kid. (It took four laps.) The last quarter mile was hell. You wanna quit every step. You fight, not quitting as your legs grow heavier and heavier and your breath grows shallow and your sides split open from cramps. Everybody is watching—the coach, the high school girlfriends, and all your friends (and a few foes)—so you persevere and cross that finish line. Amazingly, you're still alive with not a drop of blood in sight. Shit, you did it. You made it and you didn't think you could or would.

This isn't unlike the end of a tour (or relationship). When you finally throw your hands to the sky and fall to your knees and look up at God (or is that a 747?), you know you've pushed yourself to the limit and you've won another personal battle. OK, OK, let's get to the point here . . .

The point is, I wanted to die the last month on tour with Mötley Crüe. I am gonna keep saying it so you understand that I am being honest and telling you what nobody wants to admit. Like I said, this is hard to describe and probably hard for some of you to swallow but it has to be said—sometimes rock stars are fucking phonies. Liars. We have bad days, asshole days, and sometimes we whine like little bitches, and nobody wants to admit it to their fans. Begrudgingly, some days we put on the clown suit and go out there and make the kids laugh, but we're not gods. We're not always happy to be here, there, or anywhere. Some days we're just going through the motions . . .

And we get tired. Fucking tired . . . Sorry to spill the beans . . . Sorry to burst your bubble, but the truth needs to be told . . . Better to hear it from me than someone else. Honesty is the best policy and all that malarkey.

This is the stuff we talk about backstage, behind the circus tent so to speak, and it feels good to me to be honest, even to you the reader

WHY I INVITED YOU HERE | LOOK THRU MY CRACKED VIEWFINDER | LIFE'S NOT ALWAYS BEAUTIFUL | GHOSTS INSIDE ME | THIS IS WAR | ONE MAN, TWO BANDS | KILLER'S INSTINCT

HELP IS ON THE WAY | TALE OF THE SIAMESE TWINS AND THE BLACK ROSE TATTOO | ROCK N ROLL WILL BE THE DEATH OF ME | THE END, UNLESS IT'S THE BEGINNING

(or the fan). So let's continue to beat this dead horse so we can work out the kinks.

Fucking rock star poseur motherfuckers always say the same shit to the fans . . . *Had a great time . . . Can't wait to come back here again* . . . I mean come on, Madonna gets on the rag some days, Bono throws up when he gets the flu, and Paul McCartney gets the shits and still has to sing "Yesterday." Truth be told, the only sign that high-profile people are in trouble is usually suicide or overdose.

Right about now my editor is screaming "Don't put that in the book. It will make you look bad."

Note to self, fire editor.

Second note to self, continue to ruffle feathers and stir shit.

Third note to self, try and explain yourself, Sixx . . .

I've experienced everything from rolling over and picking up the phone to call room service only to realize that I was home in my own bed, to rolling over and pissing on the floor 'cause I was too tired to get out of bed. (Not a wise move, especially when you're not in a hotel.) I've had to reconnect with society in ways that will seem alien to you. Simple, everyday things like getting into your car and forgetting how to put it in gear. Going to the grocery store and standing in the cereal aisle, dumbfounded, baffled, zombielike. You have to reboot the brain at that point, or better yet, reboot your life, if you have one left. There is that old saying "He sold his soul for rock n roll" for a reason.

Years ago, I left to tour for *Shout at the Devil* and came back eighteen months later only to find my cereal bowl still sitting in the same place on the table where I left it when the tour bus pulled up to get me. Surreal doesn't describe that feeling. Like being lost in space, only to return a different man and everybody else is exactly the same. Problem is, you can't remember their names or who they are . . . To be honest, sometimes you can't remember your own name or who *you* are either . . .

This is day two for me being home from Crüe Fest 2. I can honestly say I don't feel any of that. I am so happy to be home, and there isn't one drop of Nikki Sixx of Mötley Crüe to be seen, felt, or tasted. I walked off that plane ready to take on normality. I am over it. I am DONE. Overcooked to the point of burnout.

P.S. I love what I do until what I do does me. Playing live, making albums, photography, writing books, and working with other artists is bliss.

Gimme a week of sleep and I'll be ready to take on the world again but right now, I need a coffin and an IV drip . . .

Love you . . . sorta . . .

...damn
...through the wasteland
...uld have had a battle plan
...t we were young

Close your eyes
...nd try to count to seven
...die, I'll meet you up in heaven
Cuz you're be...ful

...were so independent
...gh on ill intentions
...ould explode in fury
...e w... scared to worry anyway

...you're...thing that's worth dying for
...giv...son I can't ignore
...ma...nt to live forever
...every...waiting for
...these y...usand more
...u mak...me want to live forever

...I wo...a...nderland had gone to hell
...choke...hu...be it...as just as well
Cuz you...I, we...every brain cell and bridge we had

...re so independent
...ch o...ill intentions
...ould explode...n fury
We w...stand to wo...y any...y

But now you're the o...thing that's worth dying for
You give me a...eason I can't ignore
And make me...ant to live forever
You're everything I've been waiting for
All of these years and a thousand more
You make me want to live forever

Dancing with a razor blade

...leeping with a hand grenade
...will gladly take the blame

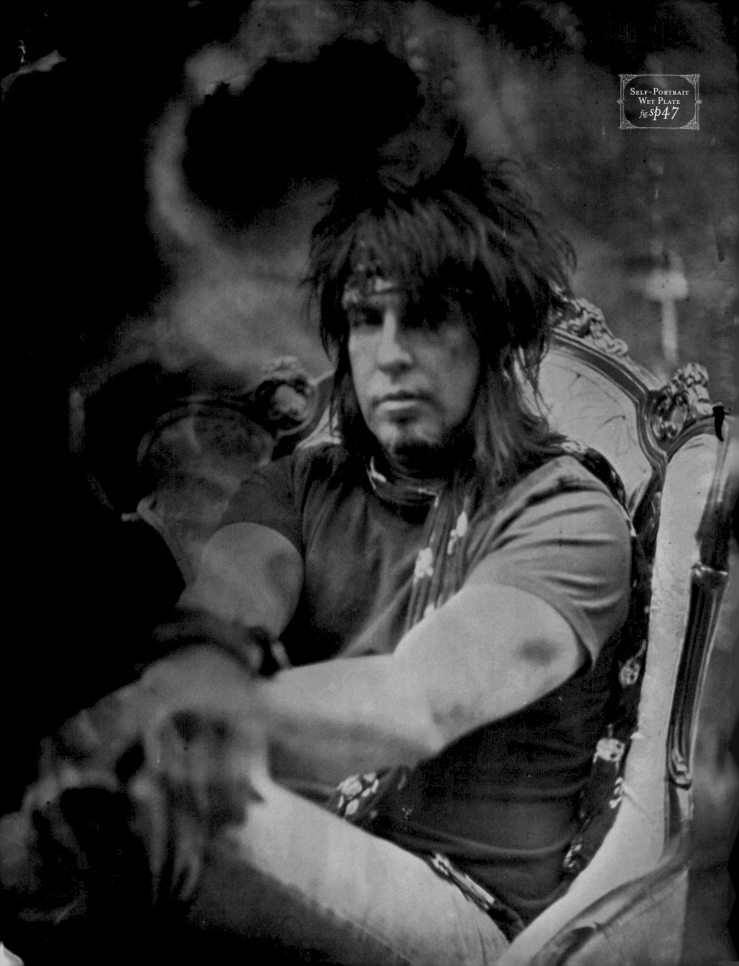

Self-Portrait
Wet Plate
fig.sp47

THE END, UNLESS IT'S THE BEGINNING

I am writing this by hand because my computer has no battery life left. I think it's a good way to start the last chapter, running outta juice, so to speak.

I don't know about you, but I am pretty exhausted by all this honesty. I have to tell you, this book has uncorked me in places I didn't know were stuck. I have had realizations about my childhood and decisions I've made based on those hard years, about how they formed my outlook and perception of my life, and how I plan to move forward with the help of this newly peeled onion.

I know this will touch some of you. Some of you will relate, some may even curse because you agree with me or, better yet, will sling these pages across the room thinking, "How *dare* he say that."

I think the biggest realization is how fear has driven me to achieve great things but also, like any double-edged sword, has cut me, sometimes to the bone. During the writing of this book I came to this realization: ego is the enemy, and fear is one of the masks of ego, as is

Why I Invited You Here

Look Thru My Cracked Viewfinder

Life's Not Always Beautiful

Ghosts Inside Me

This Is War

One Man, Two Bands

Killer's Instinct

Help Is On The Way

Tale Of The Siamese Twins And The Black Rose Tattoo

Rock N Roll Will Be The Death Of Me

The End, Unless It's The Beginning

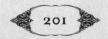

anger. I am not a psychologist or a therapist, but I have been to both over the years, and read many books, too. I think the journey to a better life begins when you find your true self and name the issue at hand. Mine would be my abandonment by my mother and father. For me, the process of recovery happens through outside help and with a spiritual connection to a power greater than myself.

I like that "peeling the onion" analogy because I don't believe we can get to the core of who we really are overnight. That's especially true when we come from a damaged place. It has taken me years to understand my teenage years, my drug and alcohol addiction, and even my recovery. Behind my core pain, I have done horrible things. I put it all out there in *The Heroin Diaries* and found that honesty not only saved my life but other lives, too. I am grateful because I could help other people feel hope. All is not lost if you're just willing to admit you are powerless.

All this brings me to an ending I never saw coming.

In the summer of 2010, as I was finishing this book, Kat came out on the road with me to Europe for a short Mötley Crüe tour. The band had a couple days off between shows. We had already booked our flight from Munich, Germany, to the next stop, Hamburg, meaning we were about to spend two days basically sitting around a hotel doing nothing, awaiting another massive rock festival.

Then it hit me. As I said before, Katherine's dream city is Prague, though she'd never been there. So why not change course, like I've done so many times in my life, and fly (literally) by the seat of my pants? Without telling Katherine, I booked us two tickets to Prague. When we got to the Munich airport, I asked her to grab us some coffee while I checked in for our flight. Tickets in hand, I tweeted that I was taking her to Prague and asked my fans not to tell her. Like with all good pranks, then came the moment when I sat back and awaited my victory.

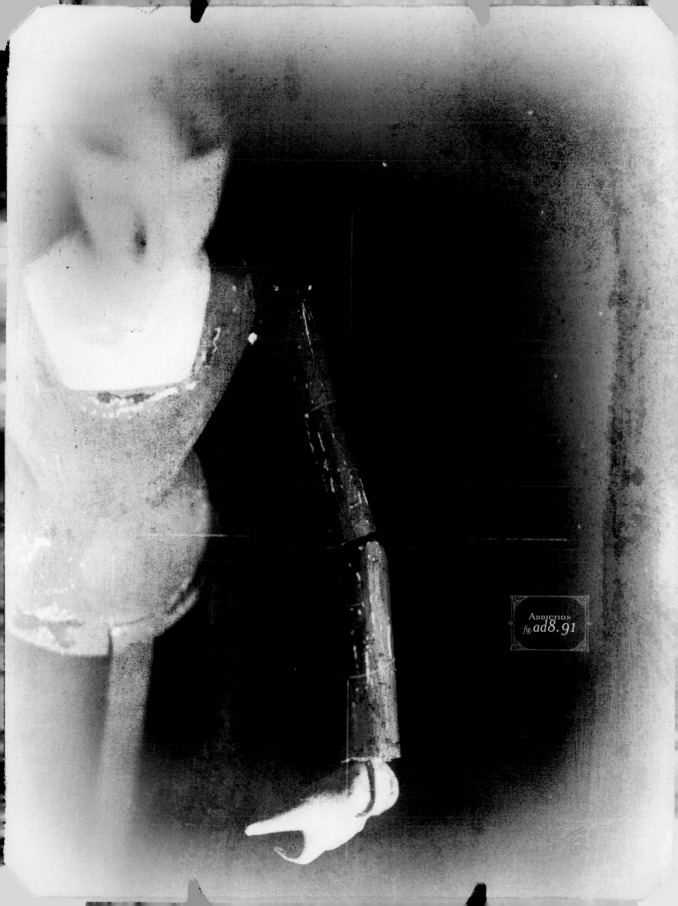

Staring at her from across the airport, I saw her check the tweets on her phone, and then watched her eyes light up as she burst into tears of joy.

We boarded the plane together, me feeling smug, her feeling loved, and we both fell into a deep sleep until the wheels hit the ground with a huge bang.

We had an amazing, romantic time in Prague, and then caught up with the tour in Germany as planned. Soon it was time to head home.

The night before we flew back to L.A., we lay in bed in Finland laughing till our bellies hurt, playing Scrabble on our phones, eating ice cream and cake till the wee hours, getting barely any sleep. By morning, when we boarded our flight, we were giddy with love and exhaustion.

But truth be told, we had been up and down, breaking up and making up, for the past two years. We were 110 percent in love one month and then crashing into the rocks the next. We both knew that, even though being together in Europe was beautiful, there was a huge pink elephant in the room, and we were trying to ignore it. Eventually, it had to be discussed.

As we flew toward L.A., we had the conversation we'd had before about how much we loved each other but something wasn't working. And so again, we decided to take a break. Yes, we were breaking up, and yes, we were still in love, and yes, it's all very confusing to us, too . . .

I refuse to dive into any of the murky bullshit and trash talk or to undermine what we had together, like the *tabloids* do. I've railed against them so often in this book. I will say this, and I probably don't even need to tell you (but I will): I still love her and I know nobody will ever own her heart the way I do. She still loves me to death, too. We are bound at the hip like Siamese twins, maybe not physically, but eternally and most certainly spiritually. Maybe our timing is just off. Maybe in a few years, or maybe never, things will change, but nothing will erase what we have experienced together.

I have learned this in my life: everything happens for a reason and everything turns out the way it is meant to be. Living in the present and accepting life on life's terms isn't always easy.

I sometimes need to remind myself that "we are exactly where we're supposed to be in the universe at this very moment." *But even with that in mind, I knew it was gonna hurt.*

Submaxillary triangle
Hyoid bone
Thyroid cartilage
Cricoid cartilage
Sternocleidomastoideus
Trapezius
Supraclavicular fossa

Clavicle

Infraclavicular fossa
Clavicular head } of Sternocleidomastoi...
Sternal head

Jugular notch

Why I Invited You Here
Help Is On The Way
Look Thru My Cracked Viewfinder
Tale Of The Siamese Twins And The Black Rose Tattoo
Life's Not Always Beautiful
Ghosts Inside Me
Rock N Roll Will Be The Death Of Me
This Is War
Supraclavicular fossa
One Man, Two Bands
Killer's Instinct
The End, Unless It's The Beginning

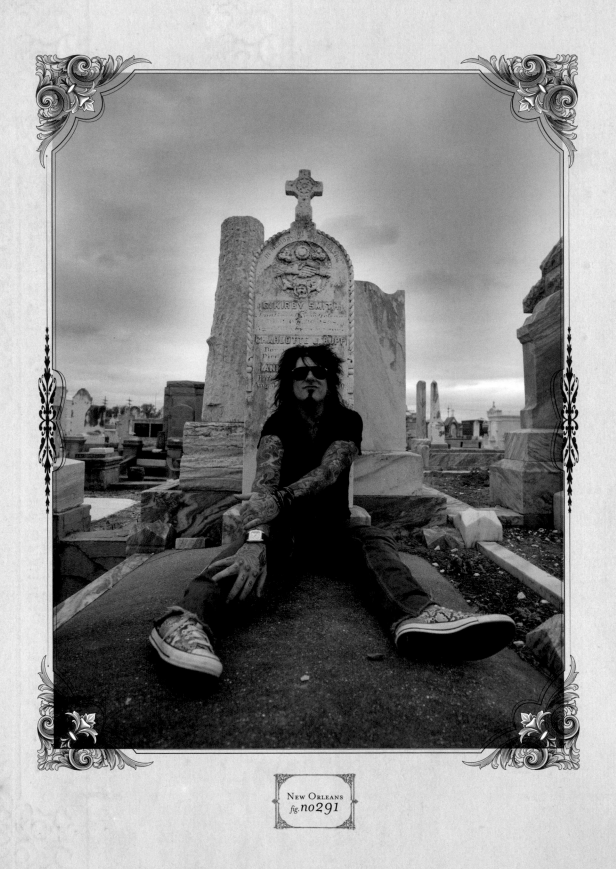

New Orleans
fig. no291

This too shall pass.

I woke up this morning and for the first time in weeks felt something was different.

I learned this one a long time ago: if you don't take control of your life, your life takes over you . . . or, if you don't deal with your demons, your demons deal with you. Shit happens and it hurts, but you're also able to change your life in the blink of an eye. Pain is a gift. It is an opportunity to make things better.

This is where I am now. I've had to look at all the heartbreaks in my life as good things—as chances to make things right, so I could forgive my mother, my father, and even my enemies. But mostly I've had to learn to forgive myself. I have to move forward and realign myself daily with a complete outpouring of positive energy. I intend to infect everybody around me with that positive energy and to push people to do more with their lives. I am so grateful that every day I get to focus on my family, on my creativity, and to manifest a wonderful future. Like all things wonderful, it will appear when I am ready—whatever "it" may be.

I don't talk much about my kids in this book or in the press, because their lives are not on display. I bring them up now only because everything else I have written about here—good times and bad, touring, career, love life—all comes in second place to them. They are my foundation, and my responsibility to them guides every decision I make.

Naturally, that ties in to my issues with my own parents. I still live with the sorrow that my father wasn't there for me as a child. But I feel I am able to go back and heal that wound by making my kids my number one priority. No woman or career or addiction will ever get in the way of that. I know that I also sometimes wallow in the fear of abandonment because of my mother and how she treated me. I am grateful that my recovery from alcohol and drug addiction happened when it did. I'm not going to do anything harmful ever again to kill the pain. Instead, unhappy experiences will push me to new levels in my music, photography, and life itself. How about you?

I am saying that if you think your life is in shambles, maybe it's a gift. It could be just the thing to push you to a new, better level. Yes, this is gonna hurt, but doesn't growing always involve some pain? I think it does.

Why I Invited You Here | Look Thru My Cracked Viewfinder | Life's Not Always Beautiful | Ghosts Inside Me | This Is War | One Man, Two Bands | Killer's Instinct

Help Is On The Way | Tale Of The Siamese Twins And The Black Rose Tattoo | Rock N Roll Will Be The Death Of Me | The End, Unless It's The Beginning

I search for and usually find the positive in everything, and in the end I am able to turn my pain into pleasure. I know I can use it to create a better life for myself and everybody around me. What I choose to focus on will become my reality. In other words, your life is whatever you think about. So you cannot allow your thoughts to get dragged down into sadness and heartbreak for too long. When hard times knock on my door these days, I say to myself, "Oh, shit, this is gonna hurt." And so it does. But from the hurt will come growth. I know that.

Over the years I have struggled to create an amazing and solid relationship with Tommy, Vince, and Mick. I love those guys even though it's safe to say we have all hurt each other pretty bad at one time or another. (All you have to do is read the Mötley Crüe bio, *The Dirt*, to see just how bad it got before it got better.) I am proud that we're still a band, and even prouder that we've all survived one another and are close friends.

My life feels challenging to me, but then I think of some of the people I have been lucky enough to photograph, and I feel humbled. Growing up being ridiculed for things that are beyond your control, suffering the cruelty of other people for being physically different—I can't fathom it. Most of us will never have to endure their torments. But when I talk to them, they say they are blessed. That they wouldn't exchange their lives for anyone else's. They feel unique. I get high on their energy and how they have overcome difficulties that make mine, and probably yours, seem trivial. They inspire me to be a better person.

This book started off as a way to showcase my photography and give us a chance to talk about creativity. It's ended up being one of the most exciting yet painful experiences of my life, making me dig into my past, discovering my deep connection to the loss of my sister, my family, and even my girlfriend. It feels as though it has all exploded onto the pages of this book. Jesus, all I wanted to do was show you some pictures. Such is my life.

Which brings me to one final story, something funny that happened at the Prague airport when Kat and I landed there. We both needed to make a pit stop. As I waited for her near the ladies' room, out came a little boy with his mom in tow. He stopped in his tracks to inspect me closely. I was still wearing my stage pants and makeup from the Munich show, so I was a sight. No wonder he stared. I waved and his face exploded in a huge smile. At that very moment his mother saw me, grabbed his hand, and jerked him to her side, then stormed off toward the baggage claim.

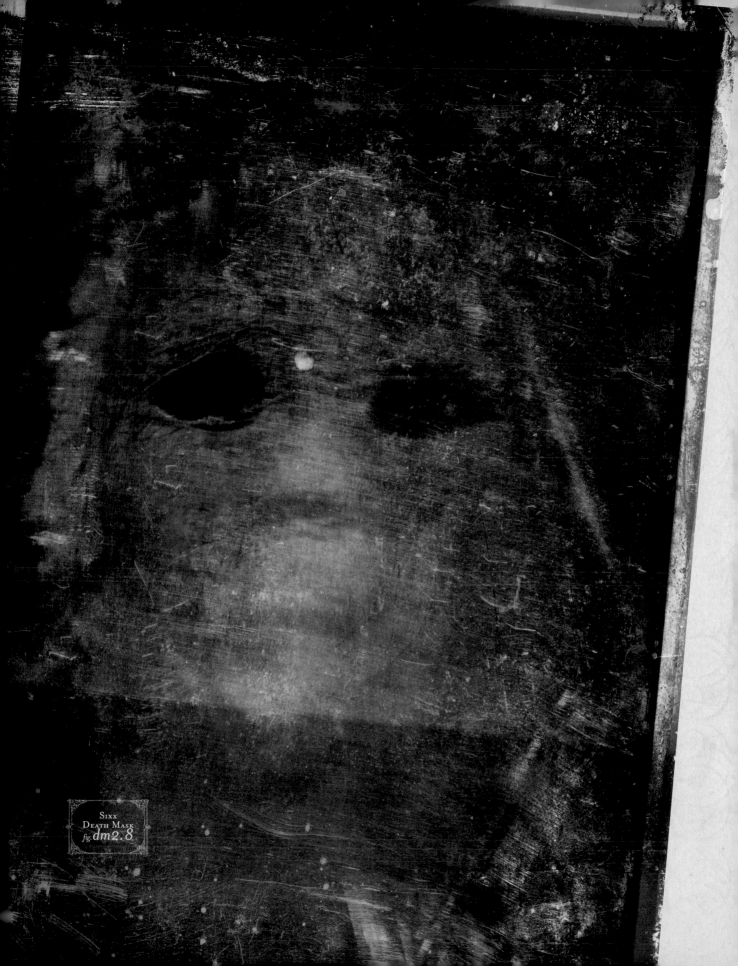

SIXX
DEATH MASK
fig. dm2.8

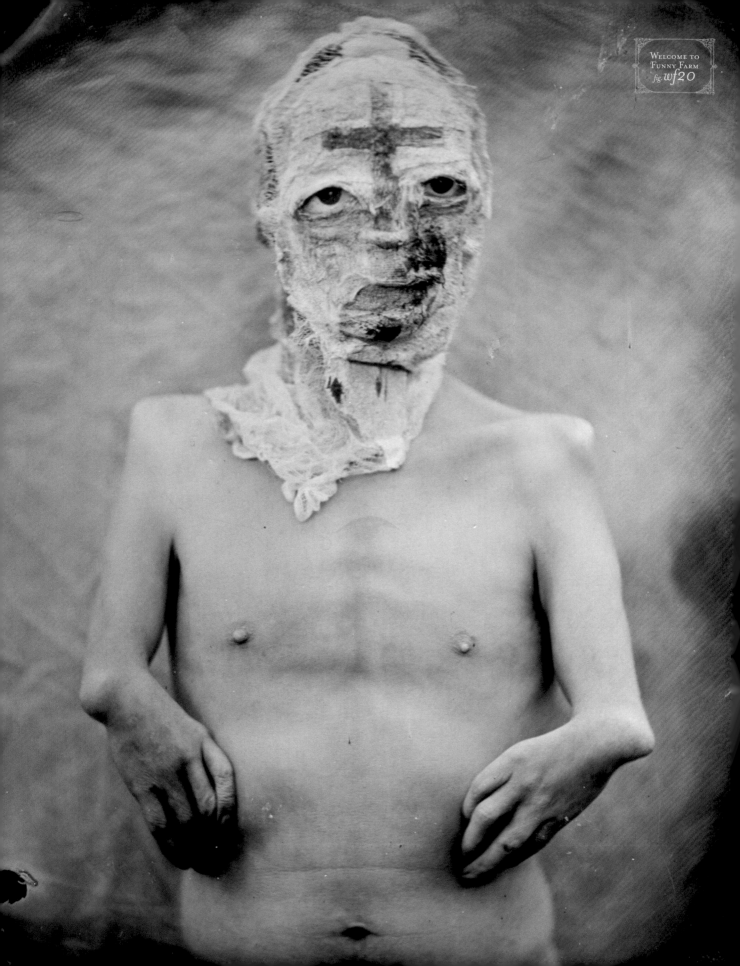

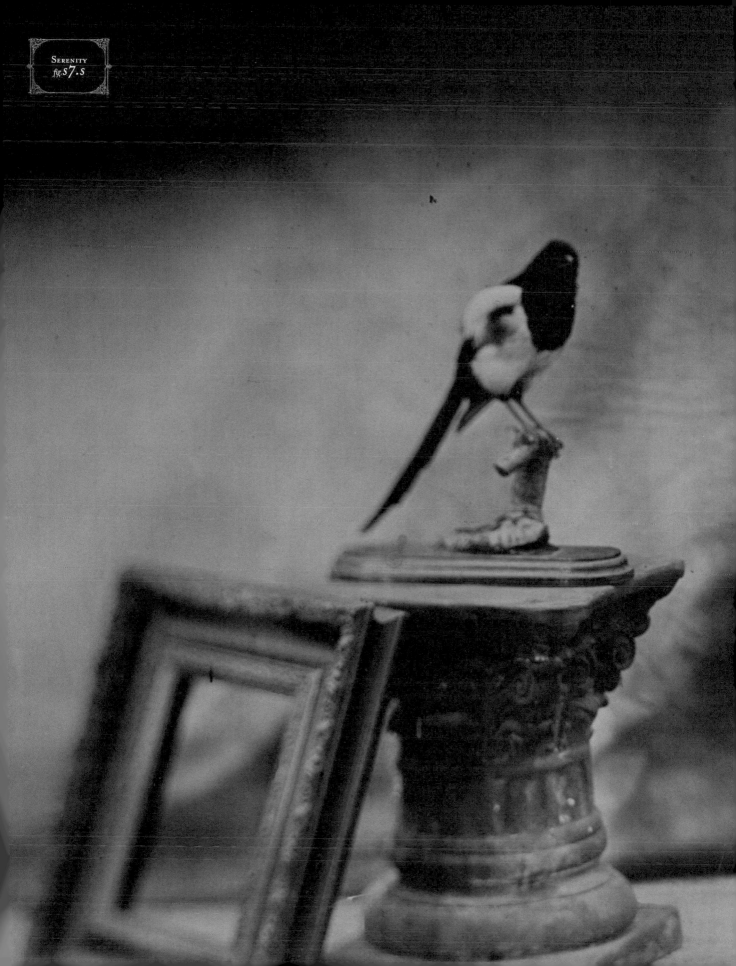

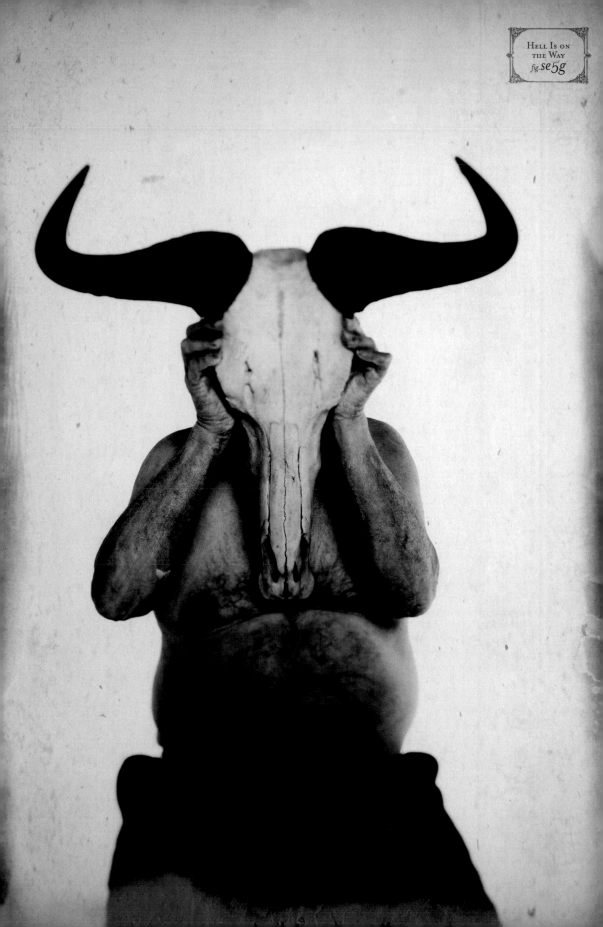

In those ten seconds, my whole life flashed before my eyes.

He turned around as he was being dragged away, still smiling, and waved back. I just grinned. My life had come full circle. Now I was the poor, unfortunate-looking wretch, and the mother was talking about me when she said, "Don't stare!" And in the innocence of that little boy's eyes, I saw myself . . . before all the hateful messages, the bad information programmed into our minds that tells us what's ugly and what's beautiful, what is in and what is out, how to feel, what to feel, and who we should want to love and to fear and to hate. Now the circle has closed and I feel like maybe my life will make a little more sense to me—and maybe to you.

So as this pen runs out of ink and the pages swallow up my last words, I feel content. In my life as a prankster, a lover, and an artist, yet another plan has come together. I know if you're still reading you must have felt something, and if I've given you a glimpse through my distorted lens, then maybe we can both agree that life is wonderful and beautiful, no matter what. Don't believe the lies of the beautiful people; believe in yourself instead.

I look forward to more lessons, and maybe, just maybe, if we cross paths somewhere, anywhere, you will tell me that this book made you feel something differently than before.

I'm gonna put down this pen, pick up my camera, and guitar and go out and change the world . . .

Are you with me now?
—NIKKI

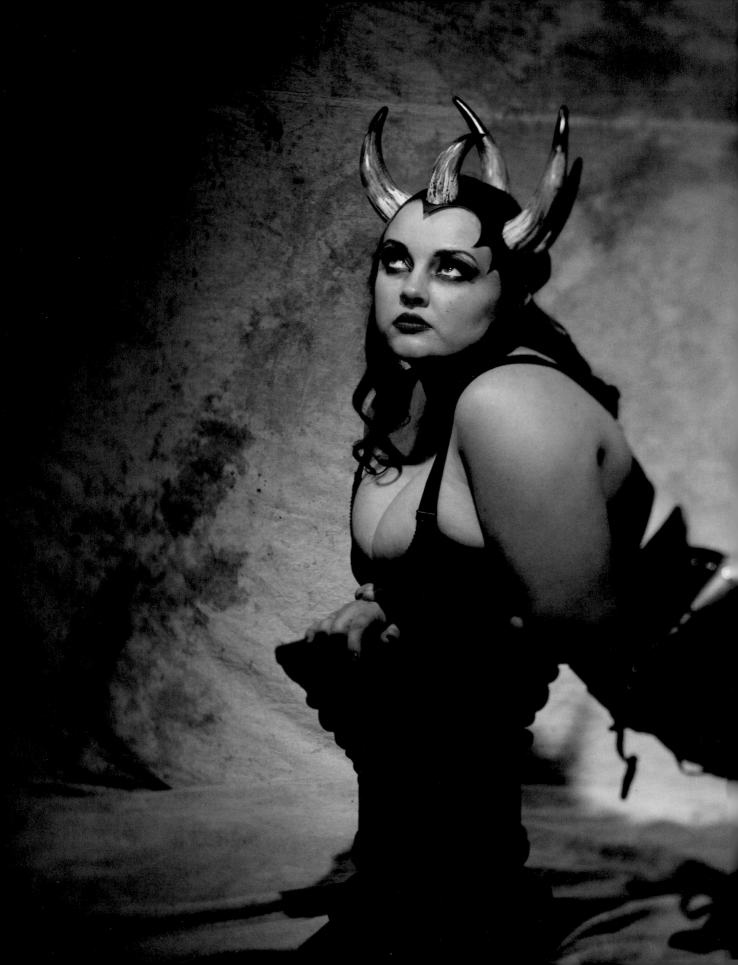

Goodbye My Friends
SIXX:A.M.

Piles of roses at my feet
Friends and lovers gather around me
Whisper farewell one by one
Clear their conscience as they surround me
Close your eyes, you will be okay

No remorse and no regrets
For what I did and what I've said isn't
Life lived right at the edge
And when it's not you know you're dead

So goodbye my friends
To hell with the sorrow
We have made amends
It's time to say
Goodbye my love
By this time tomorrow
It will be the end
Goodbye my friends

Doused my youth in gasoline
Lit a match and laughed while it's burning
Righting my wrongs word by word
All the lessons I've been learning
Close my eyes and I will be okay

No remorse and no regrets
For what I did and what I've said isn't
Life lived right at the edge
And when it's not you know you're dead